Angels, Demons, and Savages

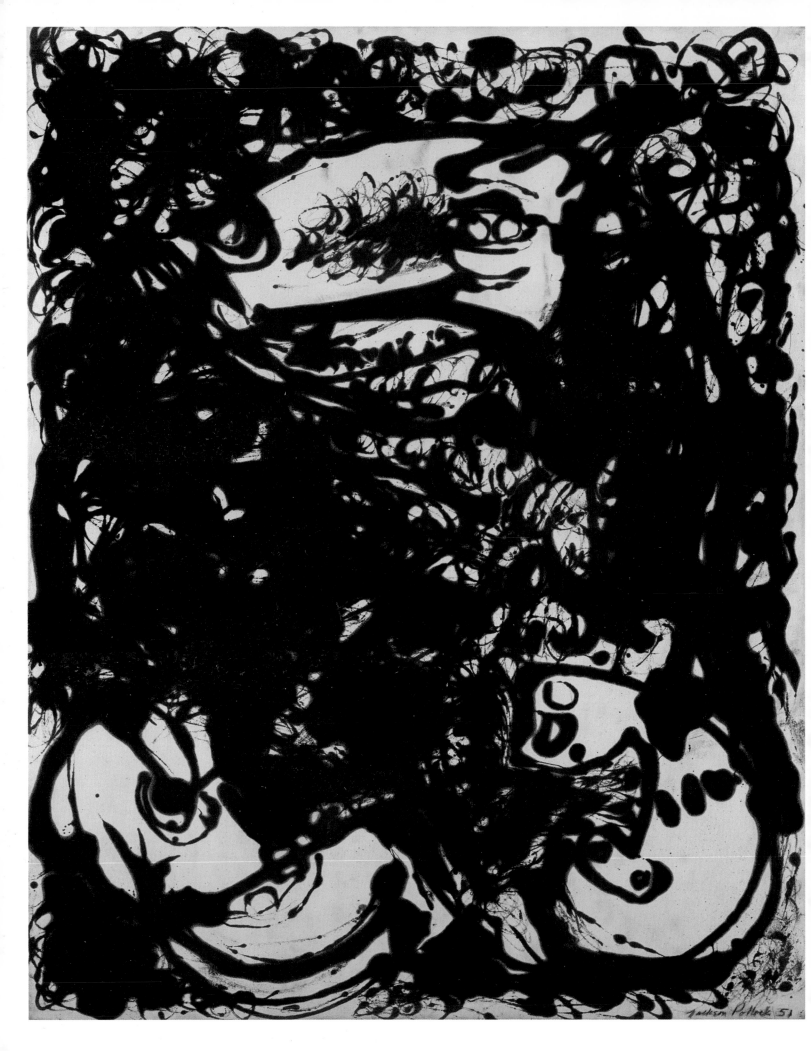

Angels, Demons, and Savages

Pollock, Ossorio, Dubuffet

Klaus Ottmann
Dorothy Kosinski

Introductions by **Dorothy Kosinski** and **Terrie Sultan**

With essays by **Klaus Ottmann** and **Alicia G. Longwell**

A text by **Jean Dubuffet**

and contributions by **Elizabeth Steele, Sylvia Albro, Scott Homolka,** and **Chantal Bernicky**

Yale University Press
New Haven and London
In association with
The Phillips Collection and **the Parrish Art Museum**

Jean Dubuffet's essay originally appeared in Jean Dubuffet, *Peintures initiatiques d'Alfonso Ossorio* (Paris: La Pierre Volante, 1951). Text copyright © 2013 Fondation Dubuffet, Paris. Translation copyright © 2013 Richard Howard, New York.

Published on the occasion of the exhibition *Angels, Demons, and Savages: Pollock, Ossorio, Dubuffet,* co-organized by The Phillips Collection and the Parrish Art Museum

The Phillips Collection
Washington, D.C.
February 9–May 12, 2013

Parrish Art Museum
Water Mill, New York
July 21–October 27, 2013

The exhibition is made possible through support from the Terra Foundation for American Art.

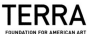
TERRA
FOUNDATION FOR AMERICAN ART

The exhibition in Washington is proudly sponsored by Lockheed Martin.

LOCKHEED MARTIN

The catalogue is published with the support of the Dedalus Foundation, Inc.

yalebooks.com/art

Designed and typeset by Katy Homans
Printed in China through Oceanic Graphic International, Inc.

Library of Congress Cataloging-in-Publication Data
Ottmann, Klaus.
 Angels, demons and savages : Pollock, Ossorio, Dubuffet / Klaus Ottmann, Dorothy Kosinski ; introduction by Dorothy Kosinski and Terrie Sultan with an essay by Alicia G. Longwell, a text by Jean Dubuffet, and contributions by Elizabeth Steele, Sylvia Albro, Scott Homolka, and Chantal Bernicky.
 pages cm
 Published on the occasion of the exhibition Angels, Demons, and Savages: Pollock, Ossorio, Dubuffet, co-organized by The Phillips Collection and the Parrish Art Museum.
 Includes bibliographical references and index.
 ISBN 978-0-300-18648-2 (cloth : alk. paper) 1. Ossorio, Alfonso, 1916–1990—Exhibitions. 2. Ossorio, Alfonso, 1916–1990—Friends and associates—Exhibitions. 3. Pollock, Jackson, 1912–1956—Exhibitions. 4. Pollock, Jackson, 1912–1956—Friends and associates—Exhibitions. 5. Dubuffet, Jean, 1901–1985—Exhibitions. 6. Dubuffet, Jean, 1901–1985—Friends and associates—Exhibitions. I. Kosinski, Dorothy M. II. Phillips Collection. III. Parrish Art Museum. IV. Title.
 N6537.O77A4 2013
 709.2—dc23 2012021496

A catalogue record for this book is available from the British Library.

This paper meets the requirements of ANSI/NISO Z39.48–1992 (Permanence of Paper).

10 9 8 7 6 5 4 3 2 1

page ii: Jackson Pollock, *Number 23, 1951* (plate 9)
page vi: Alfonso Ossorio, *Full Mother* (plate 34)
Jacket illustrations: (*front*) Alfonso Ossorio at the Creeks, 1952, with paintings by Ossorio, Clyfford Still, and Jean Dubuffet. Photograph by Hans Namuth; (*back*) Jackson Pollock, *Number 7, 1952* (plate 17).

Contents

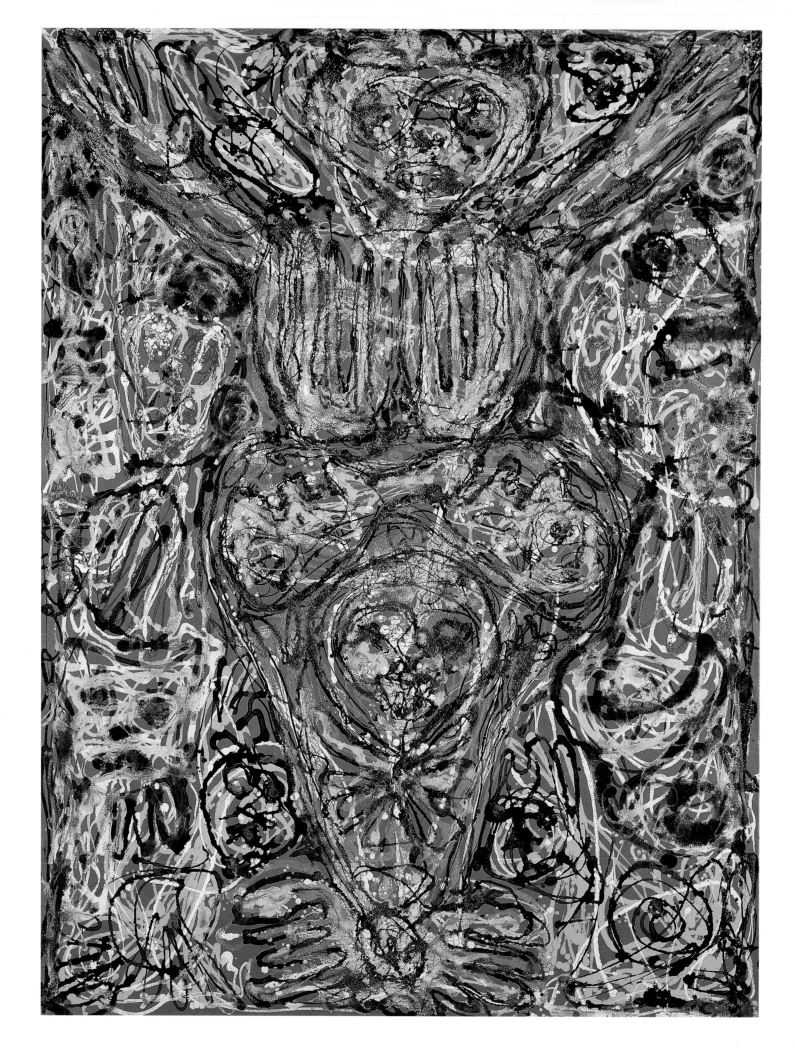

Introductions and Acknowledgments

This exhibition project reveals the convergence of three artists—Jackson Pollock, Alfonso Ossorio, and Jean Dubuffet—during the years 1948 to 1952. We insist upon Ossorio as artist and refuse to allow his artistic practice to be obscured by his roles as friend, author, patron, and collector, though inevitably those activities figure importantly in this story. Pollock and Ossorio were frequent *interlocuteurs* and eventually neighbors on Long Island. Ossorio championed Pollock, penning an introductory essay in 1951 for an exhibition at Betty Parsons's gallery, and organizing an exhibition of Pollock's work in Paris the following year. Dubuffet wrote about Ossorio, a book-length essay, "Peintures initiatiques d'Alfonso Ossorio," that he produced in 1951, a year in which the two artists saw each other frequently in Paris and then in the Mediterranean. Pollock, on the other hand, never met Dubuffet, though he knew his work keenly, whether from exhibitions such as the one at the Pierre Matisse Gallery in 1952, from popular publications, including *Life* magazine in 1948, or from major works that Ossorio purchased. Another important aspect of these years is Ossorio's installation of Dubuffet's Art Brut collection at his Hamptons estate over a decade beginning in 1952, thereby further amplifying the layers of aesthetic dialogue. We will not discover neat evidence of binary influences or balanced exchange. It might be suggested that Pollock's return to figuration in his black-and-white works from 1951 was impacted by his currency with Ossorio or Dubuffet. What is most apparent, however, is the impressive richness and intensity of these artists' convergence, in a constellation of mutual exchanges stretching between the United States and Europe (and embracing non-Western traditions), a story of personal and artistic relationships that diverges from the conventional (hagiographic and nationalistic) histories of American twentieth-century art.

It has taken almost twenty years for this project to come to fruition. It is wonderfully appropriate that the exhibition finally unfolds at the Phillips Collection and at the Parrish Art Museum, two institutions with important ties to these artists' production and the work of the mid-twentieth century in America and Europe. Duncan Phillips had already purchased Alfonso Ossorio's 1950 *Five People* from the Betty Parsons Gallery in 1951. Several years later, in 1958, he introduced an unusual collage by Pollock dating from 1951, purchased through the Sidney Janis Gallery in New York. The Parrish Museum's collection contains several works by Ossorio, as well as a work on paper by Pollock that was a gift from Ossorio.

I came to know Ossorio around 1984 during my brief tenure as curator of art at the Bruce Museum in Greenwich, Connecticut. Alfonso's brother Eric was a member of the museum's board of trustees. Eric was, of course, a passionate champion of his brother's work and proudly displayed many of his works in his elegant modernist home. Eric clearly shared his brother's keen intellect and broad-ranging interests, and especially his passionate engagement in aesthetics, religion, and philosophy, and I was the glad recipient of his long letters. I was fascinated by Alfonso's work, mesmerized by the mixture of figuration and allover gesture, by the conflation of Catholic imagery and non-Western references, by the spiritual power and visceral intensity of his works. His later works, the powerful assemblages he called Congregations, revealed no diminishment of creativity, but were rather astonishingly explosive constructions that boldly encompassed materials from seemingly impossibly disparate sources. My scholarly curiosity was piqued by the virtual absence of

this important figure from standard art-historical texts. Why and how could this huge talent be so marginalized in the conventional art-historical canons?

Though I lost touch with the Ossorios over the next ten years or so, my interest in Alfonso's work was nurtured further by my scholarly engagement with Surrealism and specifically the anti-aesthetics of Georges Bataille, whose ideas about the *informe,* the abject, and heterogeneity imply a disruption of standard art histories. Moreover, my home base in Basel, Switzerland, reinforced my impatience with the curious myth that painting had screeched to an abrupt stop in Europe after World War II. The work of Karel Appel, Gaston Chaissac, Nicolas de Staël, Jean Dubuffet, Georges Mathieu, Serge Poliakoff, Pierre Soulages, and others offered compelling evidence to the contrary. The possibility of working on Ossorio emerged in 1996 during my tenure at the Dallas Museum of Art. Klaus Ottmann proposed this exhibition project, planned by the American Federation of Arts in collaboration with the artist Mike Solomon, who had worked as assistant to Ossorio at the Creeks and for the Ossorio Foundation as director following Alfonso's death in 1990. I was especially eager to see this exhibition come to fruition in Dallas, where I had taken on an acquisition project, responding to an offer from the Ossorio Foundation to introduce his work into the permanent collection. *Red Family* (1951) joined the Dallas Museum's impressive assemblage of Abstract Expressionist works by Jackson Pollock, Willem de Kooning, Clyfford Still, Lee Krasner, Arshile Gorky, Sam Francis, Franz Kline, and James Brooks. In addition *Red Eagle,* a Congregation from 1967, was added to the museum's small but growing collection of Surrealist works. For a variety of reasons, however, the exhibition never came to pass.

It is noteworthy that the Ossorio Foundation has worked assiduously over the years at placing Ossorio's works in major museum collections. During my tenure in Washington at the Phillips Collection, we have also worked with the Foundation, under the capable leadership of Nicole Vanasse, purchasing an important painting from the 1950s, *The Family.* In addition, we received a gift of a major work on paper from 1952, *Reforming Figure,* as well as *Excelsior,* a Congregation from 1960. We were also the glad recipients of an extensive collection of late works on paper, the Recovery Drawings, which Ossorio created during a hospital stay in 1989 while recuperating from heart bypass surgery. These important acquisitions are fitting additions to a collection that reflects Duncan Phillips's enthusiasm and engagement with emerging American artists of the 1940s and '50s. This exhibition mirrors a key character of Duncan Phillips's lifelong collecting project, his desire to valorize American modernism and to frame this art in an international perspective. It is this aesthetic philosophy that is one of the driving forces behind the special quality and character of the Phillips Collection.

It is instructive to study the archives. In November 1951 Betty Parsons sent six works to Washington—one each by Theodoros Stamos, Bradley Tomlin, and Ossorio, and two works by Pollock. In March 1952, Phillips organized an exhibition entitled *Painters of Expressionistic Abstractions* that included works already in the collection or on loan from other sources, private and public. Typical of Duncan Phillips's international perspective, the exhibition included Europeans—André Masson, Soulages, Nicolas de Staël, and Jean Miró. The American modernists included Arthur Dove, Kenneth Noland, Theodoros Stamos, William Baziotes, Alfonso Ossorio, Jackson Pollock, Willem de Kooning, Adolph Gottlieb,

and Robert Motherwell. Archival material reveals Duncan Phillips's perspective and intent as he nurtured his collection and experimented with his robust exhibition program. His collection, distinguished by this fundamental aesthetic philosophy and a modest scope suitable to the means and taste of an individual, is decidedly different from the evolution of the Museum of Modern Art, for instance, which embraced a teleological model and was shaped by a powerful institutional perspective. Phillips's project remained personal, resulting in an idiosyncratic collection that did not adhere to what he described as "isms," installed in an ahistorical and fluid constellation.

One narrow avenue of our inquiry focuses on Ossorio: Why was his artistic career so thoroughly marginalized, even though he was shown by a major gallery such as Betty Parsons within months of Jackson Pollock? Was his style too chaotic? His media too heterogeneous? Was it that he adhered always to at least remnants of figuration, in seeming defiance of the all-over vocabulary that dominated the period? He was perhaps simply too difficult to categorize: foreign, born in the Philippines, and naturalized in 1933, he was wealthy, urbane, multilingual, religious, gay, an articulate writer-critic, a formidable collector. So many of these characteristics might script him outside the muscular all-American postwar art history that was the engine of critical appraisal in the 1940s and '50s.

Our project resonates now in the context of a growing number of significant revisionist studies of the state of postwar painting. Serge Guilbaut's 1983 publication *How New York Stole the Idea of Modern Art* forefronted the political valiancy of museum and gallery exhibitions and critical reception in establishing a seeming New York hegemony. The 2007 exhibition that Guilbaut organized in Barcelona with Manuel Borja-Villel, *Be Bomb: The Transatlantic War of Images and All That Jazz, 1946–1956,* offered a visually powerful manifestation of his arguments, juxtaposing, for instance, works by Bram van Velde, Jackson Pollock, and Franz Kline. An even more audacious exhibition was organized by the Musée des Beaux Arts in Lyon in 2008 under the direction of Eric de Chassey and Sylvie Raymond: *1945–49 Repartir à Zéro, comme si la peinture n'avait jamais existé.* The curators adopted a more expansive perspective for their study of the immediate postwar years, broadening the focus beyond the New York–Paris opposition to instead consider Abstract Expressionism as a truly international phenomenon, stretching from California to Canada to Czechoslovakia. The international scope of their project is revealed in their checklist, ranging from the great titans of the period to the virtually unknown, including Willi Baumeister, Peter Busa, Olivier Debré, Jean Dubuffet, Lucio Fontana, Sam Francis, Hans Hartung, Asger Jorn, Lee Krasner, Georges Mathieu, Henri Michaux, Robert Motherwell, Barnett Newman, Alfonso Ossorio, Jackson Pollock, Sal Sirugo, Charles Seliger, Pierre Soulages, Nicolas de Staël, Clyfford Still, Władysław Strzemiński, Bram van Velde, and Wols.

I am enormously grateful to my colleague Klaus Ottmann, director of our Center for the Study of Modern Art and curator at large, for patiently and persistently pursuing this project and bringing it to fruition in such elegant form. Klaus had already suggested it to me in 2008 when he was the Robert Lehmann Curator at the Parrish Art Museum. After joining the Phillips Collection in 2010, he continued directing the project for the Phillips and the Parrish. I am grateful to my colleague Terrie Sultan, director of the Parrish Art Museum, for her willingness to collaborate with the Phillips and especially for her exceptional

graciousness as Klaus took up his post here in Washington. I want to acknowledge, as well, the important contributions of Alicia G. Longwell, chief curator at the Parrish, in all aspects of this project, especially her important essay in the catalogue. It is a longstanding Phillips Collection tradition to advance new knowledge in the form of conservation-scientific and technical analysis, and I am very pleased with the fine contributions to the catalogue by the Phillips's chief conservator, Elizabeth Steele, and fellow conservators Sylvia Albro, Chantal Bernicky, and Scott Homolka. We would also like to thank the Fondation Dubuffet for allowing us to publish Richard Howard's splendid translation of Dubuffet's essay on Ossorio.

I want to recognize the invaluable contributions of other Phillips staff members who have worked hard to make this project a success: Liza Strelka, curatorial coordinator; Joseph Holbach, chief registrar; Trish Waters, associate registrar for exhibitions; Gretchen Martin, assistant registrar for visual resources and collection; Ann Greer, director of communications and marketing; Cecilia Wichmann, publicity and marketing manager; Vivian Djen, marketing communications editor; Suzanne Wright, director of education; Brooke Rosenblatt, manager of public programs and in-gallery interpretation; Christine Hollins, director of institutional giving; Dale A. Mott, director of development; Sue Nichols, chief administrative and financial officer; Cheryl Nichols, director of budgeting and reporting; Lydia O'Connor, finance assistant; Darci Vanderhoff, chief information officer; Mark Weiner, audio visual support specialist; Megan Clark, manager of center initiatives, Center for the Study of Modern Art; Karen Schneider, librarian; Sarah Osborne-Bender, cataloguing and technical services librarian; Bill Koberg, head of installations; Shelly Wischhusen, chief preparator; Alec MacKaye, preparator; Dan Datlow, director of facilities and security; and Brooke Horne, executive assistant to the director and the board of trustees.

No major loan exhibition can be accomplished without the generosity of public and private lenders who make their precious works of art available. We thank Acquavella Modern Art, New York; the Allen Memorial Art Museum, Oberlin College, Oberlin, Ohio; the Chrysler Museum of Art, Norfolk, Virginia; the Dallas Museum of Art; the Des Moines Art Center; Glenstone; Arne and Milly Glimcher; Henry H. and Carol Brown Goldberg; the Hirshhorn Museum and Sculpture Garden, Smithsonian Institution, Washington, D.C.; The Metropolitan Museum of Art, New York; The Museum of Fine Arts, Houston; the National Gallery of Art, Washington, D.C.; the Parrish Art Museum, Water Mill, New York; Michael Rosenfeld Gallery, LLC, New York; Michael Rosenfeld and halley k harrisburg; Ronnie and John E. Shore; Louis and Sally Vanasse; the Ossorio Foundation, especially Nicole A. Vanasse; and others who wish to remain anonymous. We are enormously grateful for the special engagement of the Ossorio Foundation, which has been such a great advocate of Ossorio and so generous to our project.

We are exceedingly grateful for the generous financial support of the Terra Foundation, a major champion and key funder of initiatives that offer an international perspective to the study of American art. The Dedalus Foundation has most generously supported the exhibition catalogue. Lockheed Martin has been a longtime corporate partner at the Phillips Collection, and we are enormously grateful for their engagement in this important inquiry into a special chapter in the history of mid-twentieth-century art.

Dorothy Kosinski

Director, The Phillips Collection

The Parrish Art Museum is the oldest and largest cultural institution on the East End of Long Island, uniquely placed within one of the most concentrated creative communities in the United States. Rooted in history but dedicated to the present and future tenses of art, the Parrish Art Museum celebrates the unique artistic legacy of Long Island's East End and its influence throughout the world. The Museum proudly grounds its mission in this unique community, honoring and celebrating the global influence exerted by the artists nurtured here. Some of the twentieth century's most important artists and writers lived, worked, and played on the East End of Long Island between 1940 and 1960. Creative collaborations among artists of all disciplines continue to thrive on the East End, and the Parrish is proud to play a significant role in encouraging fresh approaches to artmaking.

Angels, Demons, and Savages: Pollock, Ossorio, Dubuffet focuses on the four years from 1948 to 1952 when these three artists intersected, producing a captivating story of a special period of creative confluence. This exhibition illuminates a key moment in the history of American Abstract Expressionism that was profoundly influenced by the cross-cultural exchanges between these three international artists. Alfonso Ossorio is the central figure in this narrative. An artist and collector with a lively mind and an entrepreneurial spirit, he was early on attracted to the work of both Jackson Pollock and Jean Dubuffet. He avidly collected their work and developed collegial friendships with both. Ossorio met Pollock and his wife Lee Krasner through the gallerist Betty Parsons in 1949, and visited them often in Springs that year. The next year Ossorio traveled to Paris to meet Jean Dubuffet, an artist with whom Ossorio was becoming increasingly preoccupied.

In 1951, at Pollock's urging, Ossorio purchased a large East Hampton estate, the Creeks, where he arranged to house and display Dubuffet's Art Brut collection, and where Ossorio lived and worked for the next forty years. Designed by Grosvenor Atterbury and built in 1899, the Creeks encompassed not only Ossorio's studio but was an expansive home filled with his own important collection, including works by Pollock, Lee Krasner, Clyfford Still, Jean Fautrier, Wols, Willem de Kooning, and Dubuffet, among others. Thus, the Parrish is the perfect setting for this exhibition, with the Hamptons as the backdrop and the Creeks as the stage for a host of personal encounters and art historical exchanges by an international roster of artists.

Projects like this require enormous resources in time, energy, and finances, and the entire Parrish staff contributed to the success of the project. Alicia G. Longwell, Lewis B. and Dorothy Cullman Chief Curator of Art and Education, worked tirelessly in concert with Klaus Ottmann, and has contributed an enlightening essay illuminating this special creative narrative. Registrar Chris McNamara and curatorial assistant Sam Bridger Carroll ably assisted with all the myriad details regarding the catalogue and exhibition. Mark Segal, director of marketing and public relations, ensured that the project received wide exposure. Cara Conklin-Wingfield, deputy director, education, guided the outreach materials and programs, and curator of programs Andrea Grover developed an array of stimulating initiatives to augment understanding and appreciation of the life and work of these three artists. Deputy director Anke Jackson was enormously helpful throughout.

Of course I join my colleague Dorothy Kosinski in expressing my gratitude and appreciation to the many institutions and private collections that so generously shared the work of these great artists, and to the funders who made the exhibition possible.

Terrie Sultan
Director, Parrish Art Museum

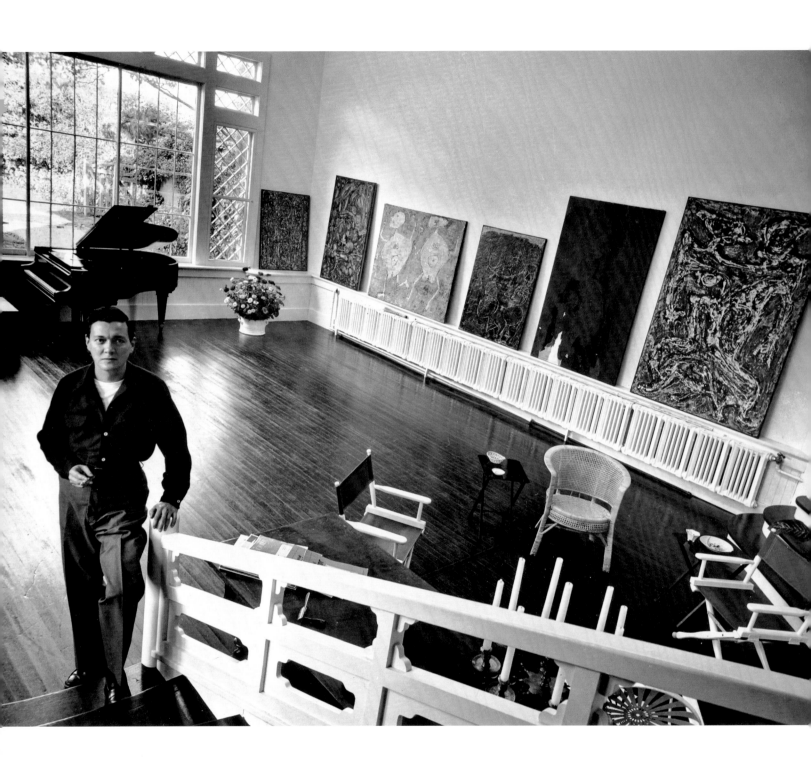

Angels, Demons, and Savages

Klaus Ottmann

. . . the Powers
That we create with are not our own
—W. H. Auden

**No one has ever written or painted,
sculpted, modeled, built, invented,
except to get out of hell.**
—Antonin Artaud

Alfonso Ossorio at the Creeks, 1952, with paintings
by Ossorio, Clyfford Still, and Jean Dubuffet.
Photograph by Hans Namuth.

In January 1948 the political and literary quarterly *Partisan Review* published an article by the influential American critic Clement Greenberg on the state of American art, "The Situation at the Moment." In it he declared, "One has the impression . . . that the immediate future of Western art, if it is to have any immediate future, depends on what is done in this country. As dark as the situation still is for us, American painting in its most advanced aspects—that is, American abstract painting—has in the last several years shown here and there a capacity for fresh content that does not seem to be matched either in France or Great Britain."[1] With these words, Greenberg almost single-handedly cut off European art from the American cultural discourse for the remainder of the decade.

And he was not alone. As the art historian and author of *The Triumph of American Art,* Irving Sandler, recalls in his recently published memoirs, Thomas Hess, who became managing editor of *ARTnews* in 1950, expressed a somewhat more subtle but equally condemning position: "Tom believed that [the New York school] had replaced the School of Paris as the vital center of international avant-garde art, and that would be the underlying premise of his art writing . . . setting up a polarity between 'Paris art' and 'French art.' Paris art was advanced and international; French art was retarded and provincial. . . . Tom concluded that after World War II, art in Paris had become French. New York had replaced Paris *as the center of 'Paris' art.*"[2]

Showing equal disregard for the social and political devastation and hardship that was still affecting both private and creative life in Europe only three years after the end of the war and the tyranny of fascism, Greenberg describes the situation of the American artist as one defined by "isolation, alienation . . . the condition under which the true reality of our age is experienced" while calling the life of artists working in Paris or London "idyllic by comparison."[3] In a similar vein, Harold Rosenberg, the most outspoken proponent of American "action painting," writes, "Europe no longer had anything to offer but a mixture of memories."[4] Rosenberg considered Abstract Expressionism "the most vigorous and original movement in art in the history of this nation."[5]

In March 1948 Greenberg followed with another *Partisan Review* article, "The Decline of Cubism," which unmistakably called for American art to sever any connections to European art, which—with one notable exception ("None of them, except Dubuffet, is truly original")—he now perceived as utterly unoriginal: "The conclusion forces itself, much to our own surprise, that the main premises of Western art have at last migrated to the United States, along with the center of gravity of industrial production and political power."[6] As Serge Guilbaut comments, this was "a crucial moment, for it was then that Greenberg chose to announce that American art was the foremost in the world."[7]

What Greenberg chose largely to ignore was the fact that the collective moral and physical breakdown of European culture after the war that went hand in hand with regained artistic liberties had given rise to a surge of creative energy without equal in the history of European art. Unable to relate to their erased past, a new generation of artists in France, Germany, Britain, Belgium, and Denmark turned to new materials and process that resulted in the emergence of highly experimental forms of painting that went by names such as Art Informel, Tachisme, CoBrA, or ZERO.

1

As the Dutch artist Constant (Nieuwenhuys), one of the members of CoBrA, the highly expressive figurative style inspired by the European avant-garde movement based in Copenhagen, Brussels, and Amsterdam, wrote in 1948, "The role of the creative artist can only be that of the revolutionary: it is his duty to destroy the last remnants of an empty, irksome aesthetic, arousing the creative instincts still slumbering unconscious in the human mind.... A new freedom is coming into being which will enable human beings to express themselves in accordance with their instincts.... A painting is not a composition of color and line but an animal, a night, a scream, a human being, or all of these things together."[8]

One of the leading protagonists of the rise of European experimental painting, in response to the collapse of the signified instigated by the experience of fascism, was the calligraphic painter Georges Mathieu, who in 1947 organized an exhibition entitled *L'imaginaire* (The imaginary) in opposition to the prevailing geometric abstraction. Its other protagonist was the Resistance painter Jean Fautrier, who became known for his Hostage series, which he painted in 1943 while hiding from the German Gestapo. In accordance with structuralist linguistics, Mathieu believed that painting was undergoing its most radical revolution in that the signified no longer preceded its signifier; rather, the sign generated its own meaning. Another artist, Alfred Otto Wolfgang Schulze (aka Wols), who had left Germany for France in 1932, had a major influence on the development of postwar French and German Art Informel painting.

The term *informel* (in the sense of formlessness, the absence of defined form, rather than "informal") was devised by the French critic, curator, and artist Michel Tapié. Art Informel represented a departure from Cubism and geometric abstraction toward a new form of free expression. It was also referred to as Tachisme (from *la tache,* "the spot, drip") or Lyrical Abstraction and formed a parallel movement with American Abstract Expressionism. In 1951 Tapié organized an exhibition at the Studio Paul Facchetti in Paris under the title *Les Signifiants de l'informel* (The signifiers of the formless), with a nod to the Swiss linguist Ferdinand de Saussure, whose structuralist theory of signifiers and signified was at the time being widely adapted by French intellectuals in diverse fields, such as the philosopher Roland Barthes, the psychoanalyst Jacques Lacan, and anthropologist Claude Lévi-Strauss. The exhibition included works by Fautrier, Mathieu, Henri Michaux, and the most controversial artist in Paris at the time, Jean Dubuffet.

Most artists on both continents rejected the notion of a "nationalist" art. Few if any American artists shared Greenberg's contempt for European, and especially French, art. Jackson Pollock's well-known remark from 1944 that he "accept[s] the fact that the important painting of the last hundred years was done in France" is utterly devoid of any such nationalism: "An American is an American and his painting would naturally be qualified by the fact, whether he wills it or not. But the basic problems of contemporary painting are independent of any one country."[9]

As Lee Krasner recounts, when she first met Pollock in 1941, she discovered that they both shared a mutual interest in the School of Paris: "We'd either be talking about Picasso, or arguing about Matisse but ... it was always French paintings. I knew of his early interest in Orozco and Siqueiros, but we were past that stage."[10]

When the Museum of Modern Art in New York acquired Matisse's *Red Studio* in 1949, Mark Rothko visited the museum every day for months to study the painting. He once told his wife Mel that they owed both his artistic achievements and their material possessions to Matisse: "You remember when I used to pass my days at the Museum of Modern Art looking at Matisse's *Red Studio*? . . . You thought I was wasting my time. But this house you owe to Matisse's *Red Studio*. And from those months and that looking every day all of my painting was born."[11]

Similarly, French artists understood themselves as very much a part of a global discourse. Both Pollock and Ossorio were embraced by the Parisian artists.[12] In 1952 Michel Tapié even organized an exhibition at Galerie Maeght, *Pollock aver nous* (Pollock with us) that made a case for a transcontinental abstract art movement.

I

I believe very much in values of savagery; I mean: instinct, passion, mood, violence, madness.

— Jean Dubuffet, 1951

Jean Dubuffet had emerged on the Parisian art scene in 1942, already forty-one years old. He had studied painting at the Académie Julian in 1918 but abandoned it in 1923 to take over his father's wine-selling business. He briefly resumed painting in 1933 and 1937, but did not decide to become an artist in earnest until 1942, when he began exhibiting his work and rapidly became one of the most talked-about artists of his time.

As Fabrice Hergott and Valerie Da Costa write in a recent monograph on Dubuffet, "Jean Dubuffet is one of the most surprising artists of the twentieth century."[13] Having taken a radically anticultural position by choosing the "raw" style of the art created in the streets and in mental hospitals ("art at its purest, rawest . . . untouched by cultural arts"[14]) and turning to highly unconventional materials such as sand, asphalt, and household paints in his works, Dubuffet literally threw mud in the face of his critics. It was the rebellion of a highly educated artist against overly intellectualized art: "He rejected the conventions of the artists and intellectual circles he moved in."[15]

Dubuffet quickly gained the reputation of a madman in Paris. By the time of his exhibition at Galerie René Drouin in Paris in 1946, where he was first showing his Hautes Pâtes (Matter paintings), he was violently attacked by French critics and curators. These highly textured paintings in dark, earthy palettes lacking any academic finesse were built up from pasted layers of a mortarlike mixture of paint, sand, and gravel that produced visible cracks, revealing laces, shards, chips, and pebbles underneath the surface. Referring to Jules Romains's popular 1923 spoof on the arrogance of the medical profession, *Knock; ou, Le Triomphe de la médicine,* René Huyghe, the chief curator of paintings and drawings at the Musée du Louvre, pronounced, "We still lacked the Dr. Knock of painting. Now we have him." One critic referred to his painting style as "le cacaïsme," while another announced that Dubuffet had "neither imagination nor genius."[16] To which Dubuffet defiantly replied, "I would rather that my pictures amused and interested the man in the street when he leaves his own work, not the art-struck, the in-people, but those who have no particular instruction or propensity. It's the man in the street that I'm after, personally, he's the one I feel akin to,

1. Georges-Pierre Seurat, *The Stone Breaker,* 1882. Oil on wood panel, 6⅛ × 9¾ in. (15.6 × 24.8 cm). The Phillips Collection, Washington, D.C.

he's the one I want to be friends with and confide in and collude with, and he's the one I'd like to delight and enchant with my works."[17]

Ultimately, the criticism of the art world drove Dubuffet away, first to the Algerian desert, following his thirst for primal, unadulterated base matter. He traveled to Algeria three times between February 1947 and May 1949, staying mostly in the oasis town of El Goléa, one of the gateways to the Sahara. In a letter to Gaston Chaissac, a self-taught painter and illustrator who made his living as a shoemaker and was highly regarded by Dubuffet, he raves about the properties of sand, and even cow dung: "It would greatly please me to use cow dung. In the Sahara, when the Arabs have something to putty or a hole to plug up, they use a paste, kneading dates with goat dung and a bit of sand. That's an ingredient which greatly moves me, and which I fully expect to use one day."[18]

As Allen Weiss states, "No artist has been more concerned, indeed obsessed, with the pure state of matter and the earth—as well as their aesthetic and anti-aesthetic transformations—than Jean Dubuffet."[19] The philosopher Gilles Deleuze has compared Dubuffet's technique of ripping through the surface of his paintings with blunt tools, often exposing the underlying ground, to Seurat's definition of painting as "the art of ploughing a surface" (fig. 1).[20] Deleuze sees a continuation from Seurat's practice of drawing to Dubuffet and beyond: "It is a promotion of the ground . . . One no longer paints 'on' but 'under.' These new powers of texture, that ascent of the ground with Dubuffet, have been pushed a long way by informal art, and by abstract expressionism and minimal art also, when they work with saturation, fibers, and layers."[21]

As soon as he'd been singled out by Clement Greenberg, Dubuffet was quickly embraced by the American Abstract Expressionists as one of their own. While remaining a highly controversial figure in Paris, he rapidly became the most visible and talked-about French artist in New York. He was the only French artist to be featured in a groundbreaking series of articles published in *ARTnews,* beginning in 1950.[22] Between November 1951 and April 1952, Dubuffet was working in a studio on the Bowery, and by that time he was arguably better known in New York than in Paris.

Each *ARTnews* article followed the creation of a single work of art from the beginning to its completion, featuring painters and sculptors working in and around New York City, including Jackson Pollock, Richard Stankiewicz, Jack Tworkov, and Larry Rivers. For the first time the American public was shown the inside of an artist's studio through words and pictures. According to the art historian Barbara Rose, Hans Namuth's photographs of Jackson Pollock creating drip paintings in his barn studio in Springs, in the town of East Hampton, accompanied by Robert Goodnough's article "Pollock Paints a Picture," changed the discourse on art by focusing on the process rather than the finished work.[23]

Reviewing an exhibition at the Pierre Matisse Gallery in New York in 1946, Greenberg had given Dubuffet a cautiously positive review in the *Nation* ("Of Dubuffet's three paintings shown . . . only one is successful") and praised him similarly as "the most original painter to have come out of the School of Paris since Miró": "It is too early to tell anything definite . . . but if Dubuffet's art consolidates itself on the level indicated by these three pictures of his, then easel painting with *explicit* subject matter will have won a new lease on life."[24]

By 1947, however, Greenberg's judgment on Dubuffet had become harsher, while his admiration of Pollock was unfaltering:

> Dubuffet is obviously, as every fleck of paint on his canvas shows, an erudite painter, and no more a primitive than Klee. . . . Pollock, again like Dubuffet, tends to handle his canvas with an over-all evenness; but at this moment he seems capable of more variety than the French artist, and able to work with riskier elements. . . . Dubuffet's sophistication enables him to "package" his canvases more skillfully and pleasingly and achieve greater instantaneous unity, but Pollock, I feel, has more to say in the end and is, fundamentally, and almost because he lacks equal charm, the more original. . . . [Pollock] is American and rougher and more brutal, but he is also completer. In any case he is certainly less conservative, less of an easel painter in the traditional sense than Dubuffet.[25]

As pointed out by Kent Minturn in his essay "Greenberg Misreading Dubuffet," Greenberg here tried to demonstrate Dubuffet's "fatal flaw," namely, that he "revels in literary leanings."[26] In an earlier article,[27] Greenberg relates Dubuffet to French existentialism, which had quickly become a global phenomenon after Jean-Paul Sartre's 1945 lecture at the Club Maintenant in Paris, "L'Existentialisme est un humanisme."[28] Sartre's philosophical and aesthetical ideas were widely read and discussed in New York, and a number of essays were translated and published in the summer of 1945 in the *Partisan Review*.

Yet, as Minturn has argued, "in many ways, Dubuffet and Sartre are diametrically opposed figures": "Whenever Dubuffet spoke about Existentialism he did so mockingly. In an interview printed in *Vogue*, May 1952, he openly insists that his paintings have nothing to do with the philosophical movement."[29]

As early as 1945, Dubuffet had taken a strong antiacademic and anticultural position in both his work and in his writings, which became widely popularized in 1951 when he delivered his lecture at the Arts Club of Chicago, "Anticultural Positions." In his essay "Notes pour les fins-lettrés" (Remarks for the well-read), written in 1945 but not published until one year later, he had already asserted that while artists must speak through works of art, so must the tools and the material: "Art needs to emerge from the material and the tool

and bear the traces of the tool and its struggle with the material. Man needs to express himself, but so do the tool and the material . . . A painting has the particular merit that it draws the viewer into a world of wonder . . . it is as exciting and stimulating as a dog that can talk. . . . Therein lies the enchanting effect of a successful picture: it can be as exciting to own a painting as to own a talking dog."[30]

Dubuffet, by his own admission, was far from being a humanist, of the existentialist variety or otherwise. In 1951 he wrote to Hans Huth, a curator in the department of painting and sculpture at the Art Institute of Chicago, "I often feel that the representation of a figure can acquire a very intense life force on account of the fact that this representation is linked to worlds very foreign to the human figure and that we do not usually associate with it (that are, for example, borrowed from the mineral world, etc.)."[31]

In a letter to the American surrealist artist and poet Kay Sage, Dubuffet proclaims outright: "I am an anti-humanist, as you know, which means that I am not convinced that the mechanisms that constitute the psychic life of man, that is, conscience and reason, are in any way superior and preferable to the mechanisms that control the life of a cow or a toad."[32]

II

Madness is the zero degree, absolutely destitute thought. What is left of thought when it no longer has the yes and the no? . . . Colour enters matter as what vibrates before the yes and the no, which is there before form and concept and destination. In the depths of the holes, the spots, the animal, the child, the madman, the clown, their gaze.

— Jean-François Lyotard

In his youth Dubuffet had been fascinated by the illustrations in a study of the art of mentally ill patients published in 1922 by the German art historian and psychiatrist Hans Prinzhorn.[33] Widely distributed, it had tremendous influence on a great many contemporary artists, including Alfred Kubin, Paul Klee, Max Ernst, and Pablo Picasso. Accompanied by the Lausanne-based critic Paul Budry, Dubuffet traveled to Switzerland in the summer of 1945 with his friend Jean Paulhan, the literary critic and publisher of a literary magazine, and the Swiss architect Le Corbusier to visit psychiatric hospitals to research the art of the mentally ill for a new series of publications by Editions Gallimard.[34] Not yet acquiring works, Dubuffet was merely gathering photographic documentation.

The outsider-art scholar Lucienne Peiry likens Dubuffet's Swiss journey to a "rite of passage."[35] There he encountered for the first time the works of now celebrated outsider artists[36] Adolf Wölfli (fig. 2), Heinrich Anton Müller, and Aloïse Corbaz, who would come to take a prominent place in his future outsider-art collection.

Dubuffet soon broadened his understanding of what he called *art brut* (raw art) to include art produced by anyone working outside the culture of the art academies. For Dubuffet, "true art is always where one does not expect it."[37] "There are (always and everywhere) two orders in art: there is the accustomed (or the polished or flawless) art which, depending on the fashion of the time, is christened classical, romantic, baroque or whatever, yet is always the same, and there is art brut, art in its raw form (as untamed and flighty as deer)."[38]

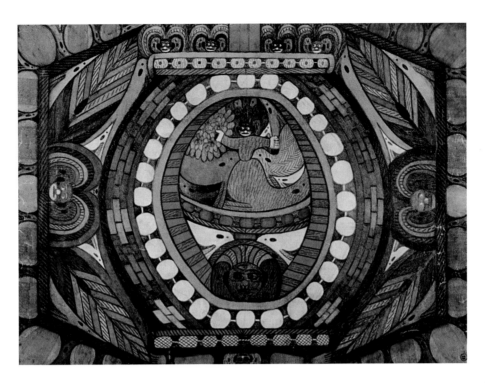

2. Adolf Wölffli, *Saint Adolf's Giant Cask,* 1922. Colored pencil, 20 × 26¾ in. (50.8 × 67.9 cm). Collection de l'Art Brut, Lausanne.

Dubuffet resisted defining Art Brut in his writings and lectures ("to define something is to corrupt it—almost equivalent to killing it"), but he supplied the following "explanation" in a text that accompanied the exhibition *L'Art brut préféré aux arts culturels* (Raw art as preferred to cultural art), which he organized in October 1949 at the Galerie René Drouin in Paris: "We understand it as works made by people that have been untouched by cultural arts, for whom conformance and imitation play little to no role—unlike the intellectual artists. The author of this art draws all (themes, choices of material, means of implementation, rhythmicity, graphic handwriting) from within themselves, and not from the clichés of classical art or the latest art trends. We are able to experience here the creative process in its purest—that is, rawest—form."[39]

In 1947 Dubuffet asked his Parisian dealer, René Drouin, to allow him to create a permanent space for exhibiting works of Art Brut in his gallery's basement, which Dubuffet called Foyer d'Art Brut. The Foyer was disbanded by Dubuffet after he returned from his third and final trip to Algeria in 1949, when he decided to create a not-for-profit membership association, the Compagnie de l'Art Brut, devoted to the collection and study of outsider art. It was housed in a small pavilion belonging to the offices of Editions Gallimard. Works were acquired mostly through gifts. Among the founding members were the Surrealist artist and writer André Breton, Jean Paulhan, and Michel Tapié.[40]

In 1951 the Compagnie de l'Art Brut was dissolved due to financial problems and Dubuffet's desire to concentrate on his own art. The Art Brut collection, which by then numbered twelve hundred works by about one hundred artists,[41] was shipped to the United States to be installed in the estate of a young Filipino-American artist and fledgling art collector, Alfonso Ossorio, who had sought out Dubuffet in Paris in 1949 at the suggestion of the American painter Jackson Pollock. Dubuffet and Ossorio discovered a deep kinship, and a rich correspondence ensued between them. Ossorio began collecting works by both Jean Dubuffet and the American painter Jackson Pollock. Over his lifetime, Ossorio would

3. Works by Dubuffet and Art Brut installed at the Creeks, c. 1952, with Dubuffet's painting *Chercheur au travail confus,* 1951, at far left. Photograph by Hans Namuth.

amass hundreds of works by Pollock and Dubuffet, including Pollock's *Number 1, 1950 (Lavender Mist)* (plate 4).

In 1951 Ossorio acquired a sixty-acre estate with an Italianate mansion designed by Grosvenor Atterbury on Georgica Pond in East Hampton, New York, which he named the Creeks. Called by the American Conifer Society "the eighth wonder of the horticultural world," it was as widely admired for the conifer arboretum that Ossorio created and developed from 1970 until his death in 1990 as it was for its art collection.

In April 1952 the Art Brut collection was installed in the upper rooms of the Creeks, alongside works by Clyfford Still, Willem de Kooning, Lee Krasner, Pollock, and Dubuffet (fig. 3).

As Da Costa and Hergott write, "Art Brut became a visiting card for Dubuffet. He used the concept out of conviction, but also as a tactic. It gave more weight to his positions and dressed them in an easily understood slogan."[42] The Art Brut collection had a lasting impact on both Ossorio and Pollock. As Siobhán Conaty remarks, "Both men were intrigued by French artist Jean Dubuffet and the style he called Art Brut . . . Ossorio and Pollock found in Art Brut the kind of liberation that African sculpture had provided Picasso at the turn of the century."[43]

Dubuffet would later write to Ossorio, "I have now received the beautiful photographs that you sent me. They are extremely beautiful and I had, as you may imagine, an extreme pleasure to study at length. I could see how well your house has been transformed since we had visited, and I can imagine what a gigantic task it was for you to install these pieces as they are now. This is a great pleasure for me to see our collection of Art Brut so well installed. They create, in these photographs, a stunning effect."[44]

The Art Brut collection remained at the Creeks until 1962, when the collection was returned to Paris, to be installed in a three-story building purchased by Dubuffet as a study center and private museum administered by the reconstituted Compagnie de l'Art Brut.

4. Alfonso Ossorio at the Creeks, 1952, with Dubuffet's *Francis Ponge (noir sur fond),* 1947, at near left; Pollock's *Number 1, 1950* (*Lavender Mist*) at center; and Dubuffet's *Les Petit Yeux haunes,* 1951, at right. Photograph by Hans Namuth.

Since 1976 Dubuffet's Art Brut collection has been housed in the Collection de l'Art Brut in Lausanne, Switzerland.

In the 1970s Dubuffet admitted that "pure Art Brut, without any reference to culture (to any of its succeeding layers) does not exist in real life, only as an ideal point. That does not preclude the existence of art that is *more* or *less* 'raw.' "[45] And in the posthumously published *Bâtons rompus* (Broken sticks), a series of mostly fictitious interrogations, Dubuffet answers the question of whether his works belong to the ambit of Art Brut: "I do not dare to make any such claim. I'm afraid I never got that far. I always strived to forget cultural art, to liberate myself from its limitations of thinking, but we are saturated and tinged with culture to the core; we can never completely detach ourselves from its influence."[46]

Subsequently, in 1982 Dubuffet expanded the definition of Art Brut by adding another category, Neuve Invention (New invention), which allowed him to incorporate works by other artists, including Ossorio.[47]

III

The picture surface, with no depth of recognizable space or sequence of known time, gives us the never-ending present. We are presented with a visualization of that remorseless consolation—in the end is the beginning.

—Alfonso Ossorio

Alfonso Angel Ossorio y Yangco was one of the most colorful figures in postwar American art. The heir of a vast Philippine sugar fortune and an artist, collector, and patron of European and American artists, particularly Jackson Pollock, Jean Dubuffet, and Clyfford Still, he lived for most of his creative life in East Hampton, New York (page xii and fig. 4). Born in the Philippines to a Spanish father and a Chinese-Filipino mother, and educated in England and the United States, he started to exhibit regularly in New York in 1941. A devout Catholic, he was a multicultural artist who synthesized Surrealism, Abstract Expressionism,

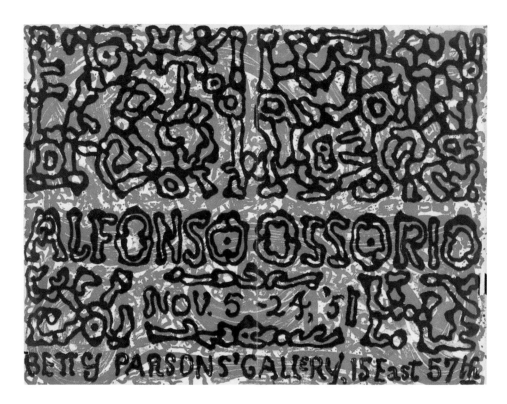

5. Exhibition poster for Alfonso Ossorio's show at the Betty Parsons Gallery, November 5–24, 1951. Alfonso Ossorio Papers, Archives of American Art, Smithsonian Institution, Washington, D.C.

and Art Brut with his Hispanic and Asian roots, "the Eurasian product of Benedictine training and oriental refinement."[48] As Mike Solomon, Ossorio's longtime studio assistant and former director of the Alfonso Ossorio Foundation, has said, "Ossorio was a major link between Europe and America."[49]

Ossorio, who had been exhibiting with a young New York art dealer, Betty Parsons, since 1941 (fig. 5),[50] took notice of Pollock's significance around 1946: "It was simply by going to Betty's gallery . . . I think it was as late as 1947 or '48 that I suddenly realized the so-called drip panels had an intensity of organization, had a message that was expressed by its physical components, was a new iconography."[51]

By 1949 Ossorio was sufficiently persuaded of Pollock's talent to buy his first of many drip paintings by the artist, *Number 5, 1948*.[52] "Here was a man," he would later say, "who had pulled together, existentialized all the traditions of the past — contemplative and active — a man who had gone beyond Picasso."[53]

A long and mutually stimulating friendship between the two artists ensued. Ossorio's belief in Pollock remained steadfast long after his friend's death in 1956. The art historian B. H. Friedman recalls, "In the 1960s, I remember looking through the multi-volume catalogue raisonné of Lautrec in his library and asking, 'Do you think someday Pollock will be considered important?' Without hesitation Alfonso replied, 'I consider him important now.' "[54]

It was Pollock who urged Ossorio to travel to Paris and to introduce himself to Dubuffet. The meeting with Dubuffet, in the fall of 1949, was arranged by Ossorio's friend, the writer and translator Blaise Allan, through Jean Paulhan. Ossorio returned from Paris with copies of several of Dubuffet's texts and three works that he purchased. The visit was followed by an intense correspondence that displayed genuine interest in Ossorio's work by Dubuffet. Ossorio would send Dubuffet photographs of his work and exchange advice on technical matters (fig. 6).

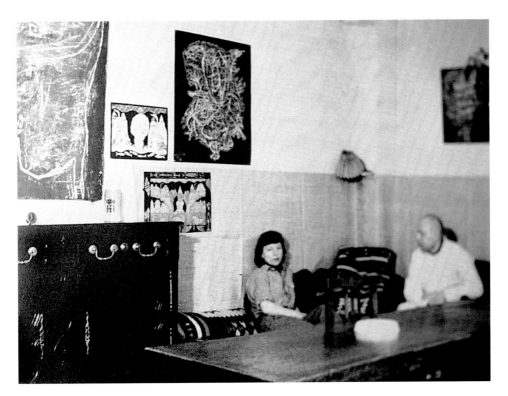

6. Lili and Jean Dubuffet at their home with Ossorio's painting *The Crowd*, 1950, on the wall. Photographer unknown. Courtesy Ossorio Foundation, Southampton, N.Y.

In the winter of 1949 Ossorio returned to the Philippines to paint a mural for the chapel of St. Joseph the Worker in the mill town of Victorias on the island of Negros. Working alongside Adé de Béthune, a Belgian-born Catholic liturgical artist and mosaicist who was asked to decorate the facade of the new church, Ossorio painted a Last Judgment, depicting an open-armed seated figure of Christ, with Adam on one side, and Joseph and John the Baptist on the other, that became known as *The Angry Christ* (fig. 7): "It's a continual last judgment with the sacrifice of the mass that is the continual reincarnation of God coming into this world. And it worked out beautifully because the services take place usually very early because of the heat and the church had been oriented so that the sun would come in and strike the celebrant as he stood at the altar with this enormous figure behind him. It worked, if I do say so myself. And although they loathed it at the time it was done, it is almost now a place of pilgrimage."[56]

Béthune later described Ossorio's work in an article for *Liturgical Arts*: "[Christ] sits in triumph over sin and death. . . . He came to bring fire on the earth; His Sacred Heart is aflame and His arms extend with love. . . . Alfonso was covering the sanctuary with an ever more refined work of brilliant flame."[57]

It was Ossorio's first visit to the Philippines since he was eight years old (see *The Child Returns*, plate 20). Confronted with the memories of his unhappy childhood underscored by a deep Catholic faith in conflict with his sexual attraction to men, he began reading the writings of Nandor Fodor, a psychoanalyst and former associate of Sigmund Freud's who specialized in the trauma of birth and prenatal conditioning. Fodor had a lasting impact on Ossorio's works, notable in the hundreds of highly personal and emotionally charged paintings on paper he created while working on the mural, filled with references to his Catholic faith as well as themes of birth, childhood, family life, and death. *Reforming Figure* (plate 40) is typical of the freedom in imagery and technique of these works. It

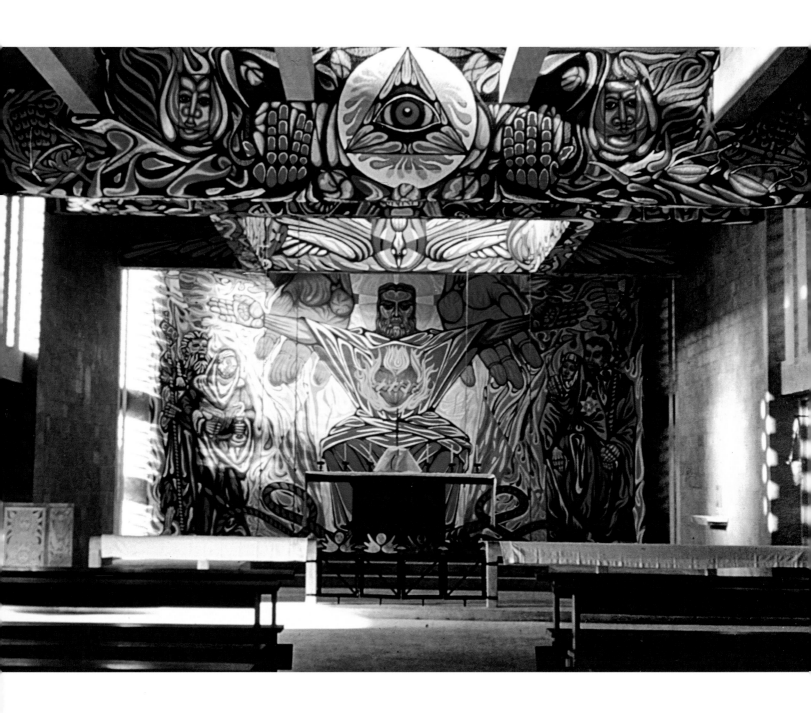

7. Alfonso Ossorio, *The Angry Christ*. Mural at the chapel of St. Joseph the Worker, Victorias, Negros Occidental, Philippines, 1950.

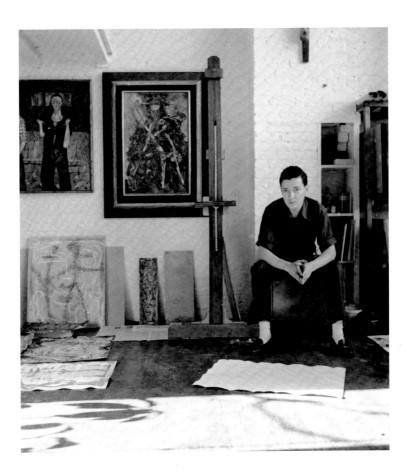

8. Alfonso Ossorio in his studio at 9 Macdougal Alley, New York, with his work *Untitled* (plate 39) leaning against the wall to his far left. Photograph by Hans Namuth.

depicts two baby faces, one hand, and angelic wings that imply potential growth, evidence of Ossorio's positive understanding of his future development as an artist. The so-called Victorias drawings resulted directly from Ossorio's intimacy with the works of Pollock and Dubuffet. From Pollock he learned how the medium itself could become the image, recording not detailed subjects but gestural force; and from Dubuffet, how a consciously intended image could be abstracted down to its most primitive essentials and presented in the bluntest possible manner. Yet in his own works, given his origins as a medical illustrator for the U.S. Army during World War II and a Surrealist painter thereafter, Ossorio stopped short of complete abstraction.

Reading about a new wax process developed by the Romanian Surrealist artist Victor Brauner[58] led Ossorio to experiment with the so-called wax-resist method. It became his signature technique of his Victorias drawings. He even introduced Pollock to it who, on at least two occasions in 1950, used wax in his own works.[59] The so-called wax-resist technique enabled Ossorio to develop a language that was informed by Pollock and Dubuffet yet fiercely independent by combining the free-associative psychic automatism of Surrealism with a direct, painterly expressionism. He would begin by drawing with candle stubs or liquid wax on paper, then apply washes of watercolor. The water was repelled by the wax, causing the paint to run off it or collect in small drops. Ossorio then finished each work by drawing on top of it with ink.

Ossorio offered Pollock and his wife, Lee Krasner, his New York house and studio (fig. 8) for their use while he was away in the Philippines. During the winter and early spring of 1950, Pollock and Krasner lived and worked in Ossorio's studio in New York City.

There they would have looked through shipments of Ossorio's Victorias drawings that arrived from the Philippines.

Ossorio also sent photographs of the works to Dubuffet in Paris, inspiring him to write a book on the Victorias drawings, *Peintures initiatiques d'Alfonso Ossorio* (The initiatory paintings of Alfonso Ossorio; 1951), to date the most insightful study of Ossorio's work.[60] According to Michel Ragon, "Dubuffet, as an art critic, here gave us a remarkable critical analysis. It is a rare, even exceptional phenomenon to find a painter able to deal with one of his contemporaries on this level."[61] When Dubuffet speaks about Ossorio's art, he seems to also speak of his own:

> Ossorio wants to be present at the creation of life; to experience it by miming it. In its entirety, of course, starting from the incipient state, before anything has begun; that is, then, from shapeless matter. He greatly enjoys the fact that this seething substance is, before his intervention, extremely shapeless. And in the course of his work, he will make sure that it never quite ceases to remain so. Hence he flings, at the outset, the chaotic and the inorganic upon his sheet of paper.
>
> When Ossorio dashes his paintings onto the moist paper, he is already manipulating living matter: that same element out of which worlds are formed. The ink he flings is not at all, in his eyes as it is for other painters, a means without an importance of its own in transcribing what he wants to reveal: it seems to him a substance endowed with life, and soul, whose slightest impulses deserve close attention. The fact that these materials, which Ossorio treats as mediums, belong to the marvelous world of living things does not leave his mind, even for a moment. He employs, in order to transcribe the world of life, substances that themselves belong to that world; they will fortify his mental creations by the contribution of their own actions. They are endowed with all the powers that slumber at the heart of metal, lava, slime, and which, on the occasion of certain circumstances (which can be provoked), wake with great power and concresce into marvelous phenomena.[62]

Dubuffet took great pride in his text on Ossorio, to whom he would write:

> I happen, from time to time, to reread my book on you cover to cover, and that is exactly what I did this morning. I rose up very early. I like this book a lot and I still love my text. It gives me great satisfaction every time I reread it, and it always has the same power to rekindle my keen taste for your paintings, which I study at length through the reproductions included in the book. . . . Your art is so special, so secret, so refined and complicated, that few people who attend New York art galleries—as I know these people—are able, I fear, to understand and to love it.[63]

Like Dubuffet, Ossorio had experienced the horrors of war. He had volunteered for military service the day after the attack on Pearl Harbor, but an injury he suffered in a car accident delayed his active duty until the spring of 1943, when he was sent to the General Hospital in Galesburg, Illinois, to work as a medical illustrator. This experience influenced his paintings from the 1940s and early 1950s (fig. 9), which in their concern for the body within a Surrealist sensibility resembled the early works of Jackson Pollock.

Drawn primarily by his friendship with Dubuffet as an artist, but also recognizing the experimental spirit of the postwar Parisian art scene, Ossorio returned to Paris in 1950 and rented a studio near Dubuffet's, where he made a series of paintings on canvas (plates 33–38): "There was something happening, there was an underground then. Wols was

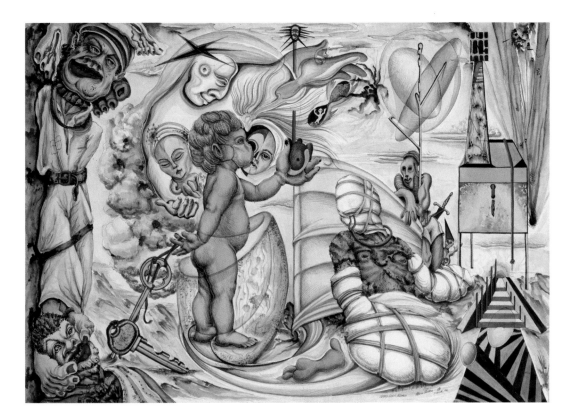

9. Alfonso Ossorio, *The New Pandora*, 1944. Ink and watercolor on paper, 14 × 20 in. (35.6 × 50.8 cm). Collection of Michael Rosenfeld and halley k harrisburg, New York.

dying, but Dubuffet was active. Michaud and Mathieu were just starting. Sam Francis was starting in Paris in 1950–51. And the very early pictures I saw, sort of muddy white, were very gruesome. Tapié had them and I liked them. However it was not a question of the excitement of Paris so much as the one man—Dubuffet."[64]

With the help of Dubuffet and Michel Tapié, Ossorio had a one-person exhibition at the newly founded Studio Paul Facchetti. Facchetti, a well-known Italian-born fashion and portrait photographer, met Ossorio through Tapié. When he decided to open a gallery in his photography studio in Saint-Germain-des-Prés in October 1951, he inaugurated the space with an exhibition of Ossorio's "initiatory paintings." Facchetti's gallery soon became the new center of Art Informel and Lyrical Abstraction.[65] Later Ossorio organized Pollock's first exhibition in Paris in 1952 at the Studio Paul Facchetti.

In December of 1951, Ossorio accompanied Dubuffet to Chicago, where the latter delivered his influential speech, "Anticultural Positions," at the Arts Club. Among the younger artists in attendance were Leon Golub and Claes Oldenburg.[66] Art dealer Richard Feigen would later write that Dubuffet's lecture "made more of an impact in one hour on the hard core . . . that Thursday morning than he had in five months on all of the New York artists."[67]

IV

Painting is a state of being. . . . Painting is self-discovery. Every good painter paints what he is.

—Jackson Pollock

Jackson Pollock may have seen Dubuffet's first exhibition in New York, but he was certainly familiar with his work through Greenberg. Most New York artists and critics discovered Dubuffet in 1946 when his work was included in a School of Paris exhibition at the

Pierre Matisse Gallery. The gallery had been opened by the youngest son of the French painter Henri Matisse in October 1931 in New York, in the Fuller Building on Fifty-Seventh Street and Madison Avenue, around the corner from the provisional headquarters of the newly founded Museum of Modern Art.

When Pierre Matisse arrived in New York in 1924, only a handful of galleries were exhibiting contemporary art. The gallery specialized in the works of established painters such as Giorgio de Chirico, Pablo Picasso, Georges Rouault, and of course Henri Matisse. Soon, however, Matisse began introducing the works of younger, lesser-known European artists to American audiences, including the paintings of the young Spanish painter Joan Miró in the late 1930s and the sculptures of the Swiss artist Alberto Giacometti in the late 1940s. Among the collectors who frequented his gallery were Walter P. Chrysler Jr., Joseph Pulitzer Jr., Joseph H. Hirshhorn, and Duncan Phillips.

After seeing Dubuffet's show at the Matisse Gallery in 1951, Pollock complimented Ossorio on the purchase of two Dubuffets from the show: "I was really excited about Dubuffet's show—was prepared not to. Your two canvases hold up with his best."[68] However, despite Ossorio's efforts, Pollock and Dubuffet never met in person. As Ossorio would later recall:

> In addition to liking the work of Dubuffet, Jackson liked the fact that people didn't like it, that here was someone trying to do something different. As to how far the liking went—well, there's no doubt they looked at each other with extreme attention and understanding, but with Jackson thinking that Dubuffet didn't go far enough and Dubuffet thinking that Jackson was too easy perhaps. I took pains to have them meet, and we brought the Dubuffets to East Hampton. The idea was that we would have dinner at the Pollocks', but Jackson decided that life would be simpler if he and Dubuffet didn't meet. With the host missing, it was just the four of us and it was rather embarrassing. Lee talked, Dubuffet talked, we all did like mad, but there was a big gap. So the plan for the meeting didn't work and I have no recollection of seeing them together.[69]

Between 1948 and 1952 Pollock's paintings culminated in the so-called Black Pourings, a series of figurative "drawings" on unprimed cotton duck using sticks or hardened brushes as well as basting syringes and mostly black industrial enamel paints such as Duco or Davoe & Reynolds.[70] Francis O'Connor designates them Pollock's fifth phase as a painter, which lasted until early 1952.[71]

During that time, Pollock wrote to Ossorio, "I've had a period of drawing on canvas in black—with some of my early images coming thru—think the non-objectivists will find them disturbing—and the kids who think it simple to splash a Pollock out."[72] O'Connor calls this "Pollock's most important statement about the black pourings":[73] "These stark and highly figurative works raise a number of questions. How can the change from the multi-colored to the black pourings be explained? How do the black pourings relate to Pollock's life-long commitment to line as an expressive medium? And finally, how can the figurative material encountered in the first three phases, be understood in the fifth?"[74]

Even Lee Krasner admitted to not knowing much about the origins of these works: "I haven't a clue as to what swung him exclusively into black-and-white at that point—

besides the drawings, he did some black-and-white paintings of considerable size earlier — but it was certainly a fully conscious decision."[75]

After Pollock's one-person show at Betty Parsons Gallery, which ran from November to December 1950, he and Lee Krasner stayed intermittently in Ossorio's town house on Macdougal Alley in New York, which allows for cautious speculation that Ossorio's loyalty to representation may have affected Pollock's works at that time. The white-and-black spaces appear to be dominated by the same polarity that characterized Ossorio's works of the period — in particular his use of figurative elements, often drawn as negative images.

The German Matisse scholar Volkmar Essers[76] has pointed to other connections: to Goya's black pictures (introduced to Pollock by Ossorio[77]), and especially to Matisse's black-ink drawings that were shown at the Pierre Matisse Gallery in 1949: "A series of large drawings from 1947–48 could be seen that had been executed with brush and black ink on white paper. In these drawings, Matisse flooded the paper with flowing, thick lines and surfaces. Figure and ground connect closely, as in Pollock's 1951 pictures, and the white of Matisse's paper is an active element of the composition, like Pollock's unprimed canvas."[78]

In the introduction for the catalogue for the 1951 exhibition of Pollock's Black Pourings at the Betty Parsons Gallery, Ossorio wrote:

> His paintings confront us with a visual concept organically evolved from a belief in the unity that underlies the phenomena among which we live. Void and solid, human action and inertia, are metamorphosed and refined into the energy that sustains them and is their common denominator. . . .
>
> New visions demand new techniques: Pollock's use of unexpected material and scales are the direct result of his concepts and of the organic intensity of the artist with his work, a denial of the accident.[79]

By all accounts, when Pollock was not plagued by the demon of his alcoholism, he was a kind and generous man.[80] He showed a genuine interest in Ossorio's work, providing occasional criticism and engaging in a dialogue about their respective works. Ossorio told Jeffrey Potter, Pollock's friend and the author of an oral biography of Jackson Pollock, that Pollock "made only a couple of criticisms about a work of mine and they were precise — very much to the point."[81] About a car trip they made together to New York, Ossorio recalled:

> He gave me a three-hour lecture about the contemporary American art scene, beginning with the chauvinist critic Thomas Craven (a Benston champion). . . . Jackson had a very clear historical sense of what had been happening in American painting, just as he had a very down-to-earth knowledge of Indian sand painting. He knew what it was all about — that they had a sociological/religious meaning, that they were stylized in certain ways. And he knew the connection between that and the Mexican muralists. It was the alphabet of that which then went into his work.[82]

Ossorio had studied printing and wood engraving in London at the studio of the printmaker and typographer Eric Gill. In the 1930s he attended Harvard University, studying not only painting and sculpture but art conservation, early on showing a great interest in art-making techniques and processes. It is not surprising, therefore, that Ossorio would have been especially attracted to Pollock and Dubuffet. Both, at about the same time, having been involved in highly experimental techniques themselves.

In 1936 Pollock began working in the "experimental workshop" of the Mexican muralist and political activist David Alfaro Siqueiros on Fourteenth Street near Union Square in New York. Siqueiros was exploring new mediums and techniques for his mural painting, and it was there that Pollock was first introduced to nontraditional art materials and tools such as spray guns and Duco, a quick-drying lacquer developed by the DuPont Company in the 1920s. Here he became also acquainted with the notion of "controlled accidents."[83] As Pollock said in an unpublished interview in 1950: "Each age finds its own technique."[84]

At about the same time, Dubuffet was deeply immersed in unconventional materials that would include household paints such as Ripolin (the French commercial paint famously used by Picasso as early as 1912), lime, cement, asphalt, mud, bitumen, sand, pieces of glass, and pebbles, often pouring those materials onto canvas laid on the floor, prefiguring Pollock's drip paintings.

One fundamental difference between Dubuffet and Pollock pertained to the notion of "accident." Pollock did not believe in it. "I don't use the accident—'cause I deny the accident," he told an interviewer.[85] For Dubuffet, however, uncontrolled accidents were absolutely essential for the vitality of his paintings; inherent in the material and necessary to keep the work animated: "Oil that wants to run, the brush that does not have enough paint and leaves only a unclear trace; the line that misses the place where the artist intended it to be."[86] He advocated letting "the hand speak": "the impulse of the human hand, its authentic spontaneity."[87]

Nowhere is this distinction more obvious than in the meticulously hand-copied versions of Pollock's photographic screen print of his painting *Number 19, 1951*—two almost identical "copies" of one of six black-and-white screen prints Pollock made in collaboration with his brother Sande (Sanford) McCoy at the latter's studio in Deep River, Connecticut, where Sande had moved with his family from the apartment he shared with Pollock in New York in August 1942.

Silk-screen printing was at that time still a highly experimental art form. Having arrived in Europe from Japan in the nineteenth century, it was adopted for commercial purposes in the beginning of the twentieth, but not seriously used for art making in the United States until the 1930s. Not until the 1960s did screen printing become an important medium for artists.

McCoy owned a commercial screen-printing studio and had been refining the still new technology of using photographs to create screen prints in order to produce circuit boards. At the suggestion of the sculptor Tony Smith, Pollock decided to create a portfolio of screen prints of six of his Black Pourings by projecting photographic negatives onto photosensitized screens (plates 15A–F). As the eminent print curator Richard Field has written, creating fine art prints from photographic stencils was "an unheard of but forward-looking event."[88] But according to noted print experts and collectors Dave and Reba Williams, who have published the most in-depth study of Pollock's print oeuvre, Pollock was not completely satisfied with the results of such a mechanically and relatively flat reproduction of his paintings:

The greatest difference in the prints does not derive from Pollock's modest reworking of the screens, or even the missing small flecks, dots, smudges, etc. on the paintings too small or faint to be recorded by the photograph. It is the difference in "color" between the paintings and the prints.

Pollock's black paintings of 1951 were made on unsized cotton duck, or sailcloth that has a color closer to tan than to white, while the prints were made on white paper. There is also "color" in Pollock's black paint; Pollock used a solvent-thinned black enamel paint that when applied to the soft unsized canvas, created a tonal effect. The centre of the poured black line is typically a glistening, glossy finish. The edges of the black lines, however, look like a "stain," where the thinned enamel has seeped into the soft canvas. Obviously these effects are lost in the prints; the "stain" at the edges of Pollock's black-painted lines is converted to a hard-edged solid black in the print.[89]

The two hand-painted copies of the screen print of *Number 19, 1951* (plates 13, 14) reveal a variety of tonal effects unmatched by the corresponding screen print. A close examination of these two works reveals that both consist of three layers: a pencil tracing of the screen print that includes every fleck, dot, and smudge, including the signature on the corresponding screen print; a second layer of diluted black ink that follows closely and fills in the pencil traces; and finally a third layer of either darker, undiluted black gouache in one case, or enamel in the other, that is applied to most but not all areas to create a greater tonal variation.

The fact that even the signature and the edition number were traced by Pollock in pencil suggests that he traced a projection of the corresponding screen print (plate 12) rather than the actual painting. These experimental works reveal much about Pollock's working process and illustrate his adamant denial of "accidents" in his art. He meticulously copied by hand almost every drip, fleck, and spot left out by the photographic process of the silk-screen and traced every "accidental" detail onto the two hand-drawn copies. As Deborah Wye notes, "The methodical nature of printmaking seems contrary to the image of Pollock as a wild man pouring paint on canvas in a kind of private performance."[90]

In the 1950 interview Pollock had compared his approach to paintings to that of drawing: "I approach painting in the same sense as one approaches drawing; that is, it's direct. I don't work from drawings. . . . The more immediate, the more direct—the greater the possibilities of making a direct—of making a statement."[91]

Pollock originally conceived the six screen prints as a set that would only be sold together and signed once on the portfolio, in an edition of twenty-five, perhaps as a way to increase sales. However, few complete sets were printed, and eventually a number of individual prints were signed and either resold or given to friends. Most of Pollock's printing oeuvre did not result in standardized editions.[92]

For Dubuffet, trying to create copies of his paintings as screen prints would have been a futile affair: "Copying paintings, one runs into the difficulty of reproducing all of its accidents. It is impossible to reproduce these chance incidents in precisely the same place where they occur in the original. They are caused by myriad flukes—the brush got stuck on a tiny protruding grain, or else it dragged along a dot of color that hadn't dried yet—

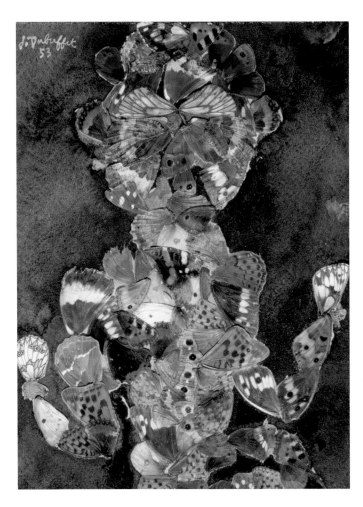

10. Jean Dubuffet, *Butterfly-Wing Figure*, 1953. Butterfly wings and gouache on paperboard, 9 ⅞ × 7 ⅜ in. (25.1 × 18.7 cm). Hirshhorn Museum and Sculpture Garden, Washington, D.C. Joseph H. Hirshhorn Purchase Fund, 1991.

and how can you rerun chance events? That's why the copyists' work is so useless and disappointing."[93]

Ossorio absorbed elements of both artists in his own work, yet also inspired them to new experimentation. As Siobhán Conaty remarks, "Ossorio's encaustic drawings and Pollock's black screenprints clearly reveal an affinity between the two men in the realms of both art and soul."[94]

Aside from the wax-resist technique, Ossorio also experimented with cutting out sections of his drawings, tearing the paper or shaping canvases into irregular forms that often suggest a butterfly or angel's wings. When Dubuffet began making a series of collages he called "assemblages" using butterfly wings (fig. 10), first in 1953, and again in 1955 and 1957, it is said that he had been influenced by Pierre Bettencourt, a writer, artist, and amateur lepidopterist who accompanied Dubuffet on a trip to the Savoy Alps in the summer of 1953. When Bettencourt started making collages of butterflies he caught, Dubuffet did the same. Bettencourt later accused Dubuffet of having plagiarized him.

Dubuffet would credit his butterfly-wing assemblages with determining the development of his later works, the Texturologies and Materiologies of the late 1950s.[95] As Sarah Rich, in her extensive study of Dubuffet's butterfly-wing assemblages, writes, with these works, Dubuffet's oeuvre shifted "from figuration to abstraction, and more important, from cohesive form to dispersal. They established a new pictorial (anti)order of disintegration."[96]

There is, however, another link that has been overlooked but may have triggered Dubuffet's interest in butterflies initially, or at least created a predisposition for this insect as a metaphor of mimicry: in 1950 Ossorio sent Dubuffet an anthropomorphic painting on paper in the shape of a butterfly. After receiving the work, Dubuffet wrote to Ossorio in the Philippines:

> Dear Friend,
>
> I have just received your kind letter and the materials attached to it and, most importantly, the impressive painting in the shape of a butterfly with outspread wings, each wing with a somewhat grimacing face; this painting contains violent graphical elements—graphical because in them are found the A's and O's, the letters of your name—which are animated by an intense life. The way in which they are painted gives them a vibrant aliveness and great strength. In this painting you have developed—one could not do any better—a means of self-expression that suits you perfectly. This painting greatly interests me and I am very fond of it. Moreover, it exudes—but this is independent of the technique used and is found in everything that comes from your hand—some indescribable and stunning sarabandes—grave, stately, cruel, naughty, a little terrifying, where death is blended into life and from which strongly radiate the state of high art in which those works were created. Keep working constantly and without any interruptions on those watercolors, gouache and wax paintings like the one you had the generosity to send me, for a whole series of such paintings would be a very important and valuable creation.[97]

Child figures with spread wings are a recurring motif in Ossorio's works (see plates 25, 28–29, and 33–34), and butterflies have long been associated with angels. Vladimir Nabokov, who besides being one of the foremost writers of the mid-twentieth century was also a brilliant and highly accomplished lepidopterist, frequently compared butterflies to angels. Both Ossorio's angel-wing-shaped drawings and Dubuffet's butterfly-wing assemblages resemble those angelic monsters celebrated by Nabokov in a poem dedicated to his passion for butterflies:

> At an angel I hit,
> and a demon's entangled
> in the haze of my net.[98]

Dubuffet and Ossorio remained lifelong friends, long after Pollock's untimely death, and both moved on to radically different stylistic innovations. In the 1960s Ossorio began constructing found-object assemblages he came to call Congregations using shells, horns, antlers, driftwood, glass eyes, gold leaf, cabinet knobs, rhinestones, mirror shards, pearls, beads, and miscellaneous plastic forms that, while inspired by Dubuffet's assemblages and his Art Brut collection, are singularly original (fig. 11). As the curator Klaus Kertess writes, with his Congregations Ossorio "made unique contributions to the art of assemblage that was so critical to modernism's jousts with the place of painting and with traditional techniques."[99]

In the late 1950s Dubuffet turned to more abstract "allover" compositions with a series of paintings he named Texturologies (plate 53), spattering paint over the canvas in the method of Tyrolean masons who scatter sand using twigs, giving the "impression of teeming matter, alive and sparkling, which I could use to represent a piece of ground, but which

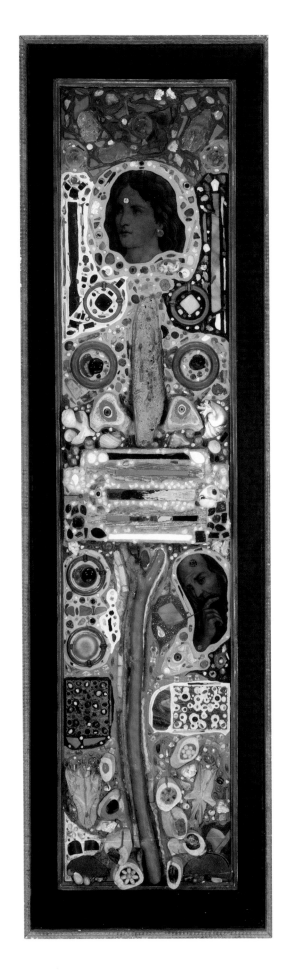

11. Alfonso Ossorio, *Excelsior*, 1960. Mixed media, 56 × 12 in. (142.2 × 30.5 cm). The Phillips Collection, Washington, D.C. The Dreier Fund for Acquisitions, 2008.

could also evoke all kinds of indeterminate textures, and even galaxies and nebulae."[100] The French novelist André Pieyre de Mandiargues has described these works as pushing art to an extreme point "where it is nearly impossible to distinguish what is art from what is not."[101]

Epilogue

This exhibition has been a long time in the making, and I have to acknowledge a number of people that have helped me shape and refine this project along the way.

I was first introduced to Alfonso Ossorio's work by my wife, Leslie Tonkonow, in 1992 when she worked as director of the Zabriskie Gallery in New York on an exhibition of Ossorio's work for the Galerie Zabriskie in Paris, *Alfonso Ossorio: Peintures, 1950–1953*. It was she who suggested to me that the dialogue between Ossorio, Pollock, and Dubuffet would make an interesting subject for an exhibition.

I first proposed the idea for such an exhibition in 1994 to Pierre Baudry of Nippon Advisart in Tokyo, and again in 1996 to the American Federation of Arts. It was then that I first contacted Mike Solomon, who was Ossorio's studio assistant and after Ossorio's death became the director of the Ossorio Foundation. Mike in turn introduced me to Francis V. O'Connor, the distinguished coauthor of Jackson Pollock's catalogue raisonnée. Both Mike and Francis were instrumental in developing the initial proposal for the AFA. It was Mike who also made available to me Richard Howard's formidable translation of Dubuffet's text and introduced me to Dorothy Kosinski, the Barbara Thomas Lemmon Curator of European Art at the Dallas Museum of Art, who had been a passionate advocate of Ossorio's work. For various reasons our proposal did not come to fruition at that time, and when I became an adjunct curator at the Parrish Art Museum in 2008, I proposed the exhibition to the Parrish's new director, Terrie Sultan, who embraced the idea without any hesitation. I am especially thankful to Terrie for her wholehearted support of this exhibition as well as to Dorothy for agreeing to serve as cocurator and for offering the Phillips Collection as co-organizer of the exhibition.

Additional thanks go to three individuals who have assisted me at various times in researching and coordinating the many aspects of this project: Shamim Momin, at the American Federation of Arts; Sam Bridger Carroll, at the Parrish Art Museum; and Megan Clark, at the Phillips Collection.

Notes

Epigraphs: W. H. Auden, "New Year Letter," in *Collected Poems*, ed. Edward Mendelson (New York: Modern Library, 2007), p. 239; Jack Hirschman, ed., *Artaud Anthology* (San Francisco: City Lights, 1965), p. 149. Section I. Jean Dubuffet, "Anticultural Positions," lecture given at the Arts Club of Chicago, December 20, 1951, printed in *Jean Dubuffet: Works, Writings and Interviews,* ed. Valérie da Costa and Fabrice Hergott (Barcelona: Ediciones Poligrafa, 2006), p. 114. Section II. Jean-François Lyotard, *Karel Appel: A Gesture of Colour* (Leuven, Belgium: Leuven University Press, 2009), p. 159. Section III. 52. Alfonso Ossorio, cited in *Jackson Pollock* (New York: Betty Parsons Gallery, 1951), n.p. Section IV. Selden Rodman, *Conversations with Artists* (New York: Davin-Adair, 1957), p. 82.

1. Clement Greenberg, "The Situation at the Moment," *Partisan Review*, January 1948, reprinted in *The Collected Essays and Criticism*, vol. 2, *Arrogant Purpose, 1945–1949*, ed. John O'Brian (Chicago: University of Chicago Press, 1986), p. 193.

2. Irving Sandler, *A Sweeper-Up after Artists: A Memoir* (New York: Thames & Hudson, 2003), p. 203.

3. "The Situation at the Moment," in Greenberg, *Collected Essays,* 2:193.

4. Harold Rosenberg, *The De-Definition of Art* (New York: Collier, 1972), p. 194.

5. Harold Rosenberg, *The Tradition of the New* (New York: Horizon Press, 1959), p. 257.

6. Greenberg, "The Decline of Cubism," *Partisan Review,* March 1948, reprinted in Greenberg, *Collected Essays,* 2:214–15.

7. Serge Guilbaut, *Success: How New York Stole the Notion of Modernism from the Parisians*, trans. Arthur Goldhammer (Chicago: University of Chicago Press, 1985), p. 168.

8. Constant, *Reflex #1* (September–October 1948), trans. Leonard Bright, http://www.cddc.vt.edu/sionline/presitu/manifesto.html.

9. "Jackson Pollock: A Questionnaire," in *Jackson Pollock: Interviews, Articles, and Reviews,* ed. Pepe Karmel (New York: Harry N. Abrams, 1989), p. 16.

10. Quoted in Gail Levin, *Lee Krasner: A Biography* (New York: William Morrow, 2011), p. 186.

11. Quoted in Dore Ashton, *About Rothko* (Cambridge, Mass.: Da Capo Press, 2003), p. 187.

12. In his manifesto-like catalogue text for an exhibition he organized at the Studio Paul Facchetti, *Un art autre* (Art of another kind), Tapié names Ossorio, alongside Dubuffet, Pollock, Henri Michaux, Jean Fautrier, Georges Mathieu, and Wols, as belonging to a group of artists that are creating "a new direction, a new scale of sensitivity, a new psychic keyboard, another sense of the Power, of Becoming, of Living." Quoted in Nina Parish, *Henri Michaux: Experimentation with Signs* (Amsterdam: Rodopi, 2007), p. 56.

13. Da Costa and Herrgott, *Dubuffet,* p. 9.

14. Jean Dubuffet, "L'art brut préféré aux arts culturels" (Raw art as preferred to cultural art), in *Prospectus et tous écrit suivants,* 4 vols. (Paris: Gallimard, 1967–95), 1:198–202. (All translations are mine, unless otherwise indicated.)

15. Da Costa and Herrgott, *Dubuffet,* p. 60.

16. Michel Ragon, *Dubuffet,* trans. Haakon Chevalier (New York: Grove Press, 1959), p. 12.

17. Dubuffet, quoted in Mildred Glimcher, ed., *Jean Dubuffet: Towards an Alternative Reality* (New York: Pace Publications / Abbeville Press, 1967), p. 46.

18. Letter from Jean Dubuffet to Gaston Chaissac, June 24, 1947, in Dubuffet, *Prospectus,* 1:466.

19. Allen S. Weiss, *Shattered Forms: Art Brut, Phantasms, Modernism* (Albany: State University of New York Press, 1992), p. 61.

20. Gustave Kahn, *Les Dessins de Seurat,* 2 vols. (Paris: Bernheim-Jeune, 1928), introduction.

21. Gilles Deleuze and Félix Guattari, *What Is Philosophy?* trans. Hugh Tomlinson and Graham Burchell (New York: Columbia University Press, 1994), p. 194.

22. Thomas B. Hess, "Dubuffet Paints a Picture," with photographs by Rudolph Burckhardt, *ARTnews* 51 (May 1952).

23. "The focus on the act—the process of art making—instead of on the static object changed the course of art criticism and even art history in a way Namuth himself could never have foreseen or intended." Barbara Rose, "Jackson Pollock: The Artist as Culture Hero," in *Pollock Painting,* ed. Barbara Rose (New York: Agrinde, 1980), p. 9.

24. "Review of an Exhibition of School of Paris Painters," *Nation,* June 29, 1946, reprinted in Greenberg, *Collected Essays,* 2:90.

25. "Review of Exhibitions of Jean Dubuffet and Jackson Pollock," *Nation,* February 1, 1947, reprinted in Greenberg, *Collected Essays*, 2:123–25.

26. Kent Minturn, "Greenberg Misreading Dubuffet," in *Abstract Expressionism: The International Context,* ed. Joan Marter (New Brunswick, N.J.: Rutgers University Press, 2007), p. 127.

27. "Jean Dubuffet and French Existentialism," *Nation,* July 13, 1946, reprinted in Greenberg, *Collected Essays,* 2:91–92.

28. Jean-Paul Sartre, *Existentialism Is a Humanism*, trans. Carol Macomber (New Haven, Conn.: Yale University Press, 2007).

29. Minturn, "Greenberg Misreading Dubuffet," p. 127.

30. "Notes pour les fins-lettrés," in Dubuffet, *Prospectus,* 1:54–88.

31. Letter from Jean Dubuffet to Hans Huth, May 19, 1951, in Dubuffet, *Prospectus,* 4: 136.

32. Letter from Jean Dubuffet to Kay Sage, September 14, 1960, in Dubuffet, *Prospectus,* 2:332.

33. Hans Prinzhorn, *Bildnerei der Geisteskranken: Ein Beitrag zur Psychologie und Psychopathologie der Gestaltung* (Berlin: Verlag Julius Springer, 1922).

34. Gallimard only printed one edition of the L'Art Brut series: *Les Barbus Müller et autres pièces de la statuaire provinciale* (1947), dedicated to a group of bearded stone figures of unknown origin that belonged mostly to the Swiss collector Josef Müller, who had discovered them in an antique shop in France, and which Dubuffet named "Les Barbus Müller."

35. Lucienne Peiry, *Art Brut: The Origins of Outsider Art,* trans. James Frank (Paris: Flammarion, 1997), p. 46.

36. The term "outsider art" was coined by Roger Cardinal in 1972. See Roger Cardinal, *Outsider Art* (New York: Praeger, 1972).

37. "L'art brut," in Dubuffet, *Prospectus,* 1:175–77.

38. Ibid.

39. "L'art brut préféré aux arts culturels," in Dubuffet, *Prospectus,* 1:198–202.

40. For a detailed history of the Compagnie de l'Art Brut, see Peiry, *Art Brut.*

41. Among the works were twelve paintings by Aloïse, three paintings by Wölfli, and more than three hundred paintings, drawings, and embroideries by Jeanne Tripier, who suffered from psychoses and died in a French mental hospital in 1944.

42. Da Costa and Hergott, *Dubuffet,* p. 55.

43. Federal Reserve, *Synergy: Alfonso Ossorio and Jackson Pollock, 1950–51* (Washington, D.C.: Federal Reserve, 2003), p. 2.

44. Letter from Jean Dubuffet to Alfonso Ossorio, March 21, 1953, Papers of Alfonso Ossorio and Edward Dragon Young (SC 15), file 602, Harvard Art Museums Archives, Harvard University, Cambridge, Mass.

45. Letter from Jean Dubuffet to Jacques Berne, February 3, 1972, J. Dubuffet, *Lettres à J.B., 1946–1985,* Collection: Sur l'Art (Paris: Hermann Editeurs des Sciences et des Arts, 1991), pp. 249–50.

46. Jean Dubuffet, *Bâtons rompus* (Paris: Editions de Minuit, 1986), no. 99.

47. There are nine works in the Neuve Invention section of the Collection de l'Art Brut by Ossorio, including the Victorias drawings *The Rose Mother, Dominant Mother,* and *The Crowd.*

48. B. H. Friedman, *Jackson Pollock: Energy Made Visible* (New York: Da Capo Press, 1995), p. 130.

49. Magda Salvesen and Diane Cousineau, eds., *Artists' Estates: Reputations in Trust* (New Brunswick, N.J.: Rutgers University Press, 2005), p. 214.

50. Parsons was director of the Wakefield Bookshop Gallery from 1940 to 1944 and director of the contemporary section of the Mortimer Brandt Gallery from 1944 to 1946. She opened the Betty Parsons Gallery at 11 East Fifty-Seventh Street in New York in 1946, later moving to 24 West Fifty-Seventh Street. Artists represented included many Abstract Expressionists, including Pollock, Rothko, Clyfford Still, and Barnett Newman.

51. Alfonso Ossorio interview, November 19, 1968, Archives of American Art, Smithsonian Institution, http://www.aaa.si.edu/collections/interviews/alfonso-ossorio-interview-5517#transcript.

52. On November 2, 2006, Carol Vogel reported in the New York Times that David Geffen sold the painting to David Martinez, a Mexican financier, in a private sale for a record price of $140 million.

53. Friedman, Jackson Pollock, p. 129.

54. As Levin writes in her recent biography on Pollock's wife, the painter Lee Krasner, "Ossorio was stimulated by the Pollocks and was also a sophisticated influence on them. He was able to respond to and support Pollock's work because of his grasp of modernism in the context of international art, philosophy, and culture." Levin, Lee Krasner: A Biography, p. 256.

55. B. H. Friedman, "Alfonso Ossorio's Elegiac Works on the Death of Jackson Pollock," in Road: Alfonso Ossorio's Responses to Jackson Pollock's Death (East Hampton, N.Y.: Pollock-Krasner House and Study Center, 2001), p. 5.

56. Ossorio interview.

57. Adé de Béthune, "Philippine Adventure," Liturgical Arts 19 (August 1951), p. 112–13.

58. Ossorio most likely read Brauner's text "Dessin à la bougie" (Drawing in Wax) published in Cahiers d'art 20–21 (1945–46) and reprinted in the catalogue for his exhibition at the Julien Levy Gallery in New York in 1947. See "Interview: Alfonso Ossorio Talks with Paul Cummings," Drawing 7 (January-February 1986), p. 107.

59. According to Gail Stavitsky, "Pollock's later use of wax-based techniques may have been part of a cultural exchange with his friend and patron Alfonso Ossorio." Gail Stavitsky, "Waxing Poetic: Encaustic Art in America during the Twentieth Century," (1999), http://www.tfaoi.com/aa/2aa/2aa626.htm.

60. Peintures Initiatiques d'Alfonso Ossorio (Paris, La Pierre Volante, 1951).

61. Ragon, Dubuffet, p. 47.

62. See pp. 125–26 in this volume.

63. Letter from Jean Dubuffet to Alfonso Ossorio, December 20, 1953, Papers of Alfonso Ossorio and Edward Dragon Young (SC 15), file 602. Harvard Art Museums Archive, Harvard University, Cambridge, MA.

64. Ossorio interview.

65. See Frédérique Villemur and Brigitte Pietrzak, Paul Facchetti: Le Studio. Art Informel et Abstraction Lyrique (Arles, France: Actes Sud, 2004).

66. See Aruna D'Souza, " 'I think your work looks a lot like Dubuffet': Dubuffet and America, 1946–1962," Oxford Art Journal 20, no. 2 (1997): 61–73; Sophie Berrebi, "Paris Circus New York Junk: Jean Dubuffet and Claes Oldenburg, 1959–1962," Art History 29, no. 1 (February 2006): 79–107.

67. Quoted in Pepe Karmel, "Jean Dubuffet: The Would-Be Barbarian," Apollo 156, no. 489 (October 2002): 12.

68. Jackson Pollock to Alfonso Ossorio and Ted Dragon, June 7, 1951, quoted in Friedman, Jackson Pollock, p. 171.

69. Jeffrey Potter, To a Violent Grave: An Oral Biography of Jackson Pollock (New York: G. P. Putnam's Sons, 1985), pp. 55–56.

70. See B. H. Friedman, "An Interview with Lee Krasner Pollock," in Jackson Pollock: Black and White (New York: Marlborough-Gerson Gallery, 1969).

71. Francis V. O'Connor, The Black Pourings, 1951–1953 (Boston: Institute of Contemporary Art, 1980).

72. Ibid., p. 4.

73. Ibid.

74. Ibid., p. 1.

75. Friedman, "Interview with Lee Krasner Pollock," p. 7.

76. "Jackson Pollock—'Painting Is Self-Discovery,' " in Jackson Pollock: Works from the Museum of Modern Art, New York, and from European Collections, ed. Armin Zweite and Volkmar Essers (Heidelberg, Germany: Kehrer Verlag, 2003).

77. Jeremy Lewison, Interpreting Pollock (London: Tate Gallery, 1999), p. 57.

78. Essers, "Jackson Pollock—'Painting Is Self-Discovery,' " p. 67.

79. Alfonso Ossorio in Betty Parsons Gallery, Jackson Pollock.

80. "Those two years when he wasn't drinking he was such a kind, gentle person," Alfonso Ossorio, in Potter, To a Violent Grave, p. 121

81. Ibid., p. 203.

82. Ibid., p. 106.

83. Francis V. O'Connor, Jackson Pollock (New York: Museum of Modern Art, 1967), p. 21.

84. Ibid., p. 79.

85. Ibid., p. 80.

86. "Notes pour les fins-lettrés," in Dubuffet, Prospectus, 1:54–88.

87. Ibid.

88. Quoted in Reba Williams and Dave Williams, "The Prints of Jackson Pollock," Print Quarterly 5, no. 4 (December 1988): 366.

89. Ibid., pp. 366–67.

90. Deborah Wye, Artists and Prints: Masterworks from the Museum of Modern Art, (New York: Museum of Modern Art, 2004), p. 129.

91. Williams and Williams, "Prints of Jackson Pollock," p. 81.

92. "It is obvious that he was not . . . comfortable with, or favorably disposed towards them, and few were editioned during his lifetime." Ibid., p. 371.

93. "Notes pour les fins-lettrés," in Dubuffet, Prospectus, 1:54–88.

94. Federal Reserve, Synergy, p. 9.

95. "Mémoire sur développement de mes travaux à partir de 1952," in Dubuffet, Prospectus, 2:112.

96. Sarah K. Rich, "Jean Dubuffet: The Butterfly Man," October 119 (Winter 2007): 51.

97. Letter from Jean Dubuffet to Alfonso Ossorio, May 22, 1950, Papers of Alfonso Ossorio and Edward Dragon Young (SC 15), file 599. Harvard Art Museums Archive, Harvard University, Cambridge, MA.

98. Vladimir Nabokov, "Long and Hazy the Evening," in Nabokov's Butterflies: Unpublished and Uncollected Writings, trans. Dimitri Nabokov, eds. Brian Boyd and Robert Michael Pyle (Boston: Beacon Press, 2000), p. 502.

99. Klaus Kertess, "Eyewitness," in Alfonso Ossorio: Congregations (Southampton, N.Y.: Parrish Art Museum, 1997), p. 13.

100. Jean Dubuffet, "Topographies, Texturologies et Quelques Peintures," in The Work of Jean Dubuffet, ed. Peter Selz (New York: Museum of Modern Art, 1962), p. 137.

101. Cf. André Pieyre de Mandiargues, "Jean Dubuffet ou le point extreme," Cahiers du Musée de Poche 2 (June 1959): 5–61.

Pollock, Ossorio, Dubuffet, 1948–1952

Alicia G. Longwell

Best of everything there was
and everything there is to come
is often undocumented.
Lost in the cosmos of time.
On the subway I saw the most
　　beautiful girl.
In an unknown pool hall I saw the
　　greatest shot in history.
A nameless blonde boy in a mohair
　　sweater.
A drawing in a Paris alleyway.
　　Second only to Dubuffet.

—Patti Smith

Alfonso Ossorio in his studio at 9 Macdougal Alley, New York, with his painting *Klan Picnic*, 1949, on wall. Photograph by Hans Namuth.

Jean Dubuffet's appearance in the New York downtown art scene in October 1951 marked the sole time that he and fellow artists Alfonso Ossorio and Jackson Pollock would find themselves in the same latitude, and even then, it was for only a few months.[1] If the French artist imagined coming upon a hegemonic band of Abstract Expressionists in New York, the reality that greeted him proved strikingly different. By 1951 the era of Pollock's classic drip paintings was over; Barnett Newman's "zip" had reached its apogee in the seven-by-seventeen-foot *Vir Heroicus Sublimis*; and a twenty-six-year-old named Robert Rauschenberg had completed his White Paintings, to be shown the next year at the Betty Parsons Gallery. The little-known account of the relationship among Pollock, Ossorio, and Dubuffet in the years 1948–52 reveals a story of artistic camaraderie, mutual admiration, and cultural exchange that affords a more nuanced view of Abstract Expressionism than the standard version. Ossorio's position as nexus and his own burgeoning artistic aware-ness, set against a backdrop of European and American exchange, are at the core of this story.

1949

In later interviews Ossorio recalled that he must have seen Pollock's paintings in New York as early as 1946 but that they made no lasting impression upon him until 1947–48. After seeing Pollock's first show at Betty Parsons in 1948, Ossorio "suddenly realized the so-called drip panels had an intensity of organization . . . had a message that was expressed by its physical components, was a new iconography."[2] He found in Pollock's work common ground with his own, sensing that they both had "bypassed the Renaissance and had gone back to a much earlier tradition of art in terms of dealing with forms and shapes dictated by the ideas rather than by appearance. I mean it's much more like . . . Celtic illumination than it is like David."[3] This "intensity of organization" brought Ossorio back to his own early exposure to the extreme stylization of the Eric Gill workshop in Sussex, England, where as a teenager he had created the woodcut *Sidrach, Misach, Abendnego* (fig. 12).[4] Not only did Ossorio admire the work in the 1948 Pollock show, he was able to acquire one of the paint-ings for himself.[5]

　　The friendship between Pollock and Ossorio began in April 1949, when Betty Parsons brought Pollock and his wife, the artist Lee Krasner, to meet Ossorio at his car-riage house at 9 Macdougal Alley in New York's Greenwich Village. The Pollock painting that Ossorio had bought was damaged in delivery, and Parsons suggested that the artist could make the repair. Pollock may well have seen Ossorio's *Klan Picnic* on that visit, for it hung prominently on Ossorio's studio wall (fig. 13). This was a work of disturbing subject matter, which Ossorio later described as "the Ku Klux Klan having a picnic on the body of a Negro . . . it *was* a horrid picture."[6] As a Eurasian, he was acutely aware of his own out-sider status in the United States. Born in 1916 in Manila to a wealthy industrialist family of Spanish, Chinese, and Filipino ancestry, he was sent at the age of ten along with two younger brothers to boarding school in England; in 1930 he transferred to Portsmouth Priory, a boys' preparatory school in Rhode Island run by Benedictine monks. At eighteen he entered Harvard, where he majored in fine arts; his senior thesis was titled "Spiritual Influences on the Visual Image of Christ."

12. Alfonso Ossorio, *Sidrach, Misach, and Abendnego,* 1933–34. Wood engraving, 7 × 5 in. (17.8 × 12.7 cm). Ossorio Foundation, Southampton, N.Y.

Parsons, an early enthusiast of Ossorio's work, met him in the summer of 1941 in Taos, New Mexico.[7] She arranged for his first one-man show in November at her New York gallery.[8] Ossorio, who had become a naturalized U.S. citizen in 1933, was called up for active duty during World War II into a still largely segregated army. His last tour of duty was at Mayo General Hospital in Galesburg, Illinois, where he served as medical illustrator. He wrote to Parsons: "I spend most of my mornings watching operations and doing sketches which I proceed to work up into finished drawings. It could be much worse, and I am even learning a great deal of anatomy that I'd never run across in the normal course of events."[9]

Ossorio persisted at his art during his time in the military and continued to show with Parsons, who by 1944 was handling contemporary art at the Mortimer Brandt Gallery in New York. The terrifying veracity of the works in his one-man exhibition held there in 1945 caused one reviewer to write: "Dalí is kid stuff compared with [Ossorio's] weird demonic visions. They speak—in phrases whose meaning you can only guess—of a demi-world, of nightmares and anguish, of things perverse. Their symbolism is involved and Freudian."[10] When he returned from the army in 1946, Ossorio realized that he was "not in the swim of things," yet his relative isolation between his graduation from Harvard in 1938 and settling in New York in 1947 had given him the chance to develop his own voice. Cursorily branded by critics as a Surrealist, he now had to navigate the increasingly contentious circles of contemporary art. Though he lived in the Village, his personal wealth always put him at a remove from most other artists, whose lives in that neighborhood during the Depression and war years had been marked by a struggle to survive.

13. Alfonso Ossorio, *Klan Picnic,* 1949. Gouache on paper, 30 × 60 in. (76.2 × 152.4 cm).

Pollock must have recognized in Ossorio the same creative struggle that he experienced. Ossorio later related that *Klan Picnic* was one of the few paintings of his for which Pollock gave a "precise criticism. He looked at it very carefully for a long time, he finally pointed to the cone and the hand and he said, 'You know, that's really what it's all about. It's the hand clasping the cone.' He never went into it any further, but it's obviously a picture of tensions."[11] Produced in a period of heightened Klan activity in the South, Ossorio's painting is an overt statement, but one veiled by the "overall" quality of the composition. Thirty years later, when asked about the abstracted elements in the painting, Ossorio admitted that there were reasons: "One didn't want to be too precise. We were dealing with the world farther back" — an evident reference to the need to mask allusions to race, gender, and sexuality.[12] "A lot of images that look as if they were just doodled were deliberately put in there to create this all-over impression of compression."[13]

After the meeting at Macdougal Alley, it was decided that the damaged Pollock painting should be brought to the studio in Springs for repair. In May 1949 Ossorio and his companion Edward (Ted) Dragon drove to East Hampton so that Pollock could reattach a dangling skein of paint. The camaraderie among Ossorio, Dragon, Pollock, and Krasner must have been immediate, for Ossorio and Dragon stayed the night and soon arranged a summer rental.[14] Ossorio was in a position to help Pollock financially by purchasing work, of course, but the basis for the relationship was more than that. "I was trying to be a painter, and here was someone who had found a viable expression, who was doing fascinating work that pulled together a lot of the education one had been given and made it blossom

14. Alfonso Ossorio, Lee Krasner, and Jackson Pollock at Louse Point, East Hampton, ca. 1949. Photographer unknown.

in a contemporary sense. You know, one studies the pre-Romanesque and then finds the same passion and the same depth not in the year 800 or 1000 but *here*. The same passion was in the air again."[15] For his part, Pollock must have been drawn to the worldly and erudite Ossorio. That first summer in the Hamptons, Ossorio recounted, they saw each other "two or three times a week."[16] Pollock was famously taciturn, and a regime of tranquilizers prescribed for his drinking the previous fall by an East Hampton physician made him even more so. "We would spend hours together on the beach," Ossorio recalled. "We would just sit looking at the dunes, the gulls, the water, or . . . fishing. He knew every inch of the island, the dunes, the northwest woods, the beaches between here and Montauk, all of them. . . . He was very silent when he was sober" (fig. 14).[17] Yet somewhere in their conversations that summer, the topic of Jean Dubuffet would likely have come up. Two years earlier, in a review of Pollock's fourth solo show in as many years at Peggy Guggenheim's Art of This Century gallery and Dubuffet's first solo show in New York at the Pierre Matisse Gallery,[18] Clement Greenberg was the first critic to make a comparison between the two artists. As early as 1944, Greenberg had championed Pollock as "the strongest painter of his generation and perhaps the greatest one to appear since Miró."[19] The relationship between the artist and the critic was such that Greenberg felt he could urge Pollock to push the "all-over" quality in his compositions. Sixteen paintings from two distinct series of Pollock's work were included in the 1947 Art of This Century show.[20]

To Greenberg's way of thinking, an artist had to suppress any hint of representation to achieve a level of distinction in art making. Pollock's evolution away from "ideographs" was to be applauded. Yet in a work like *Number 22A, 1948* (plate 3) it is virtually impossible *not* to read three figures in the composition. Much has been written about the ability to discern such figurative elements even in the large-scale classic drip paintings like *Autumn Rhythm, Number 30, 1950* (1950), and the ways in which Pollock "amplified and enriched his original composition before burying it."[21] By 1949, elements in Ossorio's paintings also had

begun to claim this aspect of "overallness."[22] For him this density had a metaphysical component. "There is very little inactive, empty space in the world. It's not that what we look at or what we can reach with our arms or our minds is something, and the rest is emptiness. The world is an intensely interlocked, densely active cell, super-cell, if you want to call it that."[23]

When the August 8, 1949, issue of *Life* magazine appeared on newsstands that summer, the question posed in its pages—"Jackson Pollock: Is he the greatest living painter in the United States?"—reverberated throughout the art world, especially in the Hamptons.[24] Pollock and Krasner were justifiably anxious about the article before it appeared in print. The previous December, *Life* had singled out another artist for attention: "Dead End Art: A Frenchman's Mud-and-Rubble Paintings Reduce Modernism to a Joke," read the headline. The article accused Dubuffet of faulty technique and less than credible intent. "There is more human dignity in Al Capp's Dogpatch than in the whole of Dubuffet's gaga cosmos."[25] The attention provoked awe as well as antipathy among Pollock's fellow artists. Perhaps America's "greatest living painter" was curious enough about France's most famous artistic export to imagine a transatlantic exchange that would elicit more publicity. Ossorio had a more than passing interest in Dubuffet's unconventional work, which he had first seen in Pierre Matisse's New York gallery. Who better to act as go-between than the cultured and French-speaking Ossorio? The suggestion may have been Pollock's, or perhaps it was Ossorio's; clearly Ossorio had the ability to act on such an impulse.

In late November, Ossorio accompanied his father on a business trip to London with the express objective of going on to meet Dubuffet in Paris. The introduction was arranged by the French writer Blaise Allan, a longtime friend of Ossorio's, through Jean Paulhan, editor of the *Nouvelle revue française* and a friend of Dubuffet's.[26] The two artists very quickly established a friendship and reciprocal admiration. Ossorio had the opportunity to view the collection of Art Brut—the term coined by Dubuffet to describe the works of artists who, unfettered by Western conventions, "present a spontaneous and strongly inventive character, as little indebted to customary art or cultural models as possible"; these were "obscure individuals, alien to the milieu of professional artists."[27] By 1948 the collection had been incorporated as a nonprofit entity under the name Compagnie de l'Art Brut; other founding members were Paulhan, the Surrealist André Breton, the critic Michel Tapié, the writer Henri-Pierre Roché, and Charles Ratton, a leading authority on African art. The first exhibition of Art Brut was at the Galerie René Drouin on the Place Vendôme. A small illustrated catalogue on the collection was published in 1949 to accompany a second exhibition at Drouin; it included Dubuffet's essay "L'Art Brut préféré aux arts culturels" and a checklist of some two hundred artists represented in the collection (fig. 15). Ossorio brought copies of the catalogue with him when he returned to New York and would no doubt have translated parts of Dubuffet's radical essay for Pollock.

Ossorio purchased three Dubuffet paintings while in Paris, *Robinson, Figure au site champêtre,* and *La dame au pompom*—paintings that Pollock would have the chance to see once they were unpacked and installed in Macdougal Alley. When asked about his enduring inclination to invest his energy and resources into the work of others, Ossorio reflected: "It was never collecting in the sense of buying. It was buying the ideas. I was buying Dubuffet, for instance, whether it was a great Dubuffet or a bad Dubuffet."[28] While

15. Cover of catalogue *L'Art Brut préféré aux arts culturels* by Jean Dubuffet, 1951.

in France, Ossorio also bought, at Dubuffet's suggestion, works by Jean Fautrier and Wols (Alfred Otto Wolfgang Schulze), Parisian artists whose work was known as Art Informel, a movement that Tapié sought to codify in his 1952 treatise *Un art autre*[29] and one that was little recognized in the United States at the time. When Pollock saw these works, he told Ossorio: "I don't know where painting is going but it certainly isn't going that way."[30]

Many artists in New York, including Pollock when he was younger, were known to frequent the American Museum of Natural History and the displays of artifacts from "primitive" peoples. This was nothing new; French artists at the beginning of the century had looked at African sculpture. Betty Parsons championed this art, and when she opened her new gallery in the former Mortimer Brandt space on Fifty-Seventh Street in 1946, the first exhibition was of Northwest Coast Indian painting, organized by Barnett Newman and Tony Smith.[31] In a catalogue essay, Newman wrote: "It is becoming more and more apparent that to understand Modern art, one must have an appreciation of the primitive arts, for just as modern art stands as an island of revolt in the stream of western European aesthetics, the many primitive art traditions stand apart as authentic aesthetic accomplishments that flourished without benefit of European history."[32]

Ossorio returned from Paris to New York in time to see Pollock's second exhibition at Betty Parsons before it closed in mid-December 1949. He purchased a second Pollock, *Number 19, 1949,* enamel on paper mounted on fiberboard. Another painting in the show held his attention and would have invited further study: *Out of the Web: Number 7, 1949,* a four-by-eight-foot oil and enamel on fiberboard in which Pollock had incised and lifted from the fiberboard surface layers of paint in arcing swaths, creating negative spaces that resemble dancing bodies, perhaps signaling a return to the figure in his paintings. The

exhibition was a resounding success, with positive critical response and record sales. Even the venerable critic Henry McBride, well into his eighties, made a turnaround in his assessment: "Previous works by Pollock which I had seen looked as though the paint had been flung at the canvas from a distance, not all of it making happy landings. Even the present one has a spattered technic [sic], but the spattering is handsome and organized and therefore I like it."[33]

1950

Early in 1950 Ossorio was commissioned to decorate a church in the Philippines, the chapel of St. Joseph the Worker, being built by his family's enterprise, the Victorias Milling Company, on Negros Occidental, an island largely destroyed by the Japanese in World War II. In over ten months of intense work that was both familial duty and artistic opportunity, Ossorio completed the interior decoration of the church, a mural depicting the Last Judgment. The enormity of the undertaking, the fact that he was returning for the first time since the age of ten to his family and his birthplace, the intense physical demands of the work and the climate,[34] the distance from his current life in the United States—these all propelled Ossorio to a breakthrough in his work in the mural he worked on by day and in the watercolors he executed at night. In a later interview, Ossorio commented on his involvement with religion: "One can say [I have] a continuing interest in problems which religion covers such as birth, death, sex—these particular aspects of humanity."[35] For Ossorio, anyone concerned with humanity is concerned with religion: "The human being is the link between God and the material world. . . . Even a little waste piece of plastic or a bone is just as much alive as the abstract concept of God, which is meaningless unless it is incarnated."[36]

For Ossorio, 1950 and 1951 were years of continuous production, both thematically and technically.

> [The] series of watercolors went straight on through my stay in the Philippines, return to America, visit to Paris, and finally back to settle permanently in East Hampton in 1952. The works *fell one out of the other* [emphasis added]; it just didn't seem to matter too much where I was or what else was going on, and there was a lot else going on. They started quietly in the Philippines; waiting for the materials to arrive that I was going to use in the mural; a working pattern evolved in which daylight [was] spent painting the mural, and spare moments in the evenings and on weekends were spent doing the watercolors.[37]

Ossorio's description of the intensity of the period, how the drawings "fell one out of the other," is borne out by the fact that some of the drawings are on sheets of his brother Frederic's Tiffany & Co. stationery—perhaps the only suitable paper at hand (plates 20, 28). The wax-resist method that Ossorio chose for these drawings may have been something he had considered exploring earlier,[38] or more simply a question of using materials (such as candles) that were readily available. The works exhibit formidable traces of the artist's hand: the paper itself may have been torn or crumpled and smoothed out; shapes were incised and lifted out to reveal negative space beneath; elements were collaged. The predominant media here are watercolor, wax, and ink. Watercolor was applied first; then

shapes were drawn with the wax; a second wash of watercolor adhered only where no wax had been applied. The wax itself was put on either with a brush or, as Dubuffet later described, directly with a "sharpened candle-end."[39] Ossorio worked with the paper both wet and dry. In a diary he annotated methods and techniques he tried: "Wax work wet i.e. hot with small or large stiff brush texture, cloudy, murky, scumble effect over dark: then use hot iron/Brush over silhouette, scrape, differing or same silhouette, with w.c., gouache, oil, ink, wax??/silhouette:/outline in wax then interior treated as cut out: outline of cutout made with hot wax; with rubbing of cold wax."[40]

The central figure in the Victorias mural is that of Christ sitting in judgment on the last day. Tellingly, his outstretched arms are held up by the huge hands of God the Father. The construct of parent and child is at the center of Christian religion and iconography: the relationship between Jesus the Son and God the Father, and the more earthbound and humanist image of the infant Christ and his mother. Given his religious upbringing and schooling, Ossorio was well versed in Christian iconography. It could be said that by day in Victorias he dealt with the heavenly family; by night his thoughts were consumed with his earthly one. Ossorio was the sixth of nine sons, three of whom died in infancy.[41] The obsession with birth, death, and nurture evident in the Victorias drawings suggests that he was accessing his earliest memories; these, combined with Christian iconography (which has never lacked for gruesome images, from martyred limbs to the bleeding heart of the Virgin), yield drawings that reveal the inherent struggle of life. The objectivity of the titles belies the roiling emotions of the drawings: *The Child Returns, First Suckling, Five Brothers, Couple and Progeny, Family with Blue Children, Holy Mother, Maimed Mother and Child.* Dubuffet would later mine a vocabulary rife with vivid imagery—"multi-colored chaos," "a storm of violently applied blobs," "vehement lines," "screaming faces," "excrescences," "viscera sprouting filthy tufts of hair," "hideous sexual organs," "some hybrid domain of sorcery," "grotesque little personage"—to describe the tumult of these works.[42] Perhaps because of his isolation in Victorias, Ossorio felt no need to censor his thoughts or purge them from his drawings. Dubuffet sensed Ossorio's relentless probing and his unwillingness to repress any emotion: "Ossorio is not a man to reject any zone whatever.... [He] is determined to despise nothing."[43] Ossorio later recalled that what appealed to him in the wax-and-watercolor combination was "the idea that you could put layers of meaning one on top of the other."[44] And so we see the "angels, demons, and savages" stirred up while he worked on the mural during the day expiated in the night as he feverishly executed the drawings. Dubuffet understood the correlation between Ossorio's days and nights, and with great acuity called the drawings "an overflow reservoir ... the decorations of his personal and private church."[45]

Ossorio kept in touch with Dubuffet throughout his time in the Philippines with letters and photographs documenting the progress of the project; he even mailed some of the sheets of drawings. Their friendship deepened, and their conversation ranged freely. Dubuffet lauded the originality of the mural concept: "I am astounded that you have executed, in such a short time, and without preliminary studies, a major work and achieved success in such an authoritative and unselfconscious way."[46] He urged Ossorio to come to Paris and proposed a book based on the Victorias drawings. They also exchanged ideas

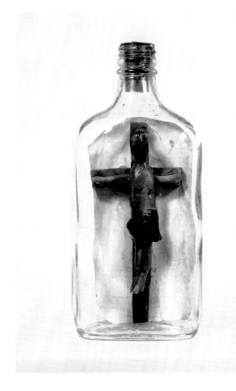

16 a and b. Anonymous American, *Crucifix and Christ Child,* 20th century. Glass, wood, and paper, h: 10 ½ inches (25.9 cm).

about Art Brut; in a letter written in May, Dubuffet thanked Ossorio for sending him a photograph of a folk art piece in his collection (fig. 16): "Many thanks as well for the lovely photograph of the crucifix in the bottle, that little work of American art brut interests me a lot and I have the greatest pleasure in pasting the reproduction in the albums of the 'Halls of Art Brut.'"[47] Pollock's name also came up. Dubuffet wrote that although he was acquainted with the artist's work only through poor reproductions, he felt that Pollock was "one of the few living painters (along with yourself) whose oeuvre interests me."[48]

There is no record of communication between Ossorio and Pollock during Ossorio's stay in the Philippines. The summer of 1950 found Pollock engaged in the paintings that would cement his reputation—*Lavender Mist, Autumn Rhythm, Number 32,* and *One.* Pollock was still an object of interest to the "outside" world, but being on top was a precarious position. Barnett Newman later observed that Pollock was "the first American artist to be devoured as a package by critics-and-collectors, by *Life* magazine . . . and subsequently by the fashion magazines and gossip columns and the rest of the paraphernalia."[49] That summer the photographer Hans Namuth introduced himself to Pollock at a Guild Hall opening in East Hampton, and Pollock allowed him complete access to his studio. Namuth took more than five hundred pictures there and in August began filming his subject. Berton Roueché, an East End neighbor and medical writer for the *New Yorker,* interviewed Pollock and Krasner for an article that appeared in the August 5 edition of the magazine. In it, Lee Krasner pointed out that Pollock once gave his paintings conventional titles but now simply used numbers: "Numbers are neutral. They make people look at a picture for what it is— pure painting."[50] Pollock interjected: "I decided to stop adding to the confusion. Abstract painting is abstract. It confronts you. There was a reviewer a while back who wrote that my pictures didn't have any beginning or any end. He didn't mean it as a compliment, but it was. It was a fine compliment. Only he didn't know it."[51]

Ossorio returned to New York from the Philippines in October with more than three hundred drawings. He experimented with ways to display the works, many of which had unconventional torn or shaped edges. Ossorio later explained that he had in effect disrupted the Renaissance picture plane: "It's part of not needing the rectangle.... There's no need for a geometrical shape to contain a vanishing point. It's a very tricky question because there is something that's very nice about the old rectangle."[52]

By December 1950, Ossorio had resolved to return to Paris and pursue the idea of publishing a book on the Victorias drawings with Dubuffet. He and Dragon took the drawings with them, as well as two recently purchased midsize Pollocks, *Number 30, 1949* and *Number 8, 1950.* In Pollock's works from this period, Ossorio was struck by "a slow-moving set of broad interlaced areas, the black a superb series of agitated, cursive figures, possessed of that double quality of biomorphically evocative abstraction and a vitality of form completely *sui generis* that Pollock so often achieved."[53] This vibrant characterization reveals how Ossorio was "buying ideas" and how much Pollock's paintings (like Dubuffet's) became talismans for him. He must have been feeling anxiety about the Victorias drawings—a huge body of work that had to be confronted before he could move on. The tremendous psychic upheaval of those months—the works that came so easily, falling "one out of the other"—had to be processed, and the impact absorbed. Dubuffet's interest was a lifeline. Before leaving New York, Ossorio offered Macdougal Alley to the Pollocks as a city base. He also asked them to be on the lookout for a house and studio in East Hampton that would be suitable for him. He had decided to move out of the city upon his return.

Much has been written about Pollock's summer production in 1950 and the critical reception for his show in the fall at Betty Parsons. Ossorio, impressed with his recent work, was determined to buy *Number 1, 1950,* known as *Lavender Mist* (plate 4). Both Ossorio and Dragon were in the Hamptons the weekend after Thanksgiving, days before the gallery opening, and were invited to the Pollocks' for a Saturday gathering of close friends.[54] Namuth, struggling to complete the film he had begun in August,[55] now pushed into the colder months to get the shots he wanted. It was almost dark by the time he finished filming. Pollock burst into the house, chilled to the bone. "Jackson went straight to the bottle and filled a tumbler full of bourbon," Ossorio later recalled. "Then he poured it down and Lee went white in the face."[56] It was the first drink Pollock had had in two years. "For the first two years I knew him," Ossorio said, "he never touched a drop of alcohol. That was when he did his classic paintings. It is curious that he did his most abstract and highly distilled paintings when he was not drinking. The minute he resumed he went into the black and white images filled with figurative, very human elements."[57]

The reception for Pollock's exhibition at Betty Parsons three days later was unexpected.[58] Parsons later remembered the show as "a disaster. For me it was heart-breaking. Those big paintings at a mere $1200. For Jackson it was ghastly; here was beauty, but instead of admiration it brought contempt."[59] Pollock retreated to Macdougal Alley (since the Springs studio did not have light or heat, he could paint there only in the summer). In January the architect and sculptor Tony Smith, sensing Pollock's desperation, gave him a sheaf of rice paper and black ink. The scale of the paper (eighteen by twenty-two inches) and the novelty of the medium prompted Pollock to work again.[60] Lines drawn or dripped

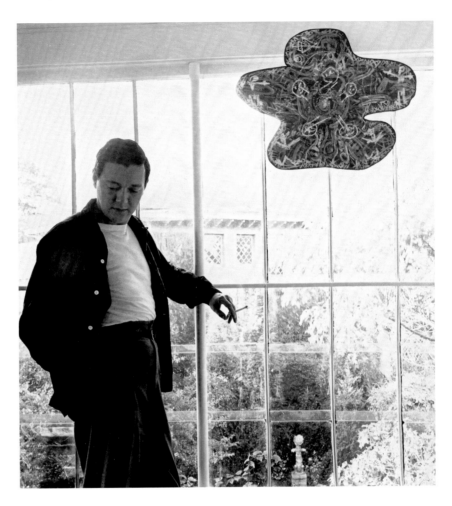

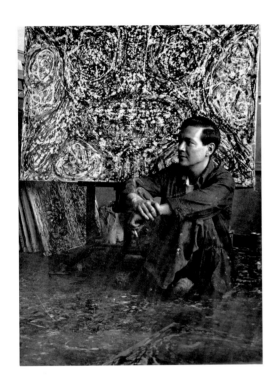

17. Alfonso Ossorio in his Paris studio, with his painting *Holy Mother Church,* 1951. Photographer unknown.

18. Alfonso Ossorio with *The Living Nails*, c. 1950, at the Creeks in 1952. Photograph by Hans Namuth.

on the top sheet would seep through to the layers beneath. Pollock would remove the top sheets until he found an image he liked (plate 10). This began a period of searching that would lead him to the Black Pourings of 1951.

1951

In Paris, Ossorio rented a studio near the Place Clichy and saw Dubuffet once or twice a week.[61] He had the luxury of working on a larger scale than in the Philippines and for the first time was using oil and enamel on canvas (plates 33–38). "I never really used oil . . . 'til Paris in 1951. I think it . . . had something to do with pre-Renaissance art and the introduction of oil painting at a later date. There may have been a residual feeling that so much of the art I was interested in did without oil."[62] The overall quality of the compositions expanded, adopting the medium if not the method of the Western tradition of mimesis. The Abstract Expressionist mandate to find new modes of expression is made manifest in the hundred works Ossorio produced during his Paris sojourn (fig. 17). He even experimented with shaped canvases mounted on plywood (fig. 18; plate 32): "A rectangular frame is not the logical necessity that it was for Renaissance painters obsessed by perspective and the vanishing point."[63]

Ossorio responded with enthusiasm to Dubuffet's new Corps de Dame series (plates 44–46). He had "tackled the female nude, laying her flat as a skate," as one critic later observed.[64] Dubuffet described the series in this way:

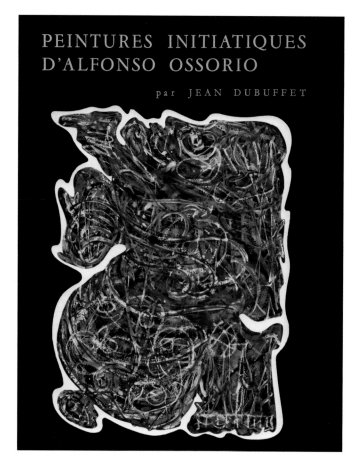

19. Cover of *Peintures initiatiques d'Alfonso Ossorio*
by Jean Dubuffet, Paris, 1951.

When I ask myself what has brought me to this subject [Corps de Dame], so typical of the worst painting. I think it is in part because the female body, of all the objects in the world, is the one that has long been associated (for Occidentals) with a very specious notion of beauty (inherited from the Greeks and cultivated by the magazine covers). . . . Surely I aim for a beauty, but not that one. The idea that there are beautiful objects and ugly objects, people endowed with beauty and others who cannot claim it, has surely no other foundation than convention—old poppycock. . . . The beauty of an object depends on how we look at it and not at all on its proper proportions.[65]

In May, Ossorio and Dragon accompanied Dubuffet and his wife, Emilie (Lili), to the Ile du Levant, one of the "Golden Islands" off France's Mediterranean coast. The two couples shared a house, and Dubuffet rented a studio, where he started working on the manuscript for the book *Peintures initiatiques d'Alfonso Ossorio*. It was published later that year in Paris, in an edition of fifteen hundred, by La Pierre Volante. The sixty-five-page catalogue featured six full-color plates tipped in and thirty-nine black-and-white illustrations, as well as a lengthy introduction and catalogue entries on each illustrated work (fig. 19). In a wide-ranging survey, Dubuffet homes in on Ossorio's work: "Yes, I am convinced that M. Ossorio . . . has a kind of double desire: to show his treasures and to hide them."[66] Dubuffet had actually lived with the more than four hundred images, poring over them with concentration and dedication, over a period of months, and had learned much about the artist. "It seems as if [Ossorio] is determined to *give body* to conceptual notions—to the point of regarding them as entirely on the level of material objects—and, at the same time, to keep the real objects he wants to represent from being excessively incarnate."[67]

The Compagnie de l'Art Brut had been disbanded the previous October because of insufficient resources, and the collection, now grown to at least a thousand objects, needed a secure home. Dubuffet initiated a campaign to move the collection to America, and he decided that Ossorio had the will and the means to provide a home for it. Through Dubuffet's introduction of Ossorio to Michel Tapié, an exhibition of Ossorio's work was arranged at the Studio Paul Facchetti (owned by the Parisian photographer turned gallerist) October 9–30, 1951. Tapié, a founding member of the Compagnie de l'Art Brut with Dubuffet and André Breton, had managed the Foyer de l'Art Brut at the Galerie René Drouin.

Ossorio kept in contact with Pollock throughout his stay in Paris. In January, Pollock wrote him: "I really hit an all-time low—with depression and drinking. NYC is brutal.... Last year I thought at last I am above water from now on in—but things don't work that easily I guess."[68] Ossorio answered with a $200 advance toward future purchases and committed to this monthly.[69] By the end of April, Pollock and Krasner were back in Springs full-time. Pollock worked on long rolls of unprimed cotton duck, painting one image after another without stopping or cutting, using black paint, often enamel, exclusively. To improve his control of the paint, he employed glass basting syringes; Krasner recalled that the syringe was "like a giant fountain pen."[70] Subsequent sessions were devoted to cutting and editing, determining the orientation of the work, and, finally, signing. The image was, in a sense, permitted to find its own orientation. Ossorio later wrote that he felt these paintings marked a "rupture with traditional compositional devices that produces, momentarily, the sense that the picture could be continued indefinitely in any direction."[71]

In June, Pollock was writing his friends in Paris: "Dear Alfonso and Ted, I've had a period of drawing on canvas in black—with some of my earlier images coming thru."[72] He mentioned that Tony Smith had suggested some of the drawings be made into a portfolio of prints—"either lithographs or silkscreens—I may try a couple to see how they look" (plates 15A–F).[73]

In August, Ossorio received a cable from Pollock letting him know about an East Hampton property that was available. The Creeks, as it was called, was a sprawling Mediterranean-style house designed in 1899 by a prominent American architect, Grosvenor Atterbury, for the artists Albert and Adele Herter.[74] Ossorio flew to the States to arrange the purchase and made a visit to Pollock's studio to view the Black Pourings. He was so taken with what he saw that he persuaded Pollock to let him, once he was back in Paris, approach Michel Tapié about a show at the Studio Paul Facchetti.[75] Ossorio's relationships with other artists were, as he put it, "a question of admiring but doing as differently as possible."[76] Pollock had insisted that Parsons produce a catalogue to accompany his exhibition scheduled for the end of 1951, and Ossorio was only too happy to provide an introduction. As he later wrote of the figurative elements in these compositions: "Those ominous and tormented images are indeed of their time and place, but they work through to universal human agonies and exaltations, not from disasters of war or the tortures of the hereafter, but through the dross and torment of everyday life."[77]

Ossorio returned to New York in October 1951, and at the end of the month Dubuffet and his wife arrived there as well. Ossorio reflected on his nearly yearlong stay in Paris fondly: "Those months ... seem an idyllicly [sic] happy time with that great luxury, work, and

no people except those one wants to see."[78] A dock strike held up the release of the shipment containing the large-scale works done in Paris that were to be included in his exhibition at Betty Parsons, which was held November 5–24. For his first solo show in six years, his expectations were high but sales proved modest, even at a mere $150 each for the smaller works.[79] Reviews were respectful if not overly enthusiastic—one critic summed up his production as "an apocalyptic art in the line of Blake." The *New York Herald-Tribune's* Emily Genauer aligned Ossorio with the "intra-subjectives, non-objectives and automatic-writing symbolists," yet went on to say: "Unlike most of them, however, his painting shows a degree of design control theirs too often lacks, plus richly resonant color, and a genuinely felt and generally communicated lyrical approach."[80]

Pollock's show at Parsons opened two days after Ossorio's closed.[81] Ossorio's catalogue essay was a testament to the closeness of the two artists. He saw that Pollock was too interested in the real problems of painting to continue simply to repaint *Autumn Rhythm*. The essay addressed head-on some of the criticisms likely to be leveled at this wholly different work: "The singleness and depth of Pollock's vision makes unimportant such current antithesis as 'figurative' and 'non-representational.' . . . The picture surface, with no depth of recognizable space or sequence of known time, gives us the never ending present . . . new visions demand new techniques. Pollock's use of unexpected materials and scale are the direct result of his concept of the organic intensity with which he works, an intensity that involves, in its complete identification of the artist with his work, a denial of accident."[82]

Dubuffet had expected to see the Art Brut collection safely installed at the Creeks before returning to France, but Ossorio's renovation plans at the new property ran behind schedule. Dubuffet rented a loft studio on Great Jones Street and relished observing the local denizens on "dramatic Bowery Avenue . . . the place where the city's bums hung out in a state of permanent drunkenness."[83] He even executed a series of animated drawings of "Bowery Bums." Through Maurice Culberg, an asbestos manufacturer who was his first American patron, Dubuffet was invited to speak at the Arts Club of Chicago on the occasion of an exhibition of his work there.[84] Ossorio accompanied him to Chicago, where he gave the speech "Anticultural Positions" on December 20. The impact of Dubuffet's speech on those assembled was immediate; they were the "small group of artists, critics, and amateurs who at that time formed the only pocket of understanding for the revolution of which Dubuffet's speech was the manifesto. The reason was that easel painting, still alive in New York, was already dead in Chicago."[85] Dubuffet told the assembled, "I have the impression that a complete liquidation of all the ways of thinking, whose sum constituted what has been called humanism and has been fundamental for our culture since the Renaissance, is now taking place, or, at least, going to take place soon. I believe very much in values of savagery; I mean: instinct, passion, mood, violence, madness."[86]

1952

Two stories in adjacent columns headlined the front page of the January 3, 1952, edition of the *East Hampton Star*—"Herter Estate Sold to Artist, Alfonso A. Ossorio" and "Jackson Pollock, Artist, Wrecks Car, Escapes Injury, No Holiday Fatalities." This was a very public junction of the two artists, who now lived in close proximity.[87]

In January 1952, twenty crates containing the Art Brut collection were sent from Paris to Rouen and then on to New York City by ship. Ossorio had the financial means and the space in his new home, but the psychic responsibility was apparently a strain. "I must say I was both flattered and appalled at the idea of it coming over to America." The works had to be "fumigated, sprayed, housecleaned" once a year.[88] Ossorio wrote to Dubuffet in late May: "The collection becomes more interesting and moving the more I see of it. Going through in the way I have these past weeks has made me realize more than ever how unique, & of what quality & inventiveness, the collection is."[89]

Although he never saw the work installed there (he departed New York in early April), Dubuffet did visit the Creeks, most likely in January or early February 1952, before Ossorio left for Paris.[90] It would have been on this visit to the Hamptons that Ossorio attempted to bring Dubuffet and Pollock together. A dinner at the Pollocks' in East Hampton was arranged, but when Ossorio and the Dubuffets arrived, the host was nowhere in evidence, making for a very strained evening. Ossorio later observed that the two artists "looked at each other's work with extreme attention and understanding," but the relationship never developed further.[91]

In Paris, Ossorio set about arranging a show of Pollock's work at the Studio Paul Facchetti. Titled *Jackson Pollock, 1948–1952,* the exhibition was held March 7–31. Buoyed by reports of early sales, Pollock wrote to Ossorio, "We liked the [Studio Paul Facchetti] catalogue as everyone did who saw it. I haven't had a decent translation of Tapié's forward [*sic*]—even Dubuffet couldn't do to [*sic*] well—he returned the damaged painting to the alley."[92] Hopes for a financial success (five of fifteen paintings were sold) dwindled as charges for shipping, catalogue production, and so on mounted.[93] Yet Pollock was eagerly anticipating the upcoming exhibition in New York: "The Museum of Modern Art show opens next week (I'll send the catalogues out as soon as they are ready)."[94]

Much of Dubuffet's production from the stay in New York was shown at the Pierre Matisse Gallery exhibition *Landscaped Tables, Landscapes of the Mind, Stones of Philosophy,* held February 12 to March 1. The painter's reputation in the United States grew during the 1950s, culminating in a major retrospective in 1961 at the Museum of Modern Art, New York, curated by Peter Selz, that traveled to the Art Institute of Chicago and the Los Angeles County Museum of Art. A portion of the Art Brut collection was shown at the same time in New York at the Cordier & Warren Gallery. A *New York Times* review of the Museum of Modern Art exhibition recognized Dubuffet as the most important French artist since World War II: "His challenge internationally is the New York School, and the challenge has grown stronger as the New York School (Rothko, Kline, de Kooning) give evidence of having reached an esthetic stalemate. . . . The exhibition at Cordier & Warren would be enlightening to anyone puzzled by why Dubuffet works as he does."[95]

By the spring of 1952, Ossorio was moving into the Creeks, and by early summer the walls were hung with Pollock, Dubuffet, Still, Fautrier, Wols, Krasner, and de Kooning, besides his own work and the Art Brut collection. Six large rooms on the upper floor were also dedicated to the display of Art Brut. A system of molding strips was devised to accommodate the many fragile objects (see fig. 3). Ossorio saw to it that every piece was put on display. Among the visitors Ossorio noted in a letter to Dubuffet were Marcel

20. The Creeks with (left to right) Dubuffet's *Grande dormeuse (Corps de dame couché),* 1950; Pollock's *Number 10, 1951;* and Ossorio's *Nevertheless,* 1959. Photograph by William Grigsby for *Art in America,* 1967.

Duchamp, Mrs. Alexina Matisse, Alfred Barr Jr., James Thrall Soby, Karel Appel, Sidney Janis, Michel Tapié, Jean Planque, and Martha Jackson.[96] He later wistfully recalled, "Jackson wasn't interested . . . He didn't feel it was serious. I don't remember Jackson showing any great enthusiasm for Art Brut. [Clyfford] Still couldn't have cared less. Practically none cared. Perhaps, Barnett Newman . . . who had a wider range of intellectual interests."[97] At the end of 1953, Ossorio wrote to Dubuffet:

> I must confess that among the dozens of interested and curious there were few that I felt were really moved by it or who understood its value and meaning. . . . Among the artists—I speak of the "avant-garde"—there were several whom it reduced to a state of fury, a condition in which they remained and which manifests itself by talking against the "Art Brut" on every conceivable occasion and denying any connection between their liberated and intelligent work and the products of the diseased unfortunates & ignorant hoi polloi in the collection. By a strange coincidence those whose work most closely resembles some aspects of the "Art Brut"—in a superficial way in some cases and in a very discernable [*sic*] and deeply-rooted manner in others—are those whom it irritates most.[98]

Dubuffet's days as an "esthetic terrorist"[99] were waning. International exhibitions of his work would place him in the ranks of the Old Masters. It would take the flat surfaces and hard-edged shapes of Ossorio's large-scale canvases of 1953–54 to elicit the term *Abstract Expressionist* from art-world nabobs, and even then it didn't really suit the work. In late 1953 Ossorio wrote to Dubuffet, "There is little news of the art world that I can give you. One thing that is happening is a violent reaction against 'abstract painting'—the good and the bad lumped together and condemned for the wrong reasons. . . . Jackson Pollock is still here in Springs but I see little of him."[100]

Between 1948 and 1952, the lives and work of Jackson Pollock, Alfonso Ossorio, and Jean Dubuffet converged briefly. None of the three found, in Dubuffet's words, "assembling colors in pleasing arrangements very noble."[101] The gallantry and morality of their shared endeavor was instead in their recognition of humanity's striving and the necessity of truthfulness. At the end of the 1950s, Ossorio hung three paintings in a stairwell at the Creeks—one by Dubuffet, one by Pollock, one of his own—and on an adjacent landing placed an elaborately carved shoeshine kit bought directly from a Turkish peddler (fig. 20). For Ossorio, the works of Pollock and Dubuffet, as well as his own, possessed a sensibility akin to that of the nameless shoeshiner's creation. The paintings, like the kit, "reawaken in us the sense of personal struggle and its collective roots."[102]

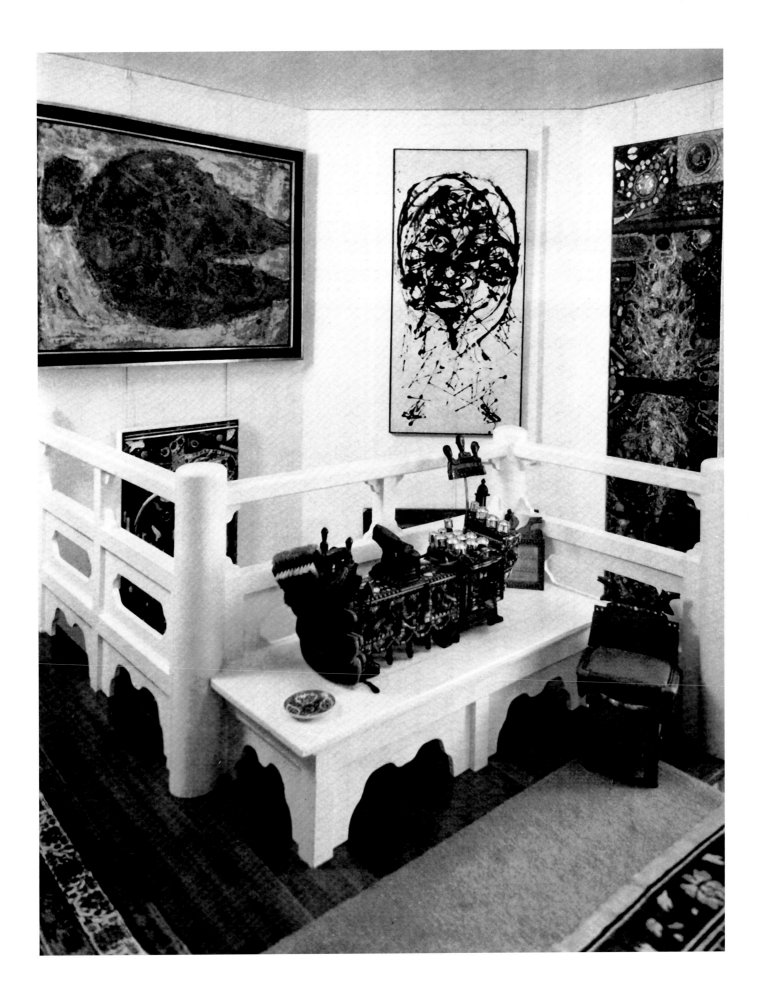

Notes

Epigraph: Letter to the editor of *Crawdaddy*, as quoted in Luc Sante, "The Mother Courage of Rock," *New York Review of Books* 59, no. 2 (February 9, 2012): 16.

1. By mid-February 1952, Ossorio had left New York for Paris; Dubuffet stayed on in New York until April. Pollock never ventured outside the United States.

2. Alfonso Ossorio, interview, November 19, 1968, Archives of American Art, Smithsonian Institution, Washington, D.C.

3. Ibid.

4. A leading figure in the English Arts and Crafts movement, Gill (1882–1940) is today perhaps best remembered for his contributions to typography, including the typefaces Gill Sans and Perpetua.

5. *Number 5, 1948,* oil, enamel, and aluminum paint on fiberboard, 96 x 48 in. (244 x 122 cm), purchased from Pollock's second show at the Betty Parsons Gallery, January 24–February 13, 1949.

6. Jeffrey Potter, *To a Violent Grave: An Oral Biography of Jackson Pollock* (New York: G. P. Putnam's Sons, 1980), p. 111.

7. Ossorio eloped to Taos with Bridget Hubrecht in the spring of 1940. They separated in 1942. B. H. Friedman, *Alfonso Ossorio* (New York: Harry N. Abrams, 1973), p. 21.

8. Parsons opened the Wakefield Gallery in New York City, in the basement of the Wakefield bookstore, in 1940.

9. As quoted in Ellen Landau, "Making the Unknown Knowable: Alfonso Ossorio in the 1940s," in *Reflection and Redemption: The Surrealist Art of Alfonso Ossorio, 1939–1949* (New York: Michael Rosenfeld Gallery, 1997), p. 4.

10. Emily Genauer, *New York World-Telegram,* 1945, quoted in Friedman, *Alfonso Ossorio,* p. 26.

11. Judith Wolfe, interview, in *Alfonso Ossorio, 1940–1980* (East Hampton, N.Y.: Guild Hall Museum, 1980), p. 15.

12. Ibid., p. 20.

13. Ibid., p. 15.

14. Ossorio rented the Helmuth House on Jericho Road in Georgica, a section of East Hampton bordering the eastern edge of Georgica Pond. The house was later purchased by Leo Castelli, whose summer guests included Willem and Elaine de Kooning, and his mother-in-law and her companion, the artist John Graham. The house was later owned by the noted Pollock collector Ben Heller.

15. Potter, *To a Violent Grave,* p. 121.

16. Typescript memoir re: Jackson Pollock, probably by Alfonso Ossorio, n.d., p. 3., Papers of Alfonso Ossorio and Edward Dragon Young (SC 15), file 251, Harvard Art Museums Archives, Harvard University, Cambridge, MA. By all accounts, Ossorio was readily welcomed into the East End art colony. He was included in a July exhibition at Guild Hall in East Hampton, *17 Eastern Long Island,* that also featured Alexander Brook, James Brooks, Balcomb Greene, Lee Krasner, John Little, Ibram Lassaw, Julian Levy, Lucia, Jackson Pollock, Ray Prohaska, Raphael and Moses Soyer, Nat Werner, and Wilfrid Zogbaum. See Enez Whipple, *Guild Hall of East Hampton: An Adventure in the Arts* (East Hampton, N.Y.: Guild Hall Museum, 1993), p. 36

17. Ibid.

18. The exhibitions were held concurrently: Art of This Century, January 14–February 1, 1946; Pierre Matisse Gallery, January 7–February 1, 1946.

19. Greenberg's 1944 review in the *Nation* of Pollock's second solo exhibition at Art of This Century.

20. The Accabonac Creek series included works painted before summer 1946 in an upstairs bedroom in the Springs farmhouse; Sounds in the Grass was a series completed in the recently converted barn/studio. Kirk Varnedoe with Pepe Karmel, *Jackson Pollock* (New York: Museum of Modern Art, 1998), p. 322.

21. In a meticulous reading of Hans Namuth's photographs documenting *Autumn Rhythm* as a work-in-progress, Pepe Karmel discovered what can be read only as figurative elements in the photographs of the initial stages of the painting's composition. Yet he is reluctant to draw conclusions about the "veiling" of the figure or to speculate as to Pollock's reasons for doing it. "It might be more accurate to say that the figures are inserted to give form and rhythm to an abstract web that might otherwise tend toward monotony and homogeneity." He suggests that the overall web may have been Pollock's way of camouflaging his imagery "to avoid even inadvertent self-revelation." Pepe Karmel, "Pollock at Work: The Films and Photographs of Hans Namuth," in Varnedoe and Karmel, *Jackson Pollock,* pp. 124, 129.

22. Wolfe, interview, p. 15.

23. Ibid.

24. *Life,* August 8, 1949.

25. *Life,* December 20, 1948, p. 22. According to Ossorio, Pollock tacked a Dubuffet reproduction from this article on the "wall of his john." Typescript memoir re: Jackson Pollock, probably by Alfonso Ossorio, n.d., p. 3. Papers of Alfonso Ossorio and Edward Dragon Young (SC 15), file 251. Harvard Art Museums Archives, Harvard University, Cambridge, MA.

26. Friedman, *Alfonso Ossorio,* p. 34.

27. Although this was not exclusively art of the insane, fully half of the works in the collection were made by institutionalized patients. Margit Rowell, *Jean Dubuffet: A Retrospective* (New York: Solomon R. Guggenheim Foundation, 1973), p. 20.

28. Alfonso Ossorio, "Interview: Alfonso Ossorio Talks with Paul Cummings," *Drawing,* 7, no. 5 (January–February 1986): 108.

29. Yve-Alain Bois and Rosalind E. Krauss, *Formless: A User's Guide* (Cambridge, Mass.: MIT Press, 1996), p. 140.

30. Typescript memoir re: Jackson Pollock, probably by Alfonso Ossorio, n.d., p. 3. Papers of Alfonso Ossorio and Edward Dragon Young (SC 15), file 251. Harvard Art Museums Archives, Harvard University, Cambridge, MA.

31. Gerald Silk, "Oral History Interview with Betty Parsons," interview on tape, June 11, 1981, Archives of American Art.

32. Barnett Newman, in *Northwest Coast Indian Painting* (New York: Betty Parsons Gallery, 1946).

33. As quoted in Steven Naifeh and Gregory Smith, *Jackson Pollock: An American Saga* (New York: Clarkson N. Potter, 1989), p. 599. McBride was reviewing a Pollock painting, *Number 14, 1949,* in the concurrent Whitney Annual, December 16, 1949–February 5, 1950.

34. The use of a traditional mural medium was not advised in the tropical climate. Ethyl silicate was selected as the most expedient binder for the dry pigments but required rapid completion before drying out.

35. Alfonso Ossorio, interview, Archives of American Art.

36. Ibid.

37. Wolfe, interview, p. 20.

38. Ossorio recalled an influential *Cahiers d'art* piece on the Surrealist Victor Brauner's wax-resist technique combined with the use of watercolor that spurred him to freer drawings. Ossorio, "Interview," p. 107.

39. Jean Dubuffet, "The Initiatory Paintings of Alfonso Ossorio," p. 116 in this volume.

40. Notebook of Alfonso Ossorio, p. 87. Papers of Alfonso Ossorio and Edward Dragon Young (SC 15), file 266. Harvard Art Museums Archives, Harvard University, Cambridge, MA.

41. Francis O'Connor, "Alfonso Ossorio's Expressionist Paintings on Paper," in *Alfonso Ossorio: The Child Returns* (New York: Michael Rosenfeld Gallery, 1999), p. 6.

42. See Dubuffet, "Initiatory Paintings," in this volume.

43. Ibid.

44. Ossorio, "Interview," p. 108.

45. As quoted in Friedman, *Alfonso Ossorio,* p. 41.

46. Ibid.

47. Dubuffet to Ossorio, Ossorio Foundation Archives, 2000. Translated by the author.

48. As quoted in Friedman, *Alfonso Ossorio,* p. 42.

49. Barnett Newman, "Jackson Pollock: An Artists' Symposium," in *Such Desperate Joy: Imagining Jackson Pollock,* ed. Helen A. Harrison (New York: Thunder's Mouth Press/Nation Books, 2000), p. 138.

50. Berton Roueché, "Unframed Space," *New Yorker,* August 5, 1950, p. 16.

51. Ibid.

52. Wolfe, interview, p. 20.

53. Alfonso Ossorio, address at Yale University, reprinted in *New Harvest,* March/April 1979, Courtesy Ossorio Foundation, Southampton, N.Y.

54. Also present were the architect Peter Blake, with whom Pollock had worked on a model for the "ideal museum," artists Wilfrid Zogbaum and John Little and their wives, and Jeffrey Potter.

55. Namuth had set up a large sheet of glass on blocks, parallel to the ground; he crawled underneath with his camera and filmed Pollock from below as he created a drip painting.

56. Potter, *To a Violent Grave,* p. 131.

57. Typescript memoir re: Jackson Pollock, probably by Alfonso Ossorio, n.d., p. 3. Papers of Alfonso Ossorio and Edward Dragon Young (SC 15), file 251. Harvard Art Museums Archives, Harvard University, Cambridge, MA.

58. The exhibition, Pollock's eighth one-man show in as many years, was held from November 29–December 16, 1950.

59. Potter, *To a Violent Grave,* p. 134.

60. Naifeh and Smith, *Jackson Pollock,* p. 667.

61. Ossorio, interview, Archives of American Art.

62. Wolfe, interview, p. 15.

63. Friedman, *Alfonso Ossorio,* p. 72.

64. John Russell, "The Many Aspects of Jean Dubuffet," *New York Times,* May 26, 1985, http://www.nytimes.com/1985/05/26/arts/art-view-the-many-aspects-of-jean-dubuffet.html.

65. Jean Dubuffet, *Landscaped Tables, Landscapes of the Mind, Stones of Philosophy* (New York: Pierre Matisse Gallery, 1952), n.p. The introductory essay for the catalogue was written in French and translated into English with the help of Marcel Duchamp before publication. Peter Selz, *The Work of Jean Dubuffet* (New York: Museum of Modern Art, 1962), p. 168, n. 28.

66. Dubuffet, see p. 115 in this volume.

67. Ibid., p. 117.

68. As quoted in Naifeh and Smith, *Jackson Pollock,* p. 658.

69. On January 21, 1951, Ossorio wrote: "Dear Jackson, In my letter to Lee I enclosed $200 to be applied towards the next painting of yrs. we acquire. We'd like to continue sending this amount on a monthly basis if this sort of arrangement is agreeable to you & Lee. We've no particular painting (or sculpture) in mind at the moment but I know that there'll [be] many we'll want in the future./Love to you both,/Alfonso." http://www.aaa.si.edu/collections/images/detail/alfonso-ossorio-letter-to-jackson-pollock-13810.

70. Naifeh and Smith, *Jackson Pollock,* p. 668.

71. Alfonso Ossorio, introduction to *Jackson Pollock* (New York: Betty Parsons Gallery, 1951).

72. Jackson Pollock to Alfonso Ossorio and Ted Dragon, June 7, 1951. Papers of Alfonso Ossorio and Edward Dragon Young (SC 15), file 702. Harvard Art Museums Archives, Harvard University, Cambridge, MA.

73. Ibid.

74. Albert Herter's father, Christian, and uncle Gustave had formed Herter Brothers, the most prominent Gilded Age interior design and furniture firm in New York and the source of the family's wealth.

75. Friedman, *Alfonso Ossorio,* p. 178.

76. Ossorio, interview, Archives of American Art.

77. Alfonso Ossorio, address at Yale University, reprinted in *New Harvest,* March/April 1979, Courtesy Ossorio Foundation, Southampton, N.Y.

78. Alfonso Ossorio to Jean Dubuffet, November 1953. Papers of Alfonso Ossorio and Edward Dragon Young (SC 15), file 611. Harvard Art Museums Archives, Harvard University, Cambridge, MA.

79. Friedman, *Alfonso Ossorio,* p. 53.

80. Ibid., p. 54.

81. Pollock's fifth solo show at Betty Parsons Gallery was held November 26–December 15. The exhibition featured sixteen oils and five watercolors, the Black Pourings, done with black paint on unprimed (raw) canvas.

82. Alfonso Ossorio, introduction to *Jackson Pollock* (New York: Betty Parsons Gallery, 1951), n.p.

83. Lucienne Peiry, *L'Art brut* (Paris: Flammarion, 2001), p. 105.

84. Eleven works from Culberg and fourteen from Dubuffet's New York dealer Pierre Matisse comprised the exhibition.

85. *Dubuffet and the Anticulture* (New York: Richard L. Feigen, 1969), p. 6. The "small group" included the painter Leon Golub.

86. Jean Dubuffet, "Anticultural Positions" (1951), in *Theories and Documents of Contemporary Art: A Sourcebook of Artists' Writings,* ed. Peter Selz and Kristine Stiles (Berkeley: University of California Press, 1996), p. 192.

87. The Pollocks had a bedroom at the Creeks reserved for their use on late nights.

88. Alfonso Ossorio in conversation with the author Susan Wilson, February 20, 1990, "From the Asylum to the Museum: Marginal Art in Paris and New York, 1938–1968," in *Parallel Visions: Modern Artists and Outsider Art,* ed. Maurice Tuchman and Carol S. Eliel (Princeton, N.J.: Princeton University Press, 1992), p. 141.

89. Alfonso Ossorio to Jean Dubuffet, May 29, 1952. Papers of Alfonso Ossorio and Edward Dragon Young (SC 15), file 611. Harvard Art Museums Archives, Harvard University, Cambridge, MA.

90. "Every day I am here I become more attached to the place," Ossorio later wrote. "It is too bad you only saw it under such gloomy circumstances." Ibid.

91. Potter, *To a Violent Grave,* p. 155.

92. Pollock and Krasner had the use of Macdougal Alley while Ossorio was in Paris. This is the only reference to Dubuffet and Pollock's meeting and having an exchange. Jackson Pollock to Alfonso Ossorio, March 30, 1952. Papers of Alfonso Ossorio and Edward Dragon Young (SC 15), file 702. Harvard Art Museums Archives, Harvard University, Cambridge, MA.

93. Naifeh and Smith, *Jackson Pollock,* p. 582.

94. Pollock to Ossorio, March 30, 1952.

The exhibition is *15 Americans,* April 9–July 27, 1952, curated by Dorothy Miller. The catalogue entry for Pollock is Ossorio's essay for Pollock's 1951 Betty Parsons Gallery exhibition. Other artists in the exhibition included William Baziotes, Edwin Dickinson, Joseph Glasco, Frederick Kiesler, Mark Rothko, Clyfford Still, and Bradley Walker Tomlin.

95. John Canaday, "Jean Dubuffet," *New York Times,* February 25, 1961.

96. Ossorio to Dubuffet, May 29, 1952. Alexina Matisse, known as Teeny, was divorced from the dealer Pierre Matisse and would soon marry Duchamp.

97. Tuchman and Eliel, *Parallel Visions,* p. 139.

98. Ossorio to Dubuffet, November 1953.

99. John Russell, "The Many Aspects of Jean Dubuffet," *New York Times,* May 26, 1985.

100. Ossorio to Dubuffet, November 1953.

101. Jean Dubuffet, "Anticultural Positions" (1951), in *Theories and Documents of Contemporary Art,* p. 192.

102. Ossorio, introduction to *Jackson Pollock.*

Plates

Jackson Pollock

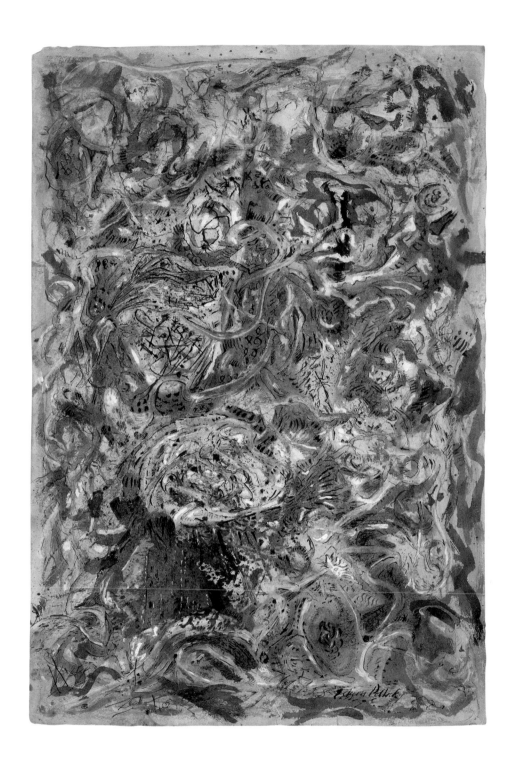

1 Jackson Pollock, **Pattern**

ca. 1945

Watercolor, ink, and gouache on paper

22½ × 15½ in. (57.2 × 39.4 cm)

Hirshhorn Museum and Sculpture Garden, Smithsonian Institution, Washington, D.C.

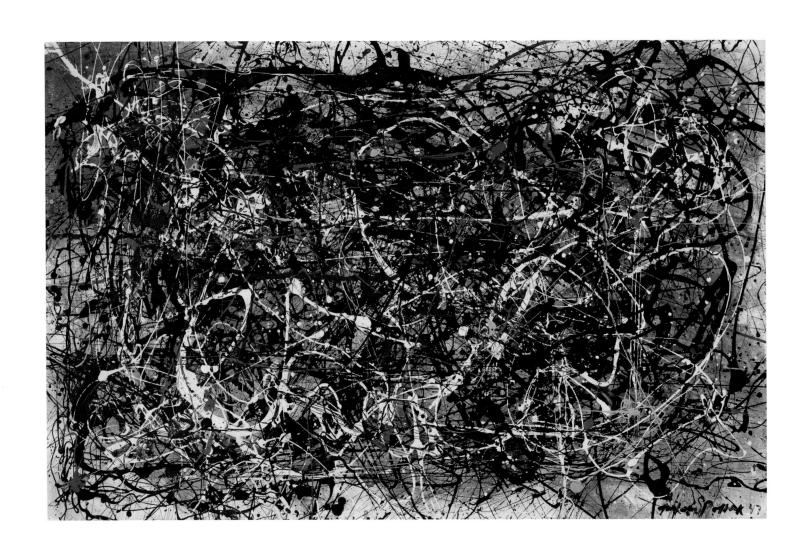

2 Jackson Pollock, **Untitled**

1947

Oil on primed Masonite

24 × 37¼ in. (61 × 94.3 cm)

Private collection

3 Jackson Pollock, **Number 22A, 1948**

1948

Enamel on gesso on paper mounted on panel

22½ × 30⅝ in. (57.2 × 77.8 cm)

The Museum of Fine Arts, Houston

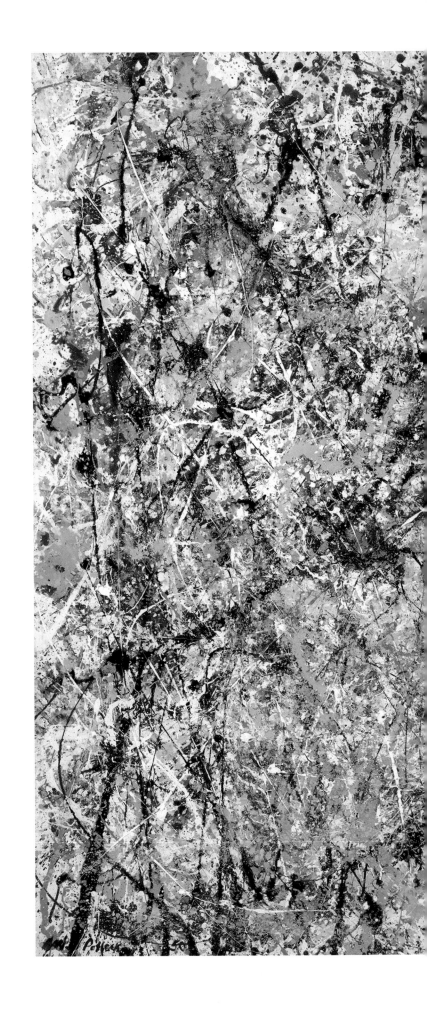

4 Jackson Pollock, **Number 1, 1950 (Lavender Mist)**

1950

Oil, enamel, and aluminum on canvas

7 ft. 3 in. × 9 ft. 10 in. (2.21 × 3 m)

National Gallery of Art, Washington, D.C.

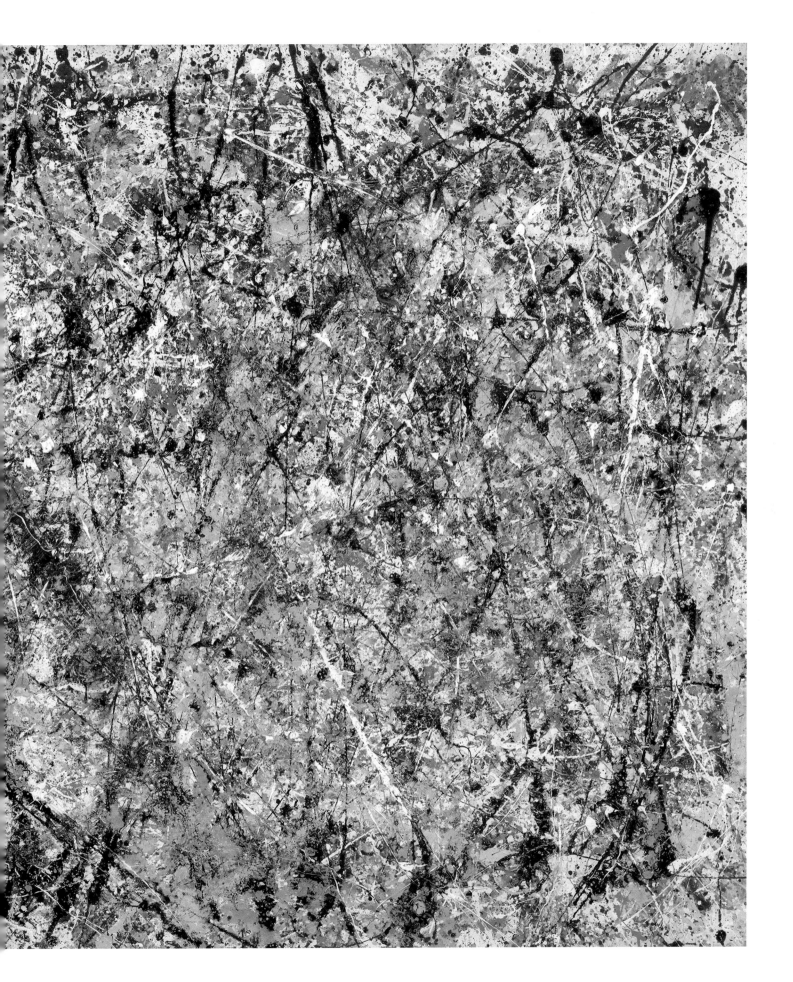

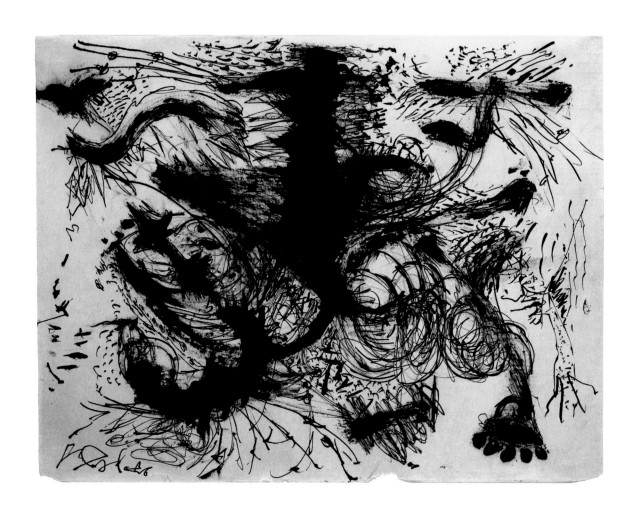

5 Jackson Pollock, **Untitled**

ca. 1948–49

Pen, brush and ink, and graphite pencil on paper

11 × 8⅜ in. (27.9 × 21.3 cm)

The Metropolitan Museum of Art, New York

6 Jackson Pollock, **The Arts Manual by Jackson Pollock**

1951

Ink and watercolor on Howell paper

17³/4 × 21½ in. (45.1 × 54.6 cm)

Collection of Ronnie and John E. Shore

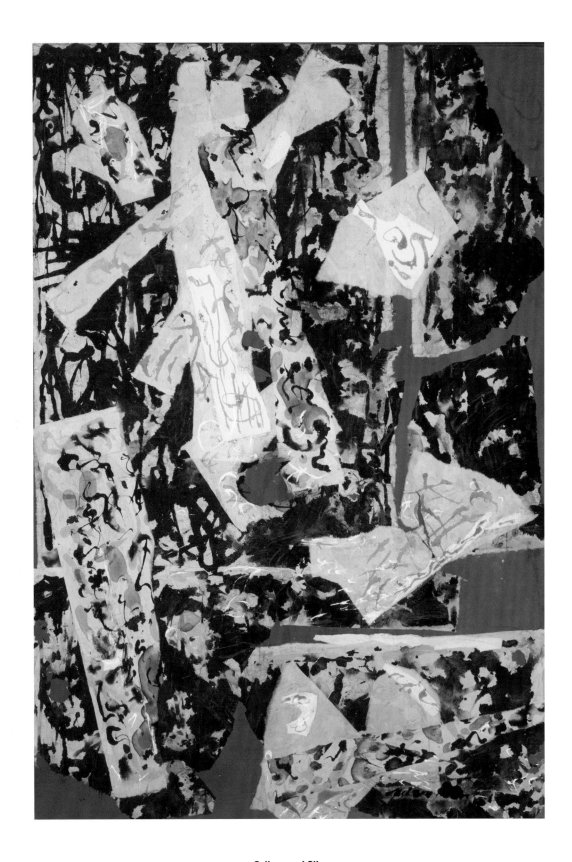

7 Jackson Pollock, **Collage and Oil**

ca. 1951

Oil, ink, gouache, and paper collage on canvas

50 × 35 in. (127 × 88.9 cm)

The Phillips Collection, Washington, D.C.

8 Jackson Pollock, **Number 2, 1951**

1951

Collage of paper soaked in glue, pebbles, twine, wire mesh, newsprint, and oil on board

41⅛ × 31⅛ in. (104.5 × 79.1 cm)

Hirshhorn Museum and Sculpture Garden, Smithsonian Institution, Washington, D.C.

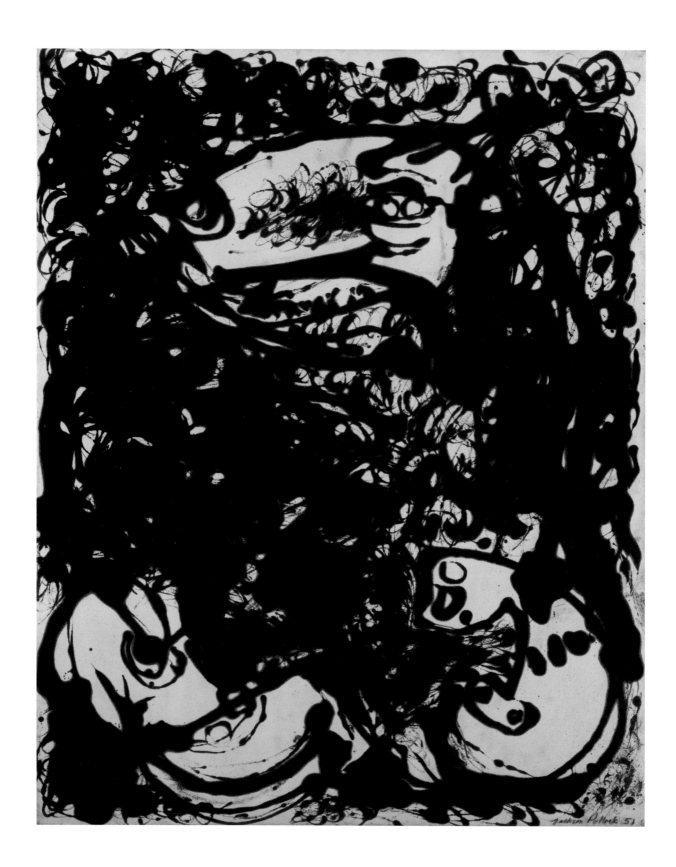

9 Jackson Pollock, **Number 23, 1951**

1951

Enamel on canvas

58½ × 47 in. (148.6 × 119.4 cm)

Chrysler Museum of Art, Norfolk, Virginia

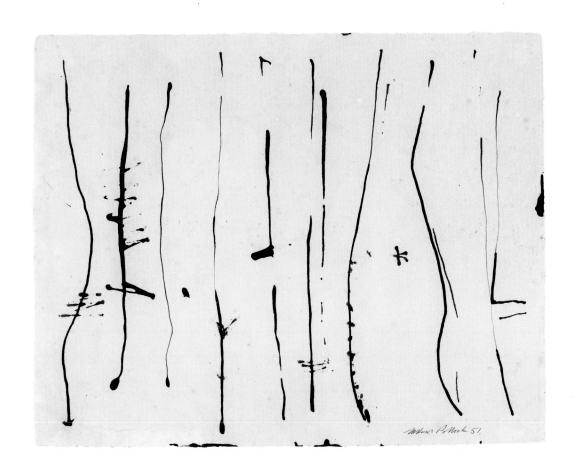

10 Jackson Pollock, **Untitled**

1951

Ink on Japanese paper

17½ × 22 in. (44.5 × 55.9 cm)

Parrish Art Museum, Water Mill, New York

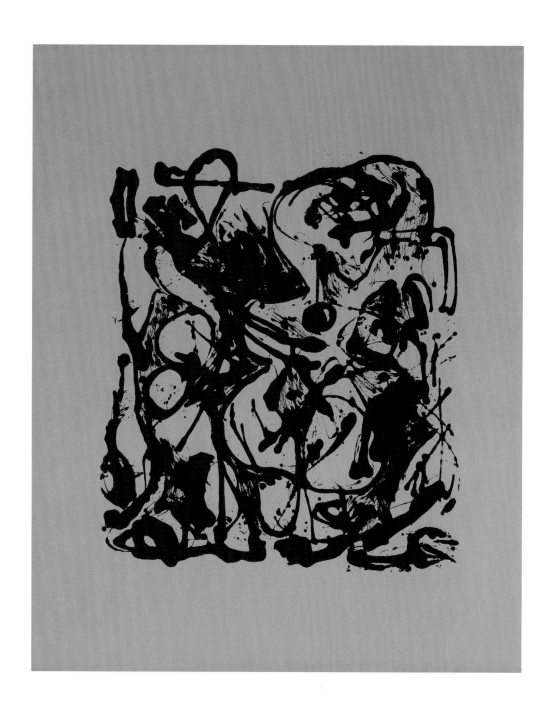

11 Jackson Pollock, **Untitled**

1951

Screen print on paper (unique trial proof)

28¾ × 23 in. (73 × 58.4 cm)

Private collection

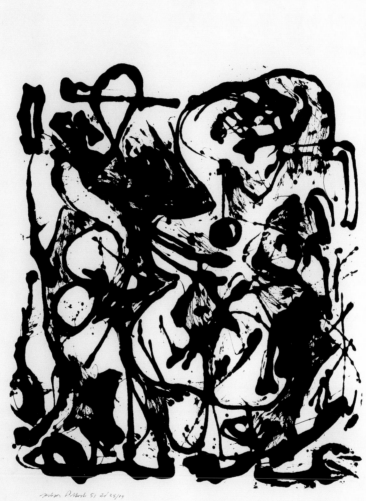

12 Jackson Pollock, **Untitled**

1951

Screen print on Strathmore paper

29 × 23 in. (73.7 × 58.4 cm)

Private collection

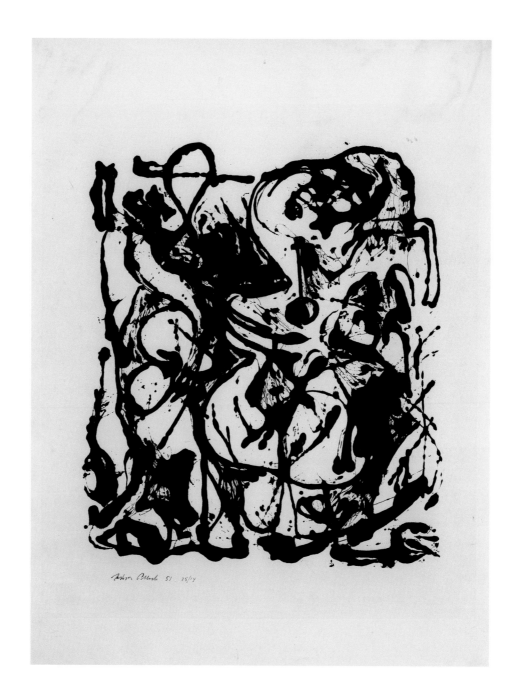

13 Jackson Pollock, **Untitled**

1951

Gouache, India ink, and graphite on paper

28½ × 21¼ in. (72.4 × 54 cm)

Private collection

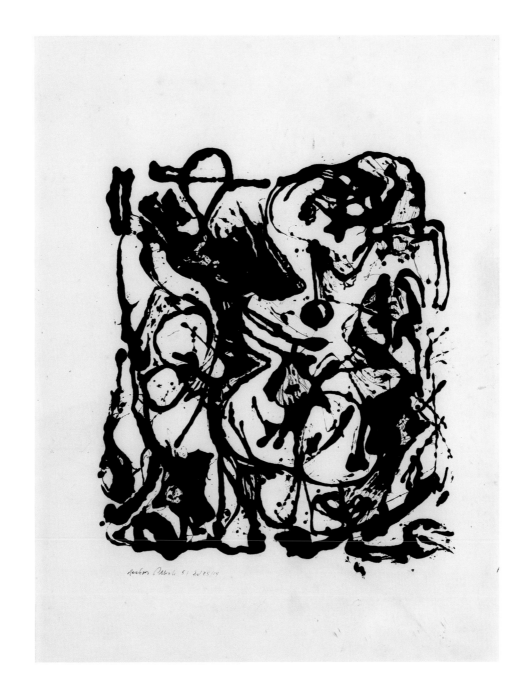

14 Jackson Pollock, **Untitled**

1951

Enamel, India ink, and graphite on paper

29 × 22 in. (73.7 × 55.9 cm)

Private collection

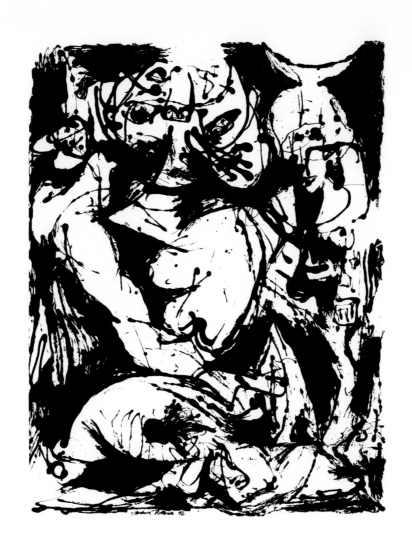

15A Jackson Pollock, **Untitled**

1951

Screen print on Strathmore paper

29 × 23 in. (73.7 × 58.4 cm)

Private collection

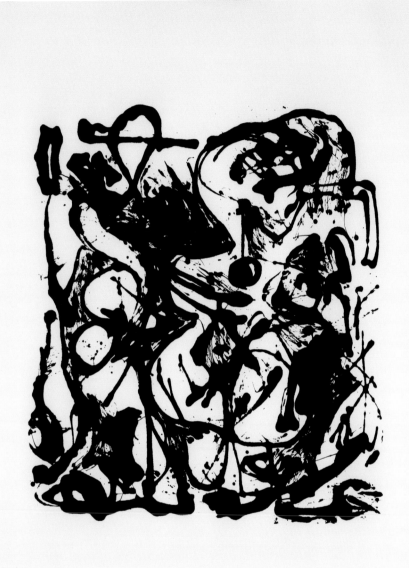

15B Jackson Pollock, **Untitled**

1951

Screen print on Strathmore paper

29 × 23 in. (73.7 × 58.4 cm)

Private collection

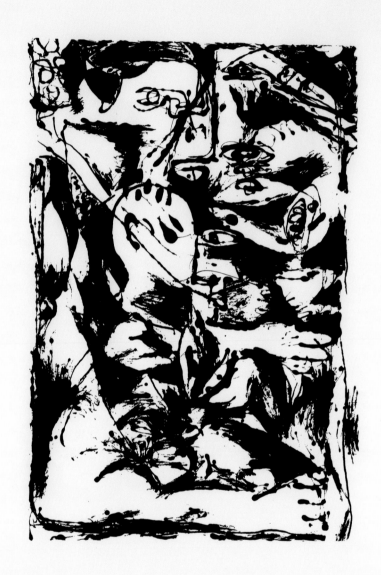

15C Jackson Pollock, **Untitled**

1951

Screen print on Strathmore paper

29 × 23 in. (73.7 × 58.4 cm)

Private collection

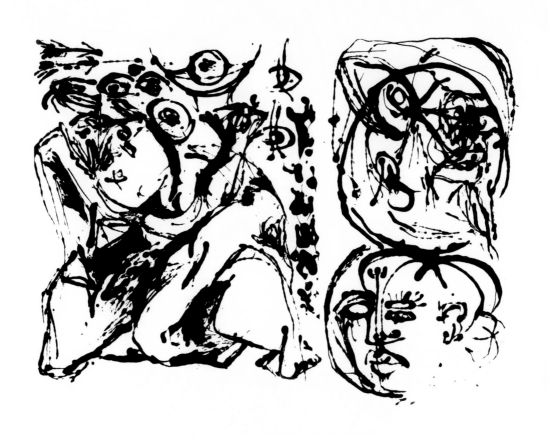

15D Jackson Pollock, **Untitled**

1951

Screen print on Strathmore paper

23 × 29 in. (58.4 × 73.7 cm)

Private collection

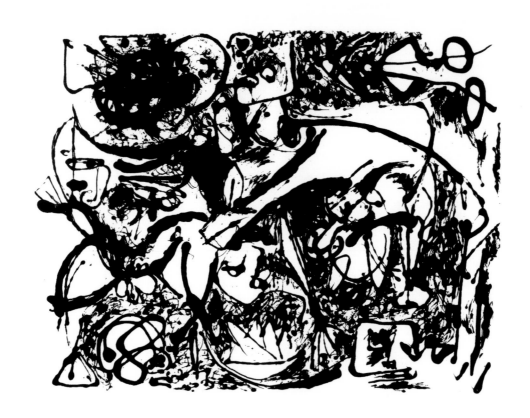

15E Jackson Pollock, **Untitled**

1951

Screen print on Strathmore paper

23 × 29 in. (58.4 × 73.7 cm)

Private collection

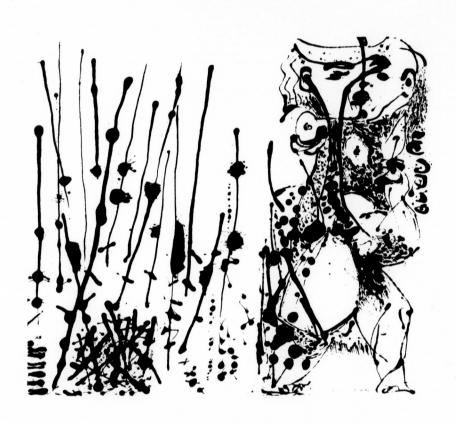

15F Jackson Pollock, **Untitled**

1951

Screen print on Strathmore paper

23 × 29 in. (58.4 × 73.7 cm)

Private collection

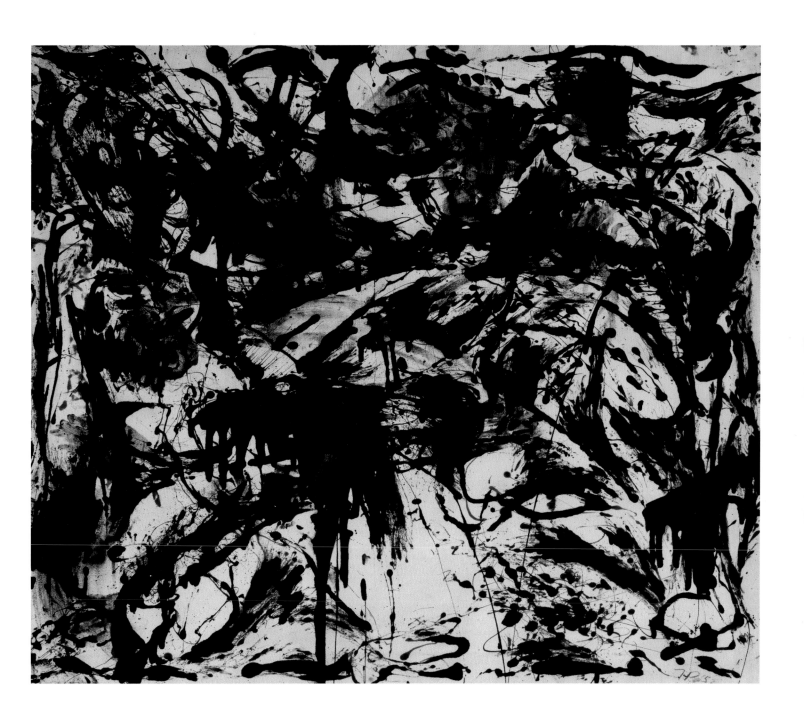

16 Jackson Pollock, **Number 3, 1952**

1952

Enamel on canvas

55⅞ × 66⅛ in. (141.9 × 168 cm)

Glenstone

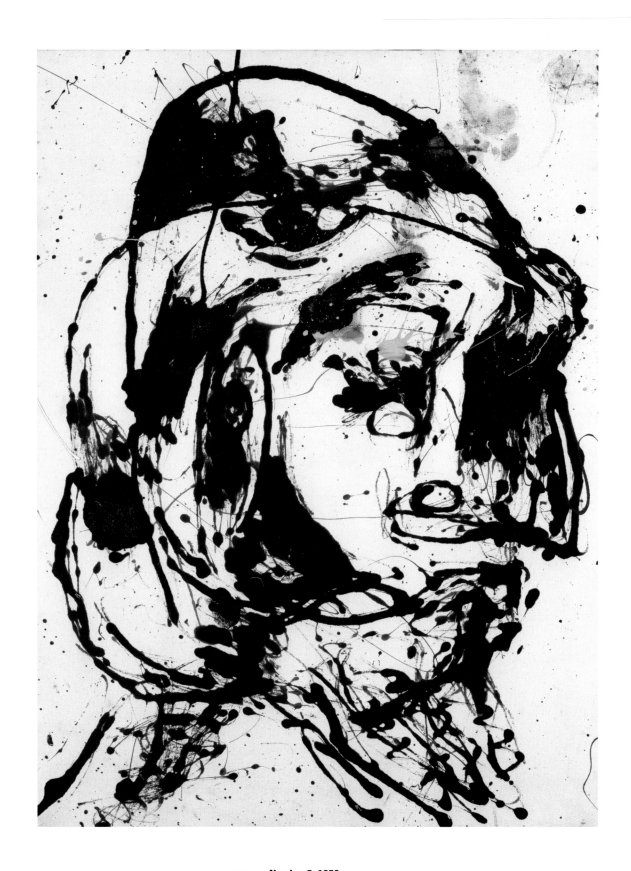

17 Jackson Pollock, **Number 7, 1952**

1952

Enamel and oil on canvas

53⅛ × 40 in. (134.9 × 101.6 cm)

The Metropolitan Museum of Art, New York

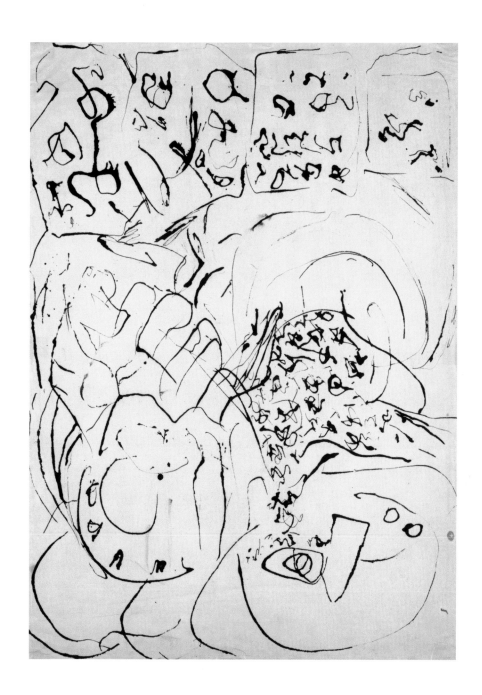

18 Jackson Pollock, **Untitled**

ca. 1952–56

Dripped ink on paper

28⅞ × 20⅞ in. (73.3 × 53 cm)

The Metropolitan Museum of Art, New York

Alfonso Ossorio

21 Alfonso Ossorio, **First Suckling (Sleeping Mother and Child)**

1950

Watercolor, gouache, ink, and wax on shaped paper mounted to canvas

22 × 30 in. (55.9 × 76.2 cm)

Courtesy Michael Rosenfeld Gallery LLC, New York

22 Alfonso Ossorio, **Five Brothers**

1950

Watercolor, ink, and wax on illustration board

18⅜ × 30¼ in. (46.7 × 76.8 cm)

The Phillips Collection, Washington, D.C.

24 Alfonso Ossorio, **Head of Christ**

1950

Ink and watercolor on torn paper

30 × 22 in. (76.2 × 55.9 cm)

Ossorio Foundation, Southampton, New York

25 Alfonso Ossorio, **The Helpful Angels**

1950

Watercolor, ink, wax, and graphite on torn paper

22½ × 30½ in. (57.2 × 77.5 cm)

Courtesy Michael Rosenfeld Gallery LLC, New York

26 Alfonso Ossorio, **Holy Mother (Mother Church No. 2)**

1950

Ink, wax, and watercolor on paper

30½ × 22½ in. (77.5 × 57.2 cm)

Courtesy Michael Rosenfeld Gallery LLC, New York

27 Alfonso Ossorio, **Untitled**

1950

Wax, watercolor, ink, and oil crayon with interior cutouts on paper

22 × 30 in. (55.9 × 76.2 cm)

Ossorio Foundation, Southampton, New York

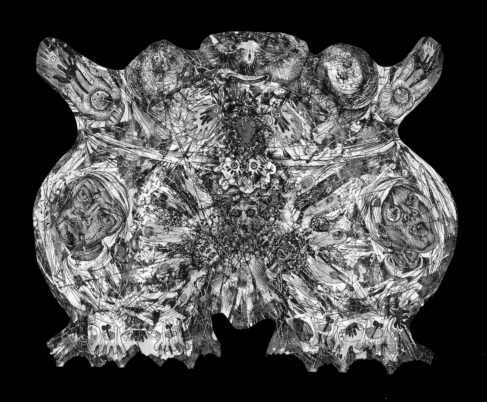

28 Alfonso Ossorio, **Untitled**

1950

Watercolor, ink, and wax on torn Tiffany & Co. stationery

9 × 11¼ in. (22.9 × 28.6 cm)

Courtesy Michael Rosenfeld Gallery LLC, New York

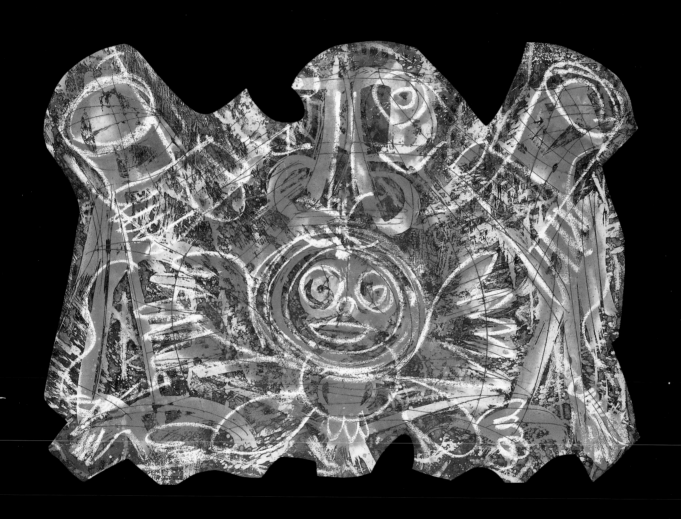

29 Alfonso Ossorio, **Maimed Mother and Child**

1950

Watercolor, ink, wax, and graphite on torn paper

21 × 30 in. (53.3 × 76.2 cm)

Collection of Henry H. and Carol Brown Goldberg

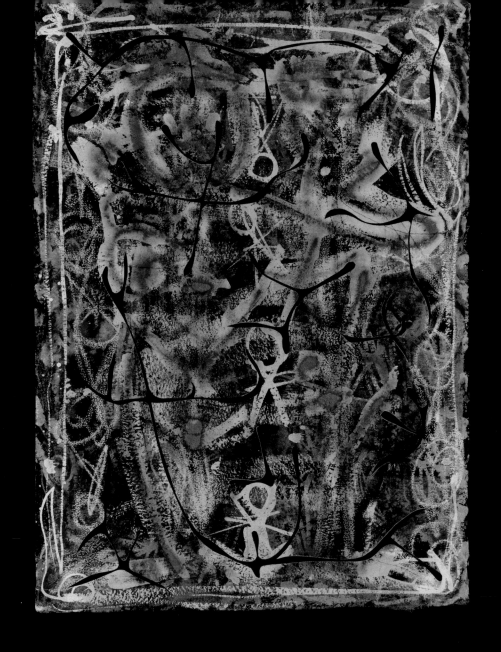

30 Alfonso Ossorio, **Couple and Progeny**

1951

Ink, wax, watercolor, and cut paper mounted on black paper

30 × 22 in. (76.2 × 55.9 cm)

Parrish Art Museum, Water Mill, New York

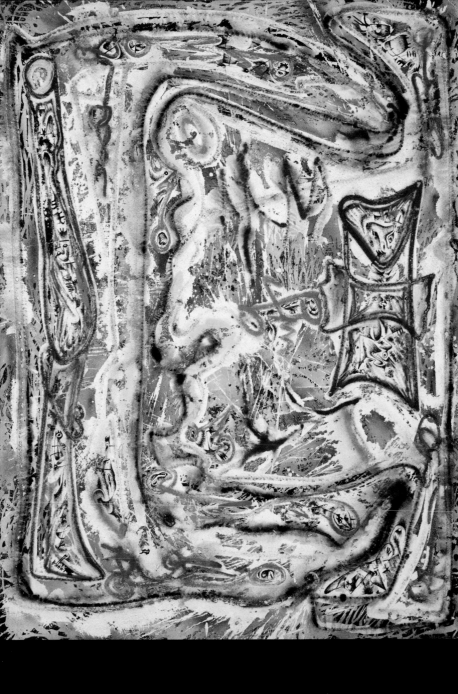

31 Alfonso Ossorio, **Family with Blue Children**

1951

Wax, gouache, ink, and watercolor on paper

30 × 22 in. (76.2 × 55.9 cm)

Collection of Louis and Sally Vanasse

32 Alfonso Ossorio, **Crucifix: Seek & Ye Shall Find**
1951
Oil and enamel on shaped canvas
38 × 51 × 2 in. (96.5 × 129.5 × 5.1 cm)
Courtesy Michael Rosenfeld Gallery LLC, New York

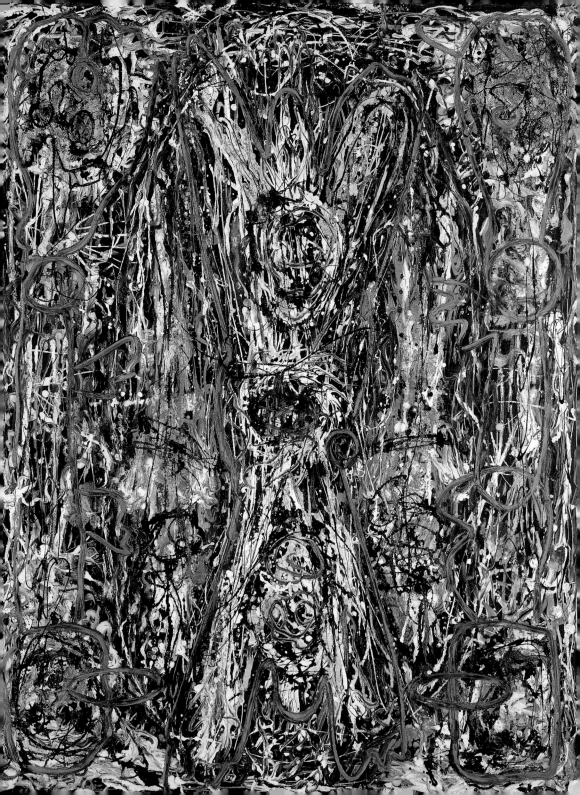

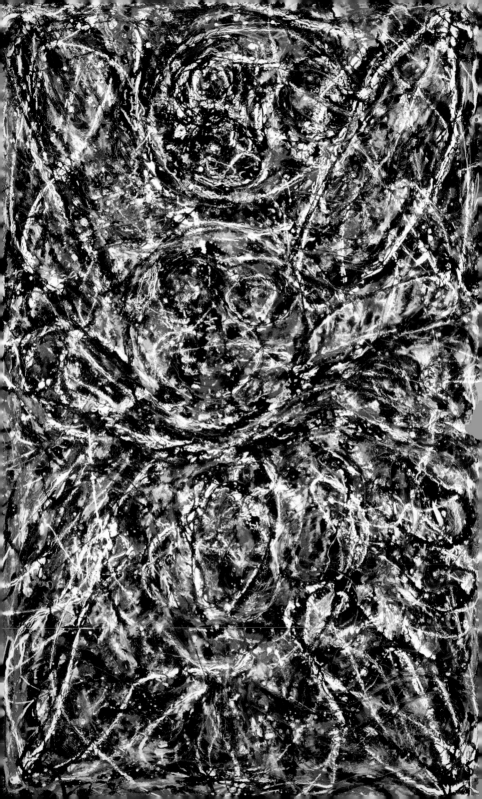

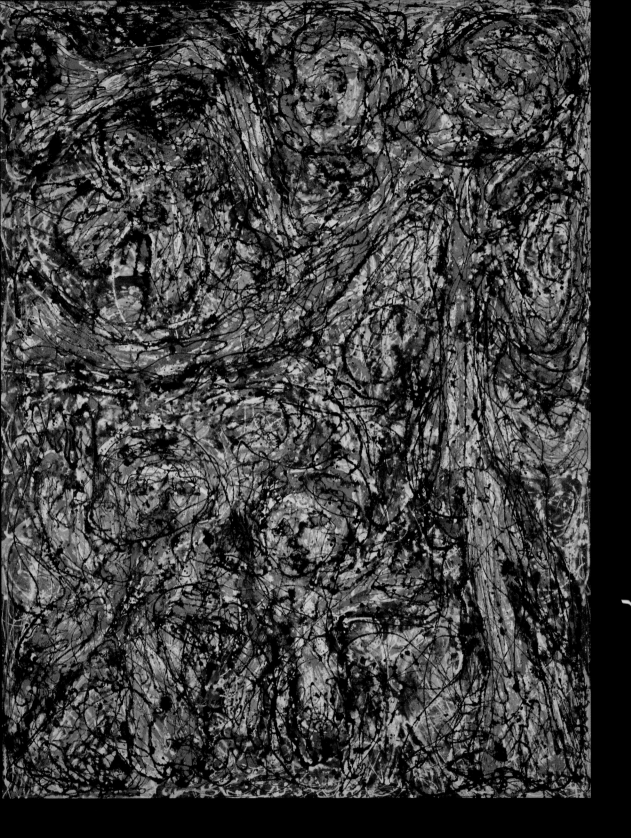

37 Alfonso Ossorio, **Red Family**

1951

Oil and enamel on canvas

77 × 59 in. (195.6 × 149.9 cm)

Dallas Museum of Art

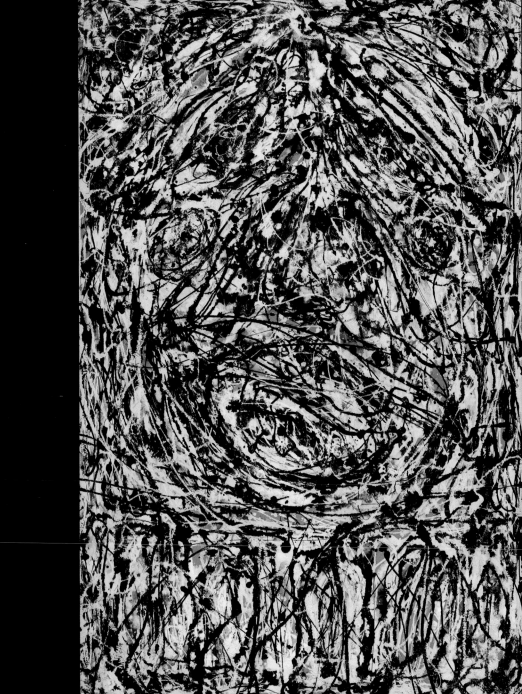

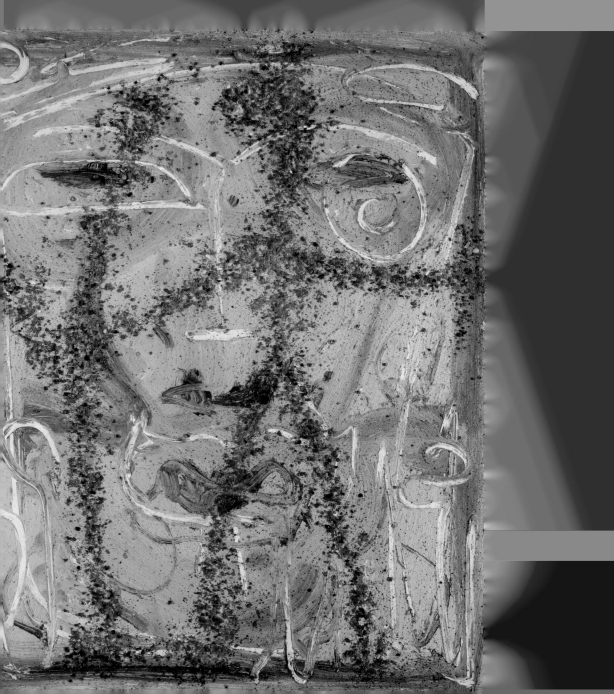

40 Alfonso Ossorio, **Reforming Figure**

1952

Ink, wax, and watercolor on paper

60 × 38 in. (152.4 × 96.5 cm)

The Phillips Collection, Washington, D.C.

Jean Dubuffet

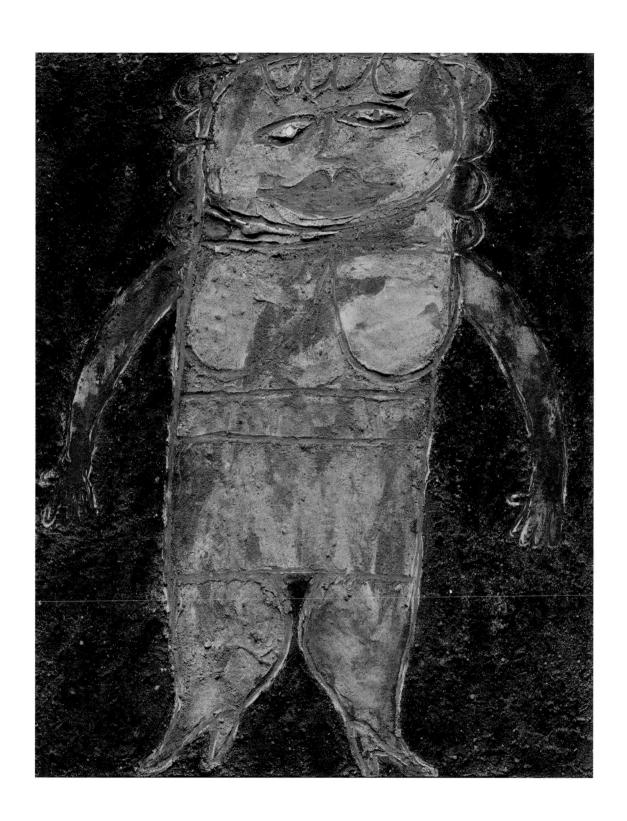

41 Jean Dubuffet, **Terracotta la grosse bouche (Big-mouth terra-cotta)**
1946
Oil, plaster, sand, pebbles, coal, and mirrored glass on canvas
39⅜ × 31⅞ in. (100 × 81 cm)
National Gallery of Art, Washington, D.C.

42 Jean Dubuffet, **Les Habitants de l'oasis (Oasis dwellers)**

1948

Ink on paper

14¾ × 21¼ in. (36.5 × 54 cm)

Collection of Louis and Sally Vanasse, Amherst, Massachusetts

43 Jean Dubuffet, **Paysage avec promeneur saluant le public (Landscape with walker greeting the public)**

1949

Oil on canvas

35 × 45¾ in. (88.9 × 116.1 cm)

Collection of Arne and Milly Glimcher

44 Jean Dubuffet, **Corps de dame (Body of a lady)**

1950

Ink on paper

10½ × 8¼ in. (26.7 × 21 cm)

Collection of Arne and Milly Glimcher

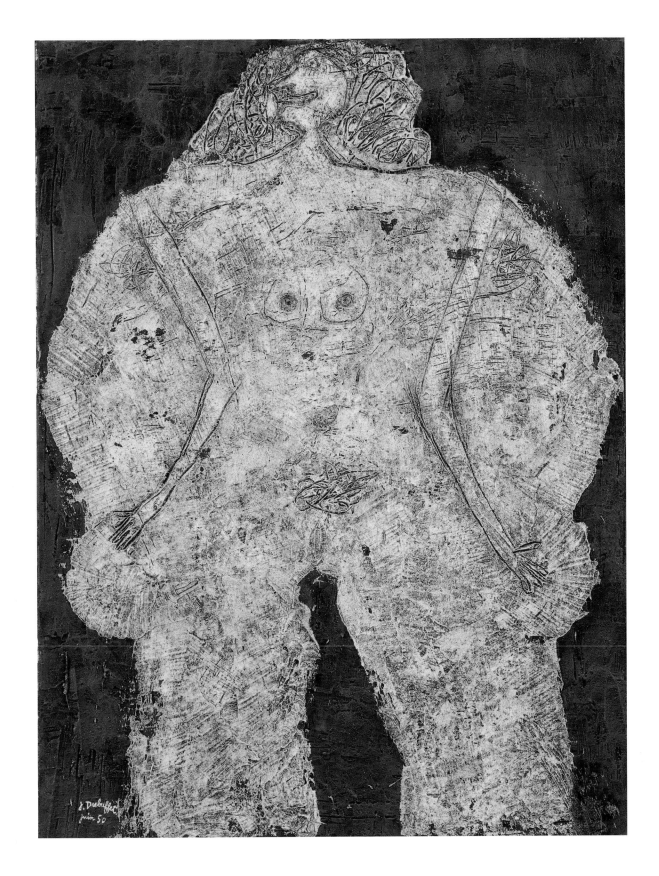

45 Jean Dubuffet, **Corps de dame — Château d'Etoupe (Body of a lady — Castle of oakum)**

1950

Oil on canvas

45¾ × 35⅛ in. (116.2 × 89.2 cm)

Allen Memorial Art Museum, Oberlin College, Oberlin, Ohio

46 Jean Dubuffet, **Corps de dame jaspé (Marbleized body of a lady)**

1950

Oil and sand on canvas

39¾ × 29 in. (101 × 73.7 cm)

National Gallery of Art, Washington, D.C.

47 Jean Dubuffet, **L'Homme au nez menu (Man with small nose)**

1950

Oil on board

31⅞ × 25⅝ in. (81 × 65.1 cm)

Courtesy Acquavella Modern Art, New York

48 Jean Dubuffet, **Concretions terreuses au soleil ardent (Earthly concretions with hot sun)**
1951
Oil on board
28¾ × 42⅞ in. (73 × 109 cm)
Courtesy Acquavella Modern Art. New York

49 Jean Dubuffet, **La Maison abandonée (The abandoned house)**

1952

Oil on board

31⅞ × 36¼ in. (81 × 92.1 cm)

Courtesy Acquavella Modern Art, New York

50　Jean Dubuffet, **Paysage métapsychique (Metapsychical landscape)**

1952

Oil on canvas

51⅛ × 63¾ in. (121.9 × 161.8 cm)

Des Moines Art Center

51 Jean Dubuffet, **Paysage au chien mort (Landscape with dead dog)**

1952

India ink on paper

19⅝ × 25¾ in. (49.8 × 65.4 cm)

Collection of Arne and Milly Glimcher

52 Jean Dubuffet, **Paysage au chien (Landscape with dog)**

1955

Oil on canvas

28¾ × 36¼ in. (73 × 92 cm)

Courtesy Acquavella Modern Art, New York

53 Jean Dubuffet, **Confiture matière lumière (Texturologie LIII)**
(Preserves of light and matter (Texturology LIII))
1958
Oil on canvas
38⅛ × 51¼ in. (96.8 × 130.2 cm)
National Gallery of Art, Washington, D.C.
The Stephen Hahn Family Collection

The Initiatory Paintings of Alfonso Ossorio (1951)

Jean Dubuffet

Painting can be a subtle machine for conveying philosophy—even, initially, for elaborating it. Faster than writing, painting can immediately transcribe the mind's movements, apprehended in *statu nascendi.* Represented at this stage, moreover, such movements may possess capacities that weaken when further elaborated within the field of consciousness. Mr. Ossorio is less interested in ideas than in the humors from which they proceed and which give them their *orient,* as is said of pearls.

Further, painting conveys things through its body; and its body is better than its name. Indeed, painting can even disembody things, at will; or can confer a body upon what has none. Out of a tree it can make an idea; out of an idea, a tree. Once such operations are performed, painting can manipulate these new bodies, move them from place to place, join them by all sorts of knots and grafts—can churn all that cream. Language reduces everything to names, turning everything into a one-dimensional plane. But painting has several levels; and where still another is required, produces it. Painting plays simultaneously on several registers.

The art of M. Alfonso Ossorio is multi-layered. Indeed I know no one else who makes painting a machine of so many movements—each of these being, furthermore, reversible. Hence his pictures are, at first sight, anything but clear. It is hard to discern, initially, what pursuits he is engaged in. This is because he is engaged in several, and constantly intermingles them. Or to put it better, he pursues his game on several spoors. I believe he is imbued with the uniform nature of all things, with the consistency of the world's appearances in every realm; and convinced that he will reach his goal whichever path he takes. That, for instance, by creating combinations of forms, he will discover combinations of ideas. That is, the realm of forms and the realm of ideas do not strike him as so different in nature as is generally supposed; his hands pass from one to the other at every moment.

Mr. Ossorio has devised a language for his own use (a language with unfamiliar and complex mechanisms). We cannot (it would be asking too much), without a little initial practice, speak this language so fluently as he does. But what do we ask? We feel—even at first glance, we immediately feel—that these paintings ask nothing of anyone. Theirs is actually the scent of solitary operations, performed for pleasure's sake, with no concern to involve others at all. Quite the contrary. They seem eager to be shielded from inspection, as if by an enveloping shell—like an egg; they want to be protected. Sometimes by even better protections than a shell: by a deceptive appearance—like those strange insects that assume the aspect of a leaf or a twig. Yes, I am convinced that Mr. Ossorio—I feel this deeply, and I know this feeling, I understand it—has a kind of double desire: to show his treasures and to hide them. To conceal access to them, at least, behind seven knots that must be undone, one after the next, like the castle gates of fairyland.

The notion that the realm of concrete forms is close to the realm of ideas must occur—in some form, I believe—to all painters. Our ideas result from the way we translate our inner pulsations—in parallel, according to another mode, by the form taken by our flesh, our bones, our teeth.... The most precious thing about our ideas is not their reasoned content but their movement, their gait—the gestures subsisting within them. The form a being takes is also its way of making a gesture. The language Mr. Ossorio has invented is an ample and learned language of gestures—imparted to thoughts, imparted to

objects—which he then works into all kinds of (remarkably ingenious) combinations. His art will doubtless produce an initial impression of ambiguity; some, surprised by its double functioning, decorative *and* metaphysical, will wonder which of these operations is primary. This is because Mr. Ossorio chooses not to separate the two orders, which for him are only one.

It might be said that Mr. Ossorio's labors are quite exempt from strictly artistic aims, since each technical means is employed exclusively for its power to translate spiritual concepts and movements; everything that goes into these works is intended to signify. We are witnessing the invention of a very rich language of signs. But it is true that Mr. Ossorio does not differentiate between a sign's power to speak and its value on the aesthetic level, since for him a sign is beautiful precisely insofar as it is expressive.

Mr. Ossorio is versed in theology, and deftly wields its complex algebra. But tinged with his own humor, the Christian dogmas assume a new and very particular style in his art. He likes to illuminate certain theological *principles* that the Christian world generally passes over in silence or leaves in shadow; specifically those, I believe, which are regarded as embarrassing and which, as he envisions them, afford religion an esoteric character not usually found in Catholic paintings.

In 1950, during an eight months' stay in the Philippines while he was completing the decoration of a church in Victorias, Mr. Ossorio began a vast series of works on paper of varying formats, in watercolor, crayon, and encaustic. It is these works that constitute the object of the present essay.

Mr. Ossorio subsequently continued this series, first of all during several weeks in New York, then in Paris, during the first months of 1951. The last twenty were executed, in my presence, so to speak, in May 1951, on one of those half-wild islands off Hyeres (where I am presently writing these lines), during the several days we spent there together. In all, about four hundred paintings—a considerable cycle, then, and completed in the very short period of sixteen months.

The size of the paintings is, for about half of them, that of an ordinary sheet of drawing paper, about nine by twelve inches. The rest are of various smaller dimensions. Some are inscribed within the habitual rectangle of the manufactured sheet, but many others, their edges oddly outlined by penknife or simply by tearing, are sometimes even incised so that areas cut out within the sheet have quite unexpected and contorted shapes.

Tormented, in any case—few paintings could be more so. Made, as I have said, with watercolors and melted wax (sometimes applied with a brush, sometimes with a sharpened candle end) in superimposed layers (usually three operations), frequently completed, after this, by final retouches—notably, in some instances, by a delicate design of pen and Chinese ink—these works certainly strike us initially by their frenetic aspect.

At first glance, they look like a multicolored chaos, a storm of violently applied blobs, spatters, and vehement lines, in which rather shapeless figures can sometimes be made out (not always right away). It also happens, in some, that this entire tumult is linked to, or has superimposed upon it, certain elements that are represented more clearly—sometimes even treated with very delicate precision. We then make out grimacing or screaming faces; hands with fingers forming strange signs; excrescences, digitations, umbilical depressions, viscera sprouting filthy tufts of hair; hideous sexual organs—all seething with varicosities,

leprosies, abscesses. A fracas of forms, sometimes vaguely anatomical, sometimes deriving from the vegetable kingdom or from some hybrid domain of sorcery—mandrakes, rats' nests—among which appear still other tiny grinning faces or grotesque little personages.

All these figures and various forms of beings are associated with symbolic signs, or else with ideal outlines representing incorporeal worlds of rhythms or numbers, from which they derive. And these outlines and signs, though having, apparently, a very different value from the objects and personages with which they mingle—though deriving, I mean, from a different mental level (the former representing concrete beings, the latter, actions performed in an immaterial realm)—are treated by the painter in the same fashion, with complete continuity, and as though on equal footing. From this comes the impression—the uneasiness—of no longer quite knowing what, in the picture, belongs to the realm of material things and what to the realm of mental phenomena; to the level of represented objects (or sites), or else to that of the painter's metaphysic. Certain elements belong simultaneously to both; and the fact that the artist has sought to endow them simultaneously with different functions—on the one hand, within the realm of things concretely evoked, and on the other, in the (so different) realm of the most incorporeal abstractions—produces the feeling of being on dangerous ground, where mirages and realities have precisely the same aspect, and where we no longer know, therefore, where to set foot. It seems as if the artist is determined to *give body* to conceptual notions—to the point of regarding them as entirely on the level of material objects—and, at the same time, to keep the real objects he wants to represent from being excessively incarnate.

A painter whose effort is to keep his figures from being incarnate! Here we are in realms grandly remote from the aims of classical European art. That art was certainly not philosophical: it firmly believed in the realm of bodies, quite independent of any other. It regarded itself as a sort of *ministry of bodies,* forbidden to intrude into any other realm.

In Ossorio's eyes, the embodiment of things seems fortuitous, as inessential as the fact, for example, that a gas may assume a liquid state. Each body seems to him a spirit occasionally passing into a field where human eyes can perceive it. As a matter of fact, for this painter there is no such thing as a body: he sees only spirits in the world, whence his need to represent, in his figurations, many more things than our eyes can commonly see. He is evidently convinced that we perceive only a very minor portion of what exists.

And what are the colors in these paintings? The range varies greatly from one to the next. First of all, it must be said that in most cases vehement colors predominate. The orchestra is chiefly rich in brasses, and plays fortissimo. But since these colors sing each as loudly as the next and explode within each other, they thereby manage to cancel each other out, constituting merely a theoretical ambiance. And then on top of that, certain explosions, or fulminations, of an exacerbated hue—sulfur yellow, for example—or else of some pale and diluted wash, belonging to a very alien register and deliberately at variance with the general harmony, break in with a strident cry, and keep the work from materializing too readily.

In general, any one picture utilizes only a few colors; so few, frequently, that we receive an impression of the conventional, the artificial (it is evident that the painter has intended this impression); but the selection changes with each picture, and in the entire

series, the number of colors employed is considerable. It seems as if Mr. Ossorio wants all the colors of the universe to contribute to his polyphony, notably certain specious ones that belong for the most part to the universe of hallucinations: colors of Middle Eastern sweets, of Bengal lights, of sunsets; colors of butterflies, of exotic birds, of gaudy plumage. Such theatrical colors, appearing (even in small doses) in other works, would impart an unbearable aspect of *qualis artifex,* of Nero's emerald monocle. In these pictures of Ossorio's, allied with the spirit of profound gravity that pervades them, they achieve a violent effect of transposition, of alienation, plunging the paintings into a kind of metaphysical bath. They seem to have been taken for colors of another world, as little physical as possible. They want to be chemical and cerebral—colors of hermetically sealed laboratories.

The effect produced—of rapture within a ritual of symbols—is augmented by the use of encaustic, which gives the paper the slippery aspect of precious parchment, and imparts the waxy tint of Spanish leather to all the colors.

The compositional structure of these images aggressively flouts humanist tastes and classical geometries. The world they create has multiple centers of expansion, or no centers whatsoever. All sorts of rhythms appear at quite unforeseen points, circling, drifting, reengendering. . . . They overlap and oppose each other, and from their conflicts are born certain systems whose bizarre structures are quite disconcerting. We are reminded, in certain cases, of compositions in the form of an explosion—eddying waters, wild hair, melting lava. . . . Here everything seethes, or threatens to; Ossorio loves whatever moves, heaves, surges. And he loves to punctuate this vehemence with whiplash signs, sudden falls, lightning flashes, flights of birds. . . . In other words, he does not care to move too far from the shapeless, the *informe*—he wants to keep his footing there as well.

As I have said, Ossorio uses wax and operates in successive phases. The areas covered by the wax are preserved against the next layer. Hence he has the choice of making designs directly with the paintbrush or proceeding toward what in engraving is called *resists.* Sometimes his images are formed by the first means, sometimes by the second, but often by both, overlapping. Then the figure is doubled, formed by two drawings on top of each other but not exactly superimposed. One is perceived as light against a void (negative), the other as a darker design over it (positive).

This procedure appears, for instance, in the small composition entitled *Red and Yellow Figure,* which I select quite at random. The background here is black (perhaps vaguely tending toward snuff color) streaked with orange and yellow. Against it is silhouetted a (dancing) figure, initially indicated by broad yellow *resists* of the same bright egg-yolk color that speckles the background, so that this crude figure is somehow linked to the surrounding area by two different means: first, it has the same color (egg-yolk yellow) that is diffused throughout the composition; then it overflows its own design in splashes of this same yellow.

But this is not all. These crude yellow patches that articulate the figure are not filled in but actually *emptied out;* the orange-speckled black background surrounding the figure reappears here and there inside it, affording it a ghostly aspect. On top of it appears a second network of lines, some a pale chemical green, others a brilliant poppy red, superimposed on the preceding material and apparently serving both to define the figure and to obscure it.

It is apparent that, within the means employed, everything hesitates between two choices, making sudden leaps from one to the other. The yolk yellow mass can function both as a void and as a presence. The pale green and poppy red lines help the figure assume concrete presence and at the same time keep it from doing so. They have, simultaneously, the function of articulating the features of the figure—a function that is quite normal, after all—and the quite different function, one that somehow belongs to another realm, of materializing the sorts of cosmic fluids in which this figure participates, or which pass through it. They also have the value of a paraph or flourish that vehemently manifests the painter's presence and functions as his signature. The various systems of lines seek both to do violence to themselves and yet, in places, to form an attractive structure. The colors are borrowed from registers that seem, to some degree, irreconcilable; they belong to different modes of regarding things or, at least, of revealing them; they suggest mental paths of which one or the other must be chosen. Yet they also dream of uniting in a final festal banner—in an enigmatic (and perhaps mad) peacock's tail (or cocktail) that affords the expressions of triumph.

This is the form Ossorio's pictures generally take: a kind of processional chariot decked with flowers. A procession of the most sumptuous kind (the artist has a taste for very sumptuous things), but always equivocal, never quite certain whether it seeks to transmute what it envelops into rare and marvelous blooms, or else to emphasize their threatening character. Or indeed both at once?

I have often thought that the most convincing timbres of voice owe their magical power to the fact that they result from a sort of layered texture in which several different expressions are combined and opposed; and that, similarly, an art achieves its necessary vibration (necessary in order to seem endowed with life) only if it proceeds by opposing aspirations.

What is certain is that Ossorio greatly enjoys transcribing, and generating, conflicts; and above all, those conflicts produced within one and the same being. This may be because he loves conflicts, and it may be, on the contrary, because he suffers from them. An artist enjoys representing the objects that delight him, but also, frequently, those that he most fears. Perhaps moreover the two are merely one. In both cases the fascinating object, by one means or another, exerts pressure on the person involved—invades him, lodges within him. Or is it the person who is transposed, who changes sign and is transformed into a summoning void, into which the object passively surges, like water into a hole?

In the world Ossorio offers us, these abrupt changes of sign occur in great numbers on all sides. I believe it is not certain if being, in such a world, is a positive or a negative value. For Ossorio, every being seems to consist essentially in a will—something absolutely incorporeal at its source—a tiny vortex, separate and contrary, which suddenly manifests itself somewhere within the great general vortex. And in the combat it wages against this latter, any separate being is invariably made to function both as a bellows and as a suction pump. It is a being at once swallowing fire and spitting fire that Ossorio continually offers us in his art.

What struck me most, when I discovered these paintings, was the dubious existence the figures are granted. Every means is employed to keep them from assuming existence. First of all, the one I have already mentioned: to articulate them by drawings superimposed

on each other, which produces a very uncomfortable effect. But also to draw them so summarily as to emphasize that they belong to a fallacious creation of man's brain, and not to the realm of realities; and then, as I have said, to incarnate them frequently *in negative space.* And also to wed their shapes and colors so closely to those of the composite milieu surrounding them that they seem to have no substance of their own—no other substance but this cosmic soup in which they swirl and surge.

And to afford them a kind of transparence; to cover them with streaks and splashes, as if with the intention of effacing them. To give them those giddy, dancing attitudes, and those inhuman facial expressions; and that appearance of floating, that quality of dust motes suspended in a ray of light, as if they were escaping weight—as if they had not yet been adopted by weight. And all of this occasionally intensified (notably in the subjects whose edges are cut out or torn) by the fact that these figures are inscribed within curiously arbitrary shapes—quite alien to them, it would seem—consisting of complicated silhouettes, as far as possible from anything natural; and these shapes are linked to the figures despite all logic, evidently attempting to replace their own shapes, or at least to become one of their shapes, according to some unknown clairvoyance.

These insubstantial, half-created beings, their edges still clinging to unorganized chaos, mustering their pale, their translucent, forces to create themselves with a little more certitude—at least to safeguard their tiny velleities of existence—seem to proceed from a sentiment that being (and in this notion of being, the painter appears to include, without much differentiation, man—notably Mr. Alfonso Ossorio—as well as the tree, the mountain, the stream, and even the ripple of the stream) is not something that ever manages to constitute itself very strongly. A will-to-being, rather than a being. A vague aspiration: a dream.

The combat waged by this being—this aspiration to being—in order to assume some measure of opacity, to fortify its individuation, to plug the recurring leaks by which that individuation constantly escapes (the envelope is extremely porous), and to protect itself against the external penetrations at work within it—this combat seems to be one of the insistent themes of the epic poem chanted by these four hundred paintings. At least it is the constant theme of one of the voices mingling here. Ossorio's art espouses, as I have said, the form of a fugue in several voices, complicated by the fact that the themes skip from one to the other: the actors, during the play, suddenly change roles.

It is striking that the fields of the picture surrounding the figures and forming the sort of background against which these figures appear consist of very complex elements—like those constituting the figures themselves, composed like them, one might say, of phenomena belonging to various overlapping realms, between each of which certain conflicts arise; illuminated by their glimmering lights, and somehow seething throughout their substance with impulses of evanescence, and everywhere swarming with signs, whence an impression that the world in which these beings live (the world in which we live, I believe) is also, like them, peopled with battles of psychic forces and with mysterious magnetizations—ultimately of their very substance and ready to assume, at any moment, at any point, the semblance of being.

The painter actually seems to attribute to these amorphous zones an even more impetuous life force than to the beings that populate them. And in the combat echoing

throughout these paintings between that great soup of continuous life, that initial diffuse liquid, and the individuated beings attempting to constitute themselves within it (between the continuous and the discontinuous, between the unique and the multiple), we cannot be certain which of the two heroes Ossorio intends to celebrate. The subject of Birth, frequently recurring here, does not seem to be treated in a celebratory sense; and as for the numerous screaming Mothers who haunt these paintings—within and outside of whose wombs surge whole populations of tiny grimacing leapers—we do not have the impression that the painter espouses the latter's cause. Lately it has even seemed to me that he regards these little soldiers of individuation not at all as the champions of life, but rather as a failure destructive of life; that Ossorio regards being, constituted at the juncture of pure cosmic forces, as a malignant tumor generated within these forces and to their cost, and not as a center of increasing life, but rather as a point of slackening and of degeneration.

But I was wrong. I was making the error of forgetting that we are reading a score written on several staves, not just one, and that by considering in isolation any one of the themes interwoven by the painter, I would be denaturing his thought altogether.

The series of paintings we are considering was begun, indeed almost completely created, within the very interval that the painter was elsewhere decorating the church in Victorias. It is likely that our paintings served as a trial balloon, but also as an overflow reservoir. Doubtless he wanted to present his religion on the church walls in a simplified form, at the same time affording himself the freedom to display its further range in these little wax compositions, intended only for his own use; the latter may be regarded, I believe, as the decoration of Ossorio's personal and private church. No doubt he could, under such conditions—strong in his faith—permit himself every liberty, even to the point of venturing deep into the fringe zones of theology.

Moreover Ossorio is not a man to reject any zone whatever. He admires and celebrates—he is determined to despise nothing. His art is one of total festivity, and it is a total world, from which nothing is excluded, that he intends to evoke. Poisons, forbidden realms, dark myths, actually seem to him, I believe, the various nuclei of especially precious tensions, sites of concentration where cosmic virtues, and mental operations, are condensed at their highest charge. He fearlessly embraces *his brother poison,* and insists on making a place for him—a place of honor—in his cosmogonies.

I have already mentioned contradictory humors, and indeed I believe that the paintings we are concerned with owe their strange beauty to the fact that, within them, several winds blow. Their tone of ardent celebration, which I have just mentioned, is constantly associated with a certain desolate temper. One is reminded of that disease in which arterial blood mingles with veinous blood. The (more or less deliberate) forms these paintings ultimately take are always extremely tragic; they have the atmosphere of catafalques, of broken wingspans, of mutilations. The creator reveals a (perhaps unconscious) tendency to employ any and every means likely to make them alarming. And among these means there is one to which he resorts a great deal: the voice of delirium. A very disturbing tone of profound mental divagation prevails throughout this art. It seems that Ossorio holds delirium (even when taken very far) in high regard; and his preference for it certainly derives from the fact that he expects revelations from it, clairvoyances to which he attaches the highest

value; but he also proceeds, on the other hand, primarily from his power to terrify. I have already emphasized the venomous aspect of the colors the painter prefers; the forms with which they are associated are just as unsettling. They are exaggeratedly arbitrary and suggest, rather than forms belonging to the physical world, traces of the mind's wanderings; and these wanderings are tortuous, convoluted, somnambulistic; they inspire dread. Within these shapes circulate certain graphisms at least as disquieting. They evoke a proliferating swarm intensely endowed with life, but a lawless life that seems a malignant tide nothing can now arrest. It is a kind of life severed from its habitats and shifted into the void, where all its mechanisms continue to function ever more powerfully, but alienated, lawless, demential. Life (that strange life the colors of raspberry, cyclamen, clotted blood, turquoise, and mimosa) by which Ossorio's pictures are embellished—draped, in their theatrical postures—is a life whose coordinations have broken down and whose constraints are dissolved. There is a great deal of terror in the hosannas of his liturgy.

This is because the arrangement of superimposed layers Ossorio employs in the technique of his paintings is analogous to the one on which his metaphysic is also based. He is convinced, I am certain, that it is by this simultaneous performance, on discordant instruments, of themes that each proceed without concern for the others, that he has a chance of encountering the voice of life.

Or if not this voice, then: some other. A voice that is not at all the voice of life but alien, very alien—an unheard-of creation—raised alongside the voice of real life, and somehow in competition with it. There are slips and skids of this kind in an artist's mood: sudden ruptures, abrupt changes of direction. What artist is not powerfully attracted to the strange? Who has not had the intuition that to immerse things in the bath of strangeness will reveal their true meaning? Who is not intoxicated by the light of the strange, seduced by its corruption, and tempted to carry it further still?

From the outset, every work of painting is based on an equivocation. The painter actually assigns himself two very different roles: on the one hand, he seeks to be an interpreter (a medium) of the objects he evokes, to grant them speech, to make himself their voice; but at the same time he wants to make his own voice heard, which is something entirely different. The mechanism of the two meanings, which might be said to be contrary—that of reception and that of emission—conjugated in a single operation (a single wire conducting two contrary currents), this mechanism so dear to Ossorio, invariably functions somehow in every painter; it is what gives the art of painting its *density*. But it happens that certain painters, instead of struggling, as others do, to conceal the play of this double meaning, delight in accentuating ambiguity, in extending and emphasizing, instead of attenuating, each of the two mechanisms (does a certain quality given to a tree express the tree's will, or the painter's own pulse?), and Ossorio, who dearly loves to provoke conflict in every instance, who loves nothing so much as to raise contrary winds, will not fail to be of their number.

Upon this multilevel machine that painting is for him (a machine to manifest everything, to render all phenomena apparent to the eye), Ossorio eagerly, without concerning himself with their contradictions, or their allegiance to different realms, produces certain marks and signs that manifest the world as he sees it, and others that seek to produce a

fantastic world of his own creation. He interweaves and braids these together. His notion is that from this mélange will be born that effect of *relief,* without which a philosophy, or an art (they are the same thing, except that what is commonly called philosophy is art stumbling, the dough of art that has not risen), can have no life.

I believe that he has still another idea. These two orders—description of the world and projection of his own humors—do not seem so opposed to him. I have said that Ossorio is convinced of a continuity within all of life. To him life seems pervasively to sustain, in any realm and at every level where it functions, the same behaviors; whether it is a matter of waters (or saps) that spread, of mud that clots, of flowers that bloom, all concretions of form, all expanding impulses, all confronting forces—biological, geographical, meteoric—remain in his eyes the same. Or further still: mental phenomena function in the same way. Between the physical formation of clouds or mountains, and the mushrooming of human thought and the architecture of its mystic towers, Ossorio sees a single realm, sustained in his eyes by the same sources, fed by the same juice, and always assuming the same appearances.

It is precisely these appearances that he undertakes to transcribe. He too possesses them, once he takes part in this world of life. Hence his humors, the impulses manifest in his muscles and in his blood, are the same as those that function within cloud and mountain, and when Ossorio projects them on his sheet of paper, and from it derives the image of the mountain, he is not creating an arbitrary and preposterous mixture: he is mixing waters that come from the same river. It is in this same spirit—of identification of all cosmic gestures—that the Chinese painter of the Tsin Dynasty, two centuries before the Common Era, filled his mouth with all the colors and then spat them out on his images in order to lubricate them with life.

And these appearances, which Ossorio discovers in all the works of life, which he recognizes as everywhere the same, in his own being as in every object external to himself, and which he consistently communicates to all his paintings—these appearances are somewhat diabolical. It is a fiery blood that circulates within the body of these terrible dragons. Ossorio, as I have said, wants to restore to us a total universe, not an expurgated one, and the Devil is not absent from it. His style is evident everywhere.

I spoke earlier of the esoteric character of Ossorio's religion, and I want to explain this a little. He has not discussed his metaphysic with me, and one hesitates to question people about such matters. It is indiscreet and embarrassing. Each man's metaphysic spreads under the surface, and prefers to remain there. Nothing is so offensive as to proceed as if one were fishing it out. Moreover, Ossorio's metaphysic is revealed in his paintings as clearly as he has wanted it to be—and, precisely, *underwater:* it is his pictures, in other words, and not him that we must interrogate. If he has taken all this trouble to invent, precisely in response to such questions, the rich and complicated grammar out of which his paintings are made (that grammar in which the terms have several values and can be declined in every direction), it is because this apparatus seemed necessary to him in order to transcribe faithfully, without distorting anything, his complex views of things. Without being a theologian (and I am far from it), I am convinced that Ossorio impresses a new and enthralling orientation upon Christian spirituality.

Notably, it seems to me that Ossorio grants every being (even the most precarious, for instance, a fleck of foam or an ink blot) more psychic essence, of a nature closer to man's (and to God's as well) than is the general rule. He thereby casts a much brighter light on the dogma of man molded out of clay. Moreover, such clay is not the inert, quivering matter that some conceive it as but a radiant substance endowed in even its tiniest particles with all capacities and splendors. The demons have a greater part in it, and more mysterious powers, than is habitually attributed to them. The artist's turn of mind is, I believe, at every point of his metaphysic, not to resolve matters into their components, to mark differences, but on the contrary constantly to see in things simple modes or aspects of one and the same thing; he tends toward the identification of all things: he is infected with unity, with oneness. Hence the forms in his paintings always tend toward those of the egg or the block, and his art assumes an aspect of inseparable imbrication, of a deep and indistinct broth into which we can dip our spoon at any point.

And it is then—beyond the realm of that thousand-armed Asian god, womb of all worlds—that there appears in Ossorio's paintings (Christian theology, too, has its two levels, and he chooses to mark them more crudely than is usual), in fitful gleams, and as though superimposed, the radiance of the second divine regard that affords man a new destiny. And this second face of God is no less surprising and no less fantastic than the other, for it is the fierce countenance of the Christ of Spain.

The Spanish preference for blood and violence seems to correspond to a notion that blood has more divinity in it than the brain. The Spanish wonderment, favoring the fell fluids of primordial life rather than the values of human reason, sets great store by gestures—values gestures more than thoughts; prizes gestures and impulses, humors and the whole realm that is said to belong to consciousness (and which precedes it). I conclude that the field of clear and distinct consciousness interests (and amazes) Ossorio much less than the zones subjacent to it, in which thoughts steep their long roots—those zones that lie between the biological (or the physiological) and the mental. We might even suppose that conscious thoughts are, in his eyes, not a fulfillment of the phenomena that form in these zones, but a degradation of the latter. In any case thoughts seem to him all the more precious if they retain the fragrance of those obscure zones from whence they originated.

Yet a moment later the wind suddenly turns, and Ossorio takes the diametrically opposite side. By means of highly differentiated and particular shapes that appear in his pictures, and which we recognize as those that he gives to human mental productions, he powerfully asserts that these belong to an alien and preeminent order. We might almost recognize them, then, no longer as human thoughts seized at their formative stage and before their entrance into the field of consciousness but rather as being at a stage where, having emerged from this field, they have ceased to maintain any connection with their creator, living instead their own life and extending into behaviors and developments no longer in his control. Perhaps the artist suggests that at a certain moment of the circuit, their light has intersected with some other, from which they have received strange powers—as if Ossorio, independent of the attention he pays to these fields of preconsciousness, which I evoked above, has, further, the notion of other fields (of postconsciousness) that are even more mysterious and much more important.

In Ossorio's art, man reveals the signs of his double nature, made more explicit than is usual. He is tree and bull, more than we ordinarily dare perceive him. He is also, more than we ordinarily dare conceive him, a medium by means of whose mind God achieves the transmutation of all things.

And for the second time we find here, no longer in conflict but on the contrary perfectly harmonious and legitimized, the two functions of painting that I indicated earlier as virtually contrary: to describe the things the artist regards, and at the same time to project his own elaborations. If we grant that man's mission is precisely to transform the world by the power of his mental operations, the painter has good reason to unite in a single image the objective description of the world and the inventions of his mind. There is no longer any contradiction here, and the two projections, on the contrary, reinforce and nourish each other.

It will doubtless be noted that the various impulses and movements of humor attributed to Ossorio in the foregoing pages are anything but concordant, even antagonistic. Of course they are! But such is the case, I am persuaded, with any individual's metaphysic. It is not displayed in an orderly fashion but coiled within us like a serpent with a thousand knots and convolutions. It is precisely out of a desire to illuminate his own metaphysic (painting offers this advantage: since everything is inscribed within a single image, everything can be seen at a single glance) that Ossorio commits himself to painting; not to communicate his philosophy, but to construct it. The execution of a picture is always, for him, an operation by means of which he hopes to achieve a certain approach to things. We do not seek, in his pictures, a philosophy revealed, but a philosophy laboring to form itself. And one that to that end employs every means, not only clear and rational ones, but others as well.

And what attitude, what posture, does Ossorio assume to manipulate this metaphysic? I mean, what procedure has he ultimately adopted as the most effective and the most fruitful for furthering his researches? He dances. Ossorio is first of all, and capitally, a dancer. His art has the character of a metaphysical dance, a danced cosmogony.

And here is our painter, standing at his worktable, about to begin. The page before him is moistened with water, hence more conducive and more impressionable. And water is the vehicle—if not the primordial element—of the birth of worlds; water is the first mother of beings, and the sacred element *numero uno*. He dashes on several colors, which produce certain patches; a few summary lines—in great haste and suddenness—are mingled with these patches; all this is flung onto the moist paper, is hastily organized (under the effect of the very rapid drying) in streaks and flows, in trees, in caterpillars, in stars.

The point is that his operation repeats, on its small scale, the creation of the world. Ossorio wants to be present at the creation of life; to experience it by miming it. In its entirety, of course, starting from the incipient state, before anything has begun; that is, then, from shapeless matter. He greatly enjoys the fact that this seething substance is, before his intervention, extremely shapeless. And in the course of his work he will make sure that it never quite ceases to remain so. Hence he flings, at the outset, the chaotic and the inorganic upon his sheet of paper.

When Ossorio dashes his paintings onto the moist paper, he is already manipulating living matter: that same element out of which worlds are formed. The ink he flings is not at

all, in his eyes as it is for other painters, a means without an importance of its own in transcribing what he wants to reveal: it seems to him a substance endowed with life, and soul, whose slightest impulses deserve close attention. The fact that these materials, which Ossorio treats as media, belong to the marvelous world of living things does not leave his mind, even for a moment. He employs, in order to transcribe the world of life, substances that themselves belong to that world; they will fortify his mental creations by the contribution of their own actions. They are endowed with all the powers that slumber at the heart of metal, lava, slime, and which, on the occasion of certain circumstances (which can be provoked), wake with great power and concresce into marvelous phenomena. They are capable, when skillfully directed, of reproducing, on their own scale, all the mechanisms of planetary formation—powers all the more interesting, for the painter, in that he tends to produce a kind of assimilation between the mineral's soul and his own, and to grant to his touches of paint as to winds and waters, beings and ideas, movements that resemble each other.

Flinging his ink upon the moistened paper, he reproduces a phenomenon that is among the most common we know, and which seems archetypical of all assumptions of form in the material world: a phenomenon consisting of the penetration of a fluid substance into another substance still more fluid, which tries to resist this invasion and succeeds in doing so variously, depending on the points of attack and the sites of resistance. A kind of rape, then, performed by a more impetuous force (the colored substance has more energy than the water on the surface of the paper) upon a more latent force. The drawings subsequently made upon the resulting touches of ink reveal in great detail every phase and form of this assault. This is what concerns Ossorio to the highest degree: the circumstantial description of the rape of one element by another. The explicit trace of the attack, and that of the defense. The painter, in effect, hungers for action, and specifically for violent action: it is, in his eyes, the capital manifestation of life, the latter's very essence.

I now want to discuss these drawings, so hasty and abrupt in their movement, which the artist mingles with his first spurts of ink, and the reasons for this abruptness. All the drawing that follows, moreover, will have the same violently impulsive character to which Ossorio is so partial. He wants his lines to obey immediately (and without allowing conscious time to intervene) his most unsupervised movements and impulses of humor. Indeed he pays to these humors, as I have said—to these impulses that form within a human being, and of which the distinct ideas which later cap them are perhaps merely a depletion and a disguise—an extreme attention; they exert a fascination upon him. By the very fact that they precede consciousness, they seem to him to belong to a kind of genesis that in every realm inveterately enthralls him. They seem to him more *divine* than any number of clear and distinct ideas, closer than such thinking to the impulses that his ink also manifests, for its part, and with which he has undertaken to mingle them.

For he wants to bring together certain marks and lines that matter itself produces with certain marks and lines drawn by man. He wants to confront the former with the latter; he wants to see them closely stitched together. And from this intimacy, two consequences will result. In various places the former will mingle with the latter to the point of confusion. The structures produced by the painter, intimately linked to the forms produced by the

actual impulses of the ink itself, will thereby gain a dignity that greatly enhances their effect. They will be somehow wrested from the level of human production and brought to the level of natural phenomena. I am not certain whether Ossorio does not also observe a procedure whereby his ink's spontaneous movement finds itself, by this intimate association with the lines drawn by the human hand, endowed with a polarization that might reveal, or at least illuminate, its own significations. At other points, on the contrary, his own drawing will not mingle with the lines produced by the whims of the ink, but will espouse movements quite eloquently different. Here then, emphasized by their brutal closeness, will manifest itself a quality particular to human mental productions amid other natural productions, and everything *strange* or *alien* about this quality.

Not only Ossorio but anyone who devotes himself to art obeys the double goal of obtaining by this operation an intimate communication with the world of things, one that functions in two directions; that is, it aims on the one hand at wallowing within it — becoming a tree, becoming a rock — and then, conversely, infusing the creator's blood into the whole world.

To this end, the artist tries to wake all his receptive faculties, to obtain a state of conductivity so that the arm holding the brush becomes the branch of a tree or a spur of rock, and at the same time to achieve an exceptional vitalization of his own emissions, to such a degree that his mental constructions expand in all their breadth (generally unsuspected by himself) and with sufficient force to be externalized without too much loss, virtually without loss at all. Losses upon externalization are always what is most to be feared.

Ossorio aims at a sudden crystallization of his thought. He tries, in order to materialize it on his sheet of paper, to provoke a phenomenon comparable to the formation of hoarfrost, when the invisible vapors meet the cold panes of our windows, and are manifested in forms that astonish us, of which we had not supposed them capable.

But when he effects this shift of the movements of his mind into the material realm of forms and colors, his idea is not only that nothing be lost but also that these humors arrive at new developments. Perhaps he has the intuition, buried somewhere in his work, that his thoughts, once separated from himself, released from the human clay imprisoning them, will be somehow unballasted, and will suddenly achieve amazing amplifications.

Indeed something of this kind occurs in Ossorio's paintings. They have, apparently, overflowed his intentions, organized themselves into images assuming a singular and independent life of their own, one that affects the mind much in the manner of myths: with great power. They may become axes for thought, nuclei of thought. Despite their enigmatic character (or perhaps in part because of it) they give the impression of possessing (coded) answers to the most crucial questions, or, if not answering these questions themselves, of being the kinds of talismans capable of provoking within us the illumination which will do so. Great art occurs, I believe, only when a painter manages (and this is very rare) to invent these forms capable of assuming, for those who have once seen them, this function of *myths*.

Obsessed, as I have said, with always linking everything together in an inseparable fashion, and with giving all his figures a constant aspect of being merely an emanation of what surrounds them, Ossorio tends to draw them only with great succinctness, by signs

often extremely elliptical, so that the subjects of these paintings, and the phenomena evoked in each of them, are not easily read. He obviously wants them to assume the character of cryptograms, and their significations not to be extracted and clearly enunciated but to remain diffused within the entire body of these serpentine coils. Indeed he succeeds in instilling their meaning in all their parts, and by this means augments their force much more than by formulating it in separation from them. The character of immediately eloquent gestures in all the elements that compose these paintings, and their general aspect, which is also very persuasive, causes anyone, however ill informed as to the precise subject motivating each picture, to understand its essentials nonetheless.

I should even suppose that a person unfamiliar with painting and its languages, and uninformed as to the specifically theological character of Ossorio's pictures, would not thereby miss their profound meaning so much as one might assume. The high lyricism of the forms generated here, the vehement impulse by which all the graphisms are animated, translate the movement of the artist's thoughts better than any more explicit formulation might do. Thus the attitudes of an inspired dancer convey a certain position of the mind, in a more evident fashion perhaps, and in any case a more exalting one, than any clearly written treatise.

Translated from the French by Richard Howard

Materials and Techniques

Introduction

Jackson Pollock, Alfonso Ossorio, and Jean Dubuffet were among a group of artists in the mid-1950s who sought a different pictorial language through innovative use of materials and techniques. While each was classically trained, they moved away from traditional painting methods that involved the application of paint using a brush to a canvas placed upright on an easel. Instead, these three artists developed alternative techniques such as dripping, pouring, rubbing, and throwing their media onto paper, canvas, and hardboard panels placed on horizontal surfaces. Even in their simpler drawings and sketches they adopted the use of different domestic and imported papers to combine with their mixed-media palette in novel ways. In their more ambitious works they incorporated a broad range of unorthodox materials that included enamel paint, wax, sand, pebbles, tar, metal screens, etc., to create unusual surface textures. The subsequent buildup of the paint surface lent itself to techniques of scraping away upper layers or selectively leaving lower layers visible as the picture evolved. The alternation of hiding and revealing parts of their compositions was an invitation to the viewer to look beyond the immediate picture plane and be drawn into their intricate process. In a 1968 interview, Ossorio commented on his desire for the general public to be exposed to "a greater visual literacy" to more fully experience Abstract Expressionist pictures like those done by Pollock, Dubuffet, and himself.[1] The close association of these men between 1948 and 1952 meant that they cultivated a familiarity with one another's output. This essay highlights the material themes that overlap and recur in each artist's work.

Pollock

Jackson Pollock was photographed at work in 1950 by Hans Namuth, dripping and pouring paint in a radical fashion onto unstretched canvases lying on the floor. The widespread reproduction and subsequent study of these images encouraged art historians and influential critics to develop interpretations of the artist's innovative methods. Within this broad discourse, it has been convincingly demonstrated that Pollock's "dance" of applying paint was not a random process. Rather, the artist demonstrated a controlled consciousness in the execution of his "action paintings."[2] In her book *Jackson Pollock: Drawing into Painting*, Bernice Rose observed that a synthesis between his drawings and paintings occurred once the line became a poured or dripped line.[3] Some of the methodologies that Pollock followed to create his paintings can also be seen in his works on paper, particularly in those works from around the midcentury. It is fascinating to observe the novel ways in which the artist transferred techniques back and forth between paintings on canvas or hardboard to works on paper. On the occasion of this exhibition, one work on paper and two collages were studied to better understand Pollock's process to manipulate line, texture, and image when venturing outside of his better-known poured paintings.

Jackson Pollock's undated work on paper *Pattern* (plate 1) is a complex interplay of materials and media, similar in that description to other drawings and paintings done by the artist in the mid-1940s.[4] The period was one of exploration of materials, calligraphic line, and color for Pollock, and in this particular drawing he has tried layering many different types of both painting and drawing media onto a textured handmade paper using a highly

21–24. Details of Pollock's *Pattern* (plate 1).

additive technique. It is possible that he began this work with a pencil or ink drawing, but if so, the original sketch is now hidden underneath brightly colored pastel mixed with water, crayon, and a shiny water-based paint applied with a brush, one layer over another, in multiple passages (fig. 21).[5] At least nine different colors of paint can be seen in this layering process. Over these painterly passages of color, delicately executed black pen-and-ink designs are added in enigmatic "patterns," along with strokes of brightly colored synthetic inks applied by both brush and pen (fig. 22).[6] The black-ink designs are highly detailed, almost like a pictographic code that is only partially revealed (fig. 23). The viewer is drawn into the picture in an effort to decipher these mysterious symbols that appear intermittently throughout the work. Pollock's strong interest in Native American as well as "primitive" art may well have been the inspiration for some of these pictographic images that appear in his paintings of the same time period.[7]

Along with the controlled and intricate ink designs in *Pattern,* spatters of black ink and color are loosely applied. The overall technique of the work seems experimental rather than random. It is as though the artist were trying out as many different types and colors of media as possible to build the effect he was after. The final layer of the picture consists of a white gouache impasto that appears to have been applied directly from the tube. Many of the design elements are repeated or reinforced with one type of media over another; for example, impastoed white gouache, an ink line, and watercolor delineate the same shape (fig. 24). Although the artist signed the picture in the lower right, the work, much like the collage *Number 2, 1951,* discussed below (see plate 8), has no clear orientation. The varied palette of media may reflect Pollock's years as a studio assistant in the Art League from 1930 to 1933, where he would have been well acquainted with all the different materials an art student would be introduced to in drawing and painting classes, and his eight years in the WPA Federal Art Project, where he fraternized with many other artists working in New York City, including his brothers Sande and Charles. In the mid-1940s Pollock lived on Eighth Street in New York City, across the street from an art supply store owned by Lou Rosenthal.[8]

We know from his other work on paper that Pollock experimented with application of media on paper using ink pens, brushes, Japanese calligraphy pens, and even sticks.[9] He explored the use of various support papers in his drawings, selecting various handmade papers throughout his career, in later years favoring custom-made products by noted papermaker Douglas Morse Howell of Long Island, in addition to Japanese and American papers of high quality.[10] The tan color and textured surface of the handmade paper used in *Pattern* provided a platform for applying, rubbing, scraping, and framing the media.

Number 2 is another complex layered structure. In this piece, Pollock layered several types of papers, pebbles, string, and metal lathe mesh and applied daubs, rubs, and strokes of green, yellow, white, and red paint to the surface. The collage is constructed upon a hardboard support, the dark brown color of which is discernable through the translucent papers. The artist frequently used this type of wood panel for his paintings and appreciated its color as a substitute for a dark ground.[11] For *Number 2,* he chose printed newspaper, Kraft paper, a thin, off-white paper (perhaps newsprint) and, interestingly, torn pieces of Japanese paper from one of the dripped ink compositions that he was making in 1951.[12] It is difficult to discern the precise order in which the various papers were affixed to the panel as Pollock alternates back and forth between the different papers as the piece evolves. Three-dimensional relief is added to collage by the inclusion of the mesh, string, and pebbles, which are sandwiched between layers of paper. It is interesting to note that these same materials appear in *Number 29, 1950* (National Gallery of Canada), the sole surviving piece from the glass painting event that Hans Namuth captured by photographing the artist's process from the other side. In places, Pollock rubs or brushes paint over some of the metal screen inclusions to highlight their crisscross pattern. The development of the collage followed his approach to the dripped and poured paintings in several ways. First, it was conceived in multiple layers, and Pollock subtly and selectively permitted certain images to emerge from its earlier states. In *Number 2* he places pieces of paper around printed words and punctuation marks taken from newspapers or magazines. Two examples of this are "Bar" (fig. 25), in the lower left, and to the right and above the signature, a

25

27

26

25–27. Details of Pollock's *Number 2, 1951* (plate 8).

question mark (fig. 26). Left of center, the partially concealed word "complete" emerges beneath some green daubs of paint (fig. 27).

An infrared photograph of this passage reveals that a greater amount of printed paper was used in the development of the collage than is visible now. A two-inch-tall letter B and a nearby printed apostrophe and hyphen are found just below center. An infrared image reveals that the remainder of the word was "BOSS" (fig. 28), which was blocked out by gluing several papers over "OSS." Carol Mancusi-Ungaro calls this process in his paintings "masking," a process he clearly employs in *Number 2*. Another characteristic that the collage shares with his paintings is the "allover" quality of the composition, in which the entire surface is evenly developed from top to bottom and left to right. If it were not for the signature at the bottom right (also on a collaged piece of paper), it would be difficult to get a sense of orientation of the composition. The final layer has the appearance of crepe paper because of the way it crinkles.[13] It was dipped in glue and covers nearly the entire work, acting as a veil over what lies below. The adhesive is most likely Rivit glue, a material that Pollock used as a preparation layer on many of his black pour canvases dating from 1951.[14] Initially clear when it was applied, it has discolored yellow and become more opaque, so that the collage today looks quite different from the way it did when Pollock completed the work. Both above and below the final paper layers Pollock added dark red, yellow, and green paint in drips and droplets, and by rubbing paint onto the surface.

The primary sources of imagery in *Collage and Oil* (plate 7) were ink-on-Japanese-paper fragments like those used in *Number 2*. In this instance, the cut and torn bits of

28

29

28. Infrared details of Pollock's *Number 2, 1951* (plate 8).

29. Detail of Pollock's *Collage and Oil* (plate 7).

paper came from two or more of the dripped paintings on paper. One was composed of fine calligraphic black and colored ink lines; another was predominately executed in black ink, and the pours are wider, with fewer squiggly shapes. Pollock also used unpainted, straight-edged cut and torn pieces of Western paper. After affixing the papers to the painted canvas, he brushed nearly the entire surface with a medium that closely resembles the discolored glue used in *Number 2*. Although it has not been analyzed, it seems likely that Pollock found another use for Rivit glue that parallels his use of it in his paintings. He apparently enjoyed brushing this adhesive over his later black poured paintings, perhaps to unify the sheen of the picture.[15] His final additions were in dripped, transparent brilliant orange and in opaque white impastoed circular shapes (fig. 29). The orange was presumably a water-based medium, since it exhibited drying/shrinkage cracks. The cracks and losses in the orange color occurred soon after the collage was finished, as shown in a gallery photo taken in 1958.[16] The white paint has the appearance of gouache squeezed from the tube, applied the same way as on *Pattern*. Losses in this color also are visible in the 1958 gallery photo. The artist developed the collage on a canvas painted a deep earth red, not dissimilar to the color of hardboard panels, and probably in an attempt to begin with a dark ground. The red paint plays a dominant role in the composition, as it shows through in several large passages. Pollock was doing something very different with this collage piece; absent is the allover working of the picture surface.[17]

—Elizabeth Steele and Sylvia R. Albro

Ossorio

Ossorio's Wax-Resist Process

In the late 1940s Ossorio developed and refined a process-intensive wax-resist technique, building up a rich visual vocabulary in layers of wax, black ink, water-based paints, and other drawing materials; Jean Dubuffet referred to this as Ossorio's "rich and complicated grammar."[18] Ossorio's process of alternating layers of watercolor and wax reached maturity in 1950–51 in the nearly three hundred works on paper he created during a ten-month span while in the Philippines executing his large mural painting for the chapel of St. John the Worker (a time of prodigious productivity known as his Victorias period). While variations in Ossorio's materials and techniques occur during the roughly forty-year period following his first wax-resist drawing, his process would always rely upon the essential immiscibility of wax and water.

Throughout his career Ossorio employed two fundamental resist methods: drawing on the paper using a candlestick or stub (typically in the early stages of making a drawing), and brushing hot, fluid wax onto the drawing surface, which typically was later scraped away.[19] Ossorio would alternate these resist layers with various paint and ink applications to create a dense, almost indecipherable visual landscape. This complex layered structure invites a sort of inverted interpretation of the relationship and sequence of materials, and the actual sequencing can be counterintuitive. For example, what at first glance appears to be a bold paint stroke on the surface is, upon closer inspection, actually part of a larger field of color revealed from beneath, "protected" from subsequent paint or ink layers by a brushed stroke of [colorless] wax resist.[20] We see this effect over and over again as a visual hallmark of Ossorio's working process.

A Process of Discovery: Ossorio's Layering of Materials

An examination of the Phillips Collection drawing *Five Brothers* (plate 22) illustrates the complexity of deciphering Ossorio's technique. The drawing is an excellent illustration of the artist's work from the period, and can be deconstructed as follows: Ossorio first drew swirling, looping lines with a colorless wax candlestick or stub. These initial resist lines form vague figural elements that only become visible (as the white of the paper) once other drawing materials applied over them color the surrounding areas (fig. 30). In this work Ossorio followed the initial resist lines with loosely brushed washes and drips of watercolor—yellow, blue, and muted red—revealing the initial drawn resist design. The artist then applied more drawn resist lines with a candlestick and swatches of hot, fluid wax resist using a brush; these applications would protect the underlying colored paint strokes and drips and bare paper from subsequent paint and ink applications (fig. 31). The artist then continued with additional, alternating layers of watercolor and brush-applied wax, and finally brushed black ink over the entire surface. This final black ink layer would temporarily obscure much of the drawing, but adhere only in those remaining areas not protected by prior applications of wax. Once the drawing process was complete, Ossorio scraped down the entire surface using a razor blade (or other flat tool), removing the buildup of wax and revealing the intermittent layers of watercolor and ink that had adhered to or absorbed into the paper during the working process.[21] A final step likely involved rubbing or polishing the

surface, removing any scraping marks or irregularities and imparting a smooth, uniform appearance to the finished work.

Other Materials and Techniques

In addition to the complex process involving wax, water-based paint, and black ink described above, variations in Ossorio's technique included the use of other drawing materials such as wax crayon and pastel. And while Ossorio apparently never used a true encaustic process—incorporating pigments or colorants into wax to be applied hot to the drawing/painting surface—colored sealing wax occasionally appears in the artist's palette.[22]

As described above, Ossorio used carbon black ink extensively in his drawings, most distinctly in the broad brush applications that often "finished" the drawings. But at times the artist also used pen and black ink with great fluidity, sometimes as an initial under-drawing to loosely sketch out abstract or figural forms, and in other instances to create distinct linear compositional elements later in the layering process. Ossorio's wax-resist drawings occasionally employ initial underdrawing in graphite pencil as well.

Finally, the artist's working techniques at times involved cutting into or contouring the edges of his paper supports, the latter evident in drawings such as *Head of Christ* (plate 24) and *The Helpful Angels* (plate 25). When we look closely at works of this type, we find evidence that Ossorio cut the contours early in the working process. For example, in *The Helpful Angels* layers of paint and wax extend over and onto the cut edges of the sheet, indicating that most of the design was carried out after the paper was shaped.[23] In other drawings, Ossorio attached cut and torn collage elements onto drawing supports, or he cut shapes out of fully developed compositions, as seen in *Untitled, 1950* (plate 27). A variation of the latter technique is visible in *Five Brothers,* where the artist cut and excised deep undulating channels from the thick illustration board on which the drawing was executed. These curvilinear forms mimic those seen in *Untitled* (although not extending completely through the support as they do in that drawing), and add a three-dimensional quality to the work that plays visually off of the dense drawn and painted elements.

30–31. Details of *Five Brothers* (plate 22).

30

31

Ossorio's Paper Supports

During his career Ossorio worked on a variety of paper supports, most of which were of good quality and produced as artist's watercolor or drawing papers (some with identifiable watermarks), or as commercial laminate paperboards (illustration or mat boards). Many works from the Victorias period, including *The Helpful Angels* and *Head of Christ,* were executed on textured watercolor papers. Other drawings from the period, such as *Untitled* (plate 28) and *The Child Returns* (plate 20), appear on Tiffany stationery, which Ossorio reportedly had to use after his arrival in the Philippines while awaiting a shipment of more suitable paper from the United States.[24] It also is possible to connect certain paper types with specific periods of the artist's career. For example, several works executed from 1951 to 1956, including *Reforming Figure* (plate 40), were executed on large vertically oriented sheets of laminate paperboard. This shift to a notably larger format in the early to mid-1950s coincided with Ossorio's first foray into "traditional" oil painting on canvas. And while Ossorio's creative focus undoubtedly centered around his Congregations during the last decades of his life, wax-resist drawings on large laminate paperboard from his final year share remarkable material similarities with those works from the 1950s, a testament to an enduring commitment to his thoroughly unique process.

— Scott Homolka

Dubuffet

The French artist Jean Dubuffet explored a wide array of artistic forms during a career spanning over four decades. In the early 1940s, Dubuffet started combining artists' materials and nontraditional materials to create complex surfaces and imagery. Questioning the prevailing notions of aesthetics and the necessity of reproducing reality, Dubuffet celebrated the ordinary, snubbed the aesthete, and targeted the common man as his audience. A painting by Jean Dubuffet may provoke feelings of pleasure or displeasure, but never indifference.

The year 1942 marks Dubuffet's third and final attempt to start an artistic career. In a war-torn Europe, the artist's paintings offered no hope, no utopist salvation, and no romantic interlude. By 1945 Dubuffet had coined the term *art brut* ("raw art"), used to describe works produced without the influence of the institutionalized culture. This concept found some resonance in his creation of a new and personal visual language. No material was rejected in the creation of his rugged and complex surfaces. Charcoal, sand, tar, glass shards, and found objects were some of the materials added to his paint layers to create a variety of textures and surface finishes. He scoured and kneaded thick layers of paint to represent figures, objects, and scenes from everyday life. The materials used to create his paintings superseded the referred image at times, enhancing the tension between the complex surfaces and the image trying to emerge from it. Peter Selz qualifies his approach accurately by stating that he "shares with dada and surrealism his dependence on chance, his interest in automatism, although he always retains a controlling hand."[25]

Within the great degree of creative liberty he allotted himself, Dubuffet remained a disciplined, systematic, and dedicated artist who feverishly worked to develop a unique body of works.

32

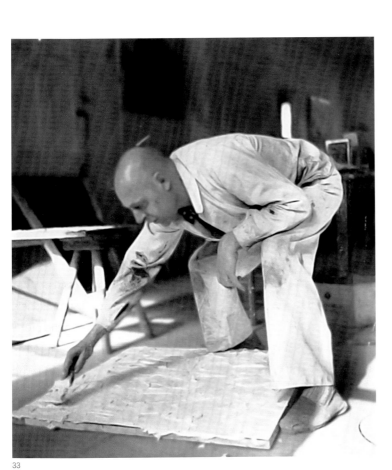

33

34

32. Dubuffet's *Cahiers d'atelier*.

33. Dubuffet applying the initial thick white paint layers, New York, 1952.

34. Cross-section of paint matrix of a Dubuffet painting, showing the thick white base layer.

Developing a Technique

From 1946 until the end of his life in 1985, Dubuffet systematically noted his use of materials, technique, and comments in his log books (*Cahiers d'atelier*), an amazing resource that reveals the artist's quest to understand interactions between wide ranges of materials (fig. 32).[26] He reproduced successful experimentations in later paintings, and reused or destroyed paintings he deemed failures.

He often used the same type of support for paintings with similar themes. Throughout the years, however, he did experiment with a large array of supports, including commercially prepared canvas, raw canvas, burlap, and Masonite-type rigid board (Isorel).[27] On these he first applied a thin layer of white base paint (lead white, casein, zinc white), followed by a thicker layer of white paint.[28] These layers were applied rapidly with a large spatula to create the basic surface texture (figs. 33 and 34).[29]

Archival images often show Dubuffet alternating the position of his supports from the floor to tables, easels, and walls, depending on the task at hand. The initial application of the thick base paint was often followed by a drying period. The surface was then painted in a dark tone or covered by multicolored paint strokes. Dubuffet experimented with artist's oil paints and commercial household paints such as Duco, Ripolin, Arte, Artista, and Lefranc & Bourgeois.[30] He also created his own paints by mixing dry pigments with oil and turpentine, varying the ratio and adding ingredients such as driers and varnishes. Interested in the way materials acted when drying, he experimented with products used in the automotive industry, such as putties and enamel paints. Dubuffet was very interested in provoking "accidents" on the surface of his works, sometimes allowing the positioning of pebbles or other objects in the paint matrix to determine elements of the composition. His use of blunt tools (end of a spatula, fingers) to rip through the wet or partially dried paint layers, in addition to creating an intended motif, dramatically exposed the underlying strata, revealing additional textures and colors. Supplemental rounds of thick paint were added to reinforce the motif inspired by the surface or the theme of the series.

Between more consistent paint layers, Dubuffet would apply layers of what he called a "sauce," consisting mainly of linseed oil and turpentine, to which he would sometimes add driers and varnishes to influence the way it reacted to the substrate. Its color varied greatly, ranging from transparent to completely opaque. He applied it generously with a brush and let the materials interact with the substrate until he found the visual arrangement satisfactory, as well as splattering or brushing pure turpentine on the surface to encourage a greater reactivity between the different components. The "sauce" migrated through the topography of his paintings, sometimes partially obliterating the design just created by the blunt tool, sometimes creating new ones. Dubuffet patented a "self-determining resist," using a material that would prevent subsequent paint layers from adhering to the surface and whose location was partially determined by the artist and by chance. He continued to add "sauce" throughout the process, often rubbing some of it off after letting it dry partially, until the composition was deemed satisfactory.[31]

Sand, pebbles, tar, charcoal, lime, and cement were among the materials Dubuffet applied or threw onto his works. Depending on the tack level of the surface, they became partially or completely incorporated within the paint layer. After a longer drying time (half a day or more), he often brushed paintings with turpentine or benzene and rubbed vigorously to reveal additional elements of the underlayer.

Terracotta la grosse bouche (plate 41) clearly illustrates Dubuffet's technique and use of materials. Technical and scientific investigations have revealed the use of a commercially primed canvas, coated with a layer of white paint (Rolloplast) followed by the application of fine multicolored brushstrokes and left to dry.[32] Thick layers of white paint (Rollplastique), sometimes sprinkled with sand and pebbles of varying hues of terra-cotta, were applied on the entire composition (figs. 35 and 36). The design was then scoured into the wet terra-cotta layer, revealing the colorful underlayer. Scratches on the surface might have been made by the tip of a spatula, which Dubuffet often used (fig. 37).

The background and the arms of the figure were reinforced with the application of paint and brush. Additional sand, pebbles, and coal dust were sprinkled on the surface and

35

36

37

39

38

35. Microphotograph of a Dubuffet painting, showing in the bottom section a dark glaze partially removed after rubbing and exposing a white underlayer. A whitish glaze is visible in the top section and has migrated away from the surface, which is occupied by pebbles and large grains of sand.

36. Close-up view of the side of the canvas and paint layer showing the thick dark paint and sand layers sitting on top of a multicolored thinner layer and the white preparation layer.

37. Colorful underlayer revealed after scouring the top layers. Scratches on the surface are possibly made by the tip of a spatula, which Dubuffet often used.

38 and 39. Detail (fig. 38) and microphotograph (fig. 39) of *Corps de dame jaspé*, showing the layering and reinforcement of the background surrounding the figure as one of the steps in the composition.

fused to varying degree to the damp surface. As in many of Dubuffet's compositions, small pieces of mirrored glass reinforce details such as the eyes, and thin painted lines, pebbles, or strings sit on the surface of the painting to reinforce its referred subject. A very similar technique was used to create the design and reinforce the figure in *Corps de dame jaspé* (plate 46; figs. 38 and 39).

Another factor noted during this period of production is the absence of underdrawing, confirmed both by Dubuffet's *Cahiers d'atelier* and by technical analysis of the National Gallery of Washington's collection. Infrared reflectographs have not revealed any underdrawings, indicating that the compositions were made with rapid, precise, and free-flowing gestures, with virtually no alterations.[33]

The nature of the substrate did not allow such a liberal use of materials in Dubuffet's works on paper, but he took great pains to prepare his surface here as well, again using the process to encourage potential "accidents." He would often abrade his paper with sandpaper and superficially slash it with utility knives and blades before he wetted it down and primed it with gouache, sometimes mixed with ink.[34] The painting or drawing medium was consequently encouraged to follow a route completely independent from the one

determined by the artist during the creation of his composition. This, once again, creates a tension between the artist's representation and the physicality of his materials.

Representing the Accident

Dubuffet continued to explore the physical and topographic qualities of his paint matrix throughout the 1950s, experimenting with various homemade and commercial pastes that offered a wide array of drying patterns and resist potential.[35] During some interludes, his paints became thinner and his surfaces smoother, as in *Paysage promeneur saluant le public* (plate 43). His log books note a change in materials in 1951–52, when he reduced his use of aggregates and experimented with a paste of zinc white and gold size. This change allowed him to produce a slightly smoother surface, but the resist factor between the materials was still at the forefront of the artist's intentions. The textured preparation layer, in combination with multiple applications of paint mixtures, solvents, and manipulations of the surface, greatly facilitated the creation of networks that seem to become the main protagonists in the composition. *Paysage au chien mort* (plate 51) reveals the importance of the network created by unstable fluids.

The Texturologie series of the late 1950s sees yet another change in technique (plate 53). Here the heavily textured preparation layer seems to have been replaced by several layers of thinly applied paint. In addition to using a spatula to apply the paint layers, Dubuffet pressed pieces of Arches papers, newspaper, and wax paper directly onto the wet surface and then removed them to create a specific texture. These pieces of paper were sometimes painted before being pressed on the work on paper, creating a different set of motifs. Additional paint was splashed and dripped over the surface of the work to create a myriad of fine droplets. Dubuffet further distressed the surface by scratching it with objects such as a fork or by pressing down energetically on the surface with more paper. The rendered image, evocative of the ground, a predominant theme in Dubuffet's work, seems to offer the viewer an intimate return to a material that had served the artist since the beginning of his production in the 1940s.

—Chantal Bernicky

Notes

1. Interview with Forrest Selvig, Archives of American Art, Smithsonian Institution, November 19, 1968.

2. Pepe Karmel, "Pollock at Work: The Films and Photographs of Hans Namuth," in *Jackson Pollock*, ed. Kirk Varnadoe (New York: Museum of Modern Art, 1998), pp. 87–137; James Coddington, "No Chaos Damn It," in *Jackson Pollock: New Approaches*, ed. Kirk Varnadoe and Pepe Karmel (New York: Museum of Modern Art, 1999), pp. 101–115.

3. Bernice Rose, *Jackson Pollock: Drawing into Painting* (New York: Museum of Modern Art, 1980), pp. 7–11.

4. See drawings 723–43 in Francis Valentine O'Connor and Eugene Victor Thaw, *Jackson Pollock: A Catalogue of Paintings, Drawings and Other Works* (New Haven, Conn.: Yale University Press, 1978), vol. 3, especially drawing 723, *Untitled*, 1944, 22½ x 30⅝ in.

5. Without an infrared image of the underdrawing, it is impossible to say, but other of his pictures did begin this way.

6. Under UV examination these inks fluoresce brightly, consistent with the synthetic dyes used in colored inks like those marketed by Dr. Martin's.

7. Deborah Solomon, *Jackson Pollock: A Biography* (New York: Cooper Square Press, 2001), pp. 102–3.

8. Ibid., p. 127.

9. Ink pen reference in ibid., 177.

10. Pollock used Strathmore laminated papers for his screen prints.

11. Hardboard is the generic name for a panel made from wood fibers fused under heat and pressure, originally made for the building industry in 1924 by the Masonite Corporation. See R. Bruce Hoadley, *Understanding Wood: A Craftsman Guide to Wood Technology* (Newton, Conn.: Taunton Press, 1980), p. 227. A discussion of the use of dark grounds can be found in Carol C. Mancusi-Ungaro, "Jackson Pollock: Response as Dialogue," in *Jackson Pollock, New Approaches*, p. 146.

12. The Phillips Collection conducted no analysis of the media. In Bernice Rose, *Jackson Pollock: Works on Paper* (New York: Museum of Modern Art, 1969), the medium line for these Japanese paper drawings is "black and colored inks." There may be other aqueous media in these pieces, such as gouache or watercolor.

13. Crepe paper is a crinkly paper produced by "crowding" a roll of paper after it is formed on the continuous papermaking machine using a blade called a "doctor." This blade stretches and crimps the paper while it still has a high moisture content. *Dictionary of Paper*, 3rd ed. (New York: American Pulp and Paper Association, 1965), p. 146.

14. Unpublished report by Walter R. Hopgood and R. M. Organ, January 9, 1978. Rivit glue was analyzed by the Conservation Analytical Lab, Smithsonian Institution, and determined to be a polyvinyl acetate emulsion. For a complete discussion of Pollock's use of Rivit glue, see Kirk Varnadoe, "Comet: Jackson Pollock's Life and Work," in Varnadoe, *Jackson Pollock*, p. 64; and Coddington, "No Chaos," pp. 110–11. Also discussed in Roni Polisar, unpublished HMSG conservation report on *Number 2*, May 1994.

15. Coddington, "No Chaos," p. 111.

16. *Jackson Pollock*, Sidney Janis Gallery, 15 East 57 Street, New York, November 3–29, 1958.

17. Interestingly, blue, black, and red paint are found along the edges of the painting. Pollock apparently chose to paint over an unfinished or abandoned composition and reuse the canvas for *Collage and Oil*.

18. See p. 123 of this volume.

19. Dr. Narayan Khandekar analyzed samples of colorless waxes used as resists and taken from the surfaces of Ossorio drawings in 2004. He confirmed wax compositions were by analysis using gas chromatography-mass spectroscopy as mixtures of different types of organic and mineral waxes, and would be consistent with the artist using candles as source materials for his resists. For instrumental conditions, see Scott Homolka, "Horror Vacui and the Process of Expression: A Technical Examination of Drawings by Alfonso Ossorio," research paper, Straus Center for Conservation and Technical Studies, Harvard University Art Museums, 2004.

20. According to Mike Solomon, former director of the Ossorio Foundation, Ossorio described the process of applying the wax resist as "saving" the information or image beneath (personal communication).

21. Mr. Solomon, who was present when Ossorio executed wax-resist paintings later in his career, described this final black ink application step as frightening to watch, since the entire surface was brushed with ink, and then as equally satisfying to see the artwork finally "come together" in the way that Ossorio confidently expected.

22. Pieces of sealing wax made by Dennison Manufacturing Co. Inc., Framingham, Mass., were among the materials from the artist's studio that survive in the Ossorio Foundation archive. According to Mr. Solomon, to his knowledge Ossorio never used a true encaustic painting technique, although he did use sealing wax occasionally in the fashion described above.

23. Close examination also revealed graphite and pen and ink underdrawing that loosely sketched out the contour to act as a guide for cutting; some areas of these lines were subsequently cut away during the process, providing clear evidence for the proposed order of execution.

24. Ossorio reportedly used his brother Frederic's Tiffany stationery, which was printed with Frederic's name. Mike Solomon, personal communication.

25. Peter Selz, "The Work of Jean Dubuffet," in *New Images of Man* (New York: Museum of Modern Art, 1959).

26. J. Dubuffet, *Cahiers d'atelier,* unpublished log books, Foundation Dubuffet, Paris. It is unclear whether earlier log books exist.

27. Masonite, patented in 1924 by William H. Mason, is created through a wet process in which wood fibers are compressed with heat to form a rigid sheet. One side of the sheet is very smooth, while the other has a grid texture. The European equivalent is called Isorel. Dubuffet arbitrarily painted on the smooth and the rough side. He sometimes made small gouges on the surface of the board to act as anchor sites for the thick layer of paint. Most of his canvas supports were commercially prepared with a lead white base ground.

28. The material used for these layers is identified by the artist as "Rollpeinture" and "Rollplastique." Dubuffet, *Cahiers d'atelier,* 1946. Preliminary testing at the NGA in 2004 revealed the Rollpeinture to be composed mainly of linseed oil and lead white. The Rollplastique, on the other hand, also contained lead white with zinc white and calcium-based components.

29. The thickness of this material ranged from very thin layers to approximately one inch.

30. Duco produced cellulose nitrate enamel based paints used by artists in the 1930s and '40s. R. Lodge, A *History of Synthetic Painting Media with Special Reference to Commercial Materials* (New Orleans: AIC, 1988).

31. Clusters of fibers often found on the surface, covered with oil and natural resin varnish, may have come from the rags with which Dubuffet removed excess glazes or solvents.

32. Chantal Bernicky, "The Organized Chaos of Jean Dubuffet: Investigating His Techniques and Materials," in *AIC Paintings Specialty Group Postprints, Providence, Rhode Island, June 16–19* (Philadelphia: AIC, 2007), pp. 110–17.

33. Infrared reflectography was carried out with a digital system consisting of a Mitsubishi M600 PtSi camera fitted with a 512-by-512-pixel platinum silicide focal plane array and a Nikon F/1.2 silicon lens with AR coating, a Macintosh Quadra computer, a Perceptics Pixelbuffer NuBus video frame grabber card, a Macintosh Power Mac computer, a Scion PCI video frame grabber card AG-5, Systems Analytics' IP-Lab Spectrum software, and Adobe Photoshop software.

34. Annie Hochard, "Jean Dubuffet: Les Matériaux de la création" in *Traitement des supports; Travaux interdisciplinaires* (Paris: ARAAFU. 1989), p. 119.

35. While in New York, Dubuffet experimented with Spot Putty, a putty used in the auto body industry. It was initially formulated as a nitrocellulose-based product, and eventually became available as an acrylic-based putty. He also made Swedish putty, a mixture of plaster, glue, and varnish.

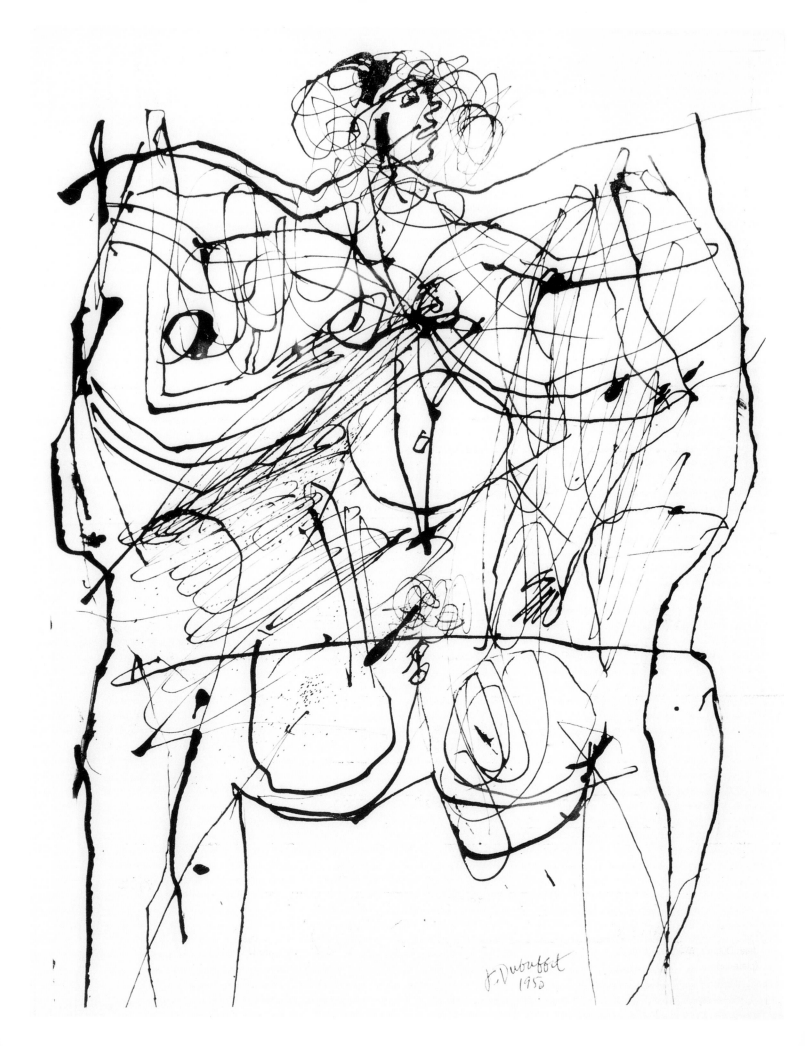

Exhibition Checklist

Jackson Pollock
(American, 1912–1956)

1. **Pattern**
ca. 1945
Watercolor, ink, and gouache on paper
22½ × 15½ in. (57.2 × 39.4 cm)
Hirshhorn Museum and Sculpture Garden,
Smithsonian Institution, Washington, D.C.
Gift of the Joseph H. Hirshhorn Foundation, 1966
(The Phillips Collection only)

2. **Untitled**
1947
Oil on primed Masonite
24 × 37¼ in. (61 × 94.3 cm)
Private collection

3. **Number 22A, 1948**
1948
Enamel on gesso on paper mounted on panel
22½ × 30⅝ in. (57.2 × 77.8 cm)
The Museum of Fine Arts, Houston
Museum purchase with funds provided by the
Brown Foundation Accessions Endowment Fund

4. **Number 1, 1950 (Lavender Mist)**
1950
Oil, enamel, and aluminum on canvas
7 ft. 3 in. × 9 ft. 10 in. (2.21 × 3 m)
National Gallery of Art, Washington, D.C.
Ailsa Mellon Bruce Fund
(formerly in the collection of Alfonso Ossorio)
(The Phillips Collection only)

5. **Untitled**
ca. 1948–49
Pen, brush and ink, and graphite pencil on paper
11 × 8⅜ in. (27.9 × 21.3 cm)
The Metropolitan Museum of Art, New York
Gift of Lee Krasner Pollock, 1982

6. **The Arts Manual by Jackson Pollock**
1951
Ink and watercolor on Howell paper
17¾ × 21½ in. (45.1 × 54.6 cm)
Collection of Ronnie and John E. Shore

7. **Collage and Oil**
ca. 1951
Oil, ink, gouache, and paper collage on canvas
50 × 35 in. (127 × 88.9 cm)
The Phillips Collection, Washington, D.C.

8. **Number 2, 1951**
1951
Collage of paper soaked in glue, pebbles, twine,
wire mesh, newsprint, and oil on board
41⅛ × 31⅛ in. (104.5 × 79.1 cm)
Hirshhorn Museum and Sculpture Garden,
Smithsonian Institution, Washington, D.C.
Gift of the Joseph H. Hirshhorn Foundation, 1966
(The Phillips Collection only)

9. **Number 23, 1951**
1951
Enamel on canvas
58½ × 47 in. (148.6 × 119.4 cm)
Chrysler Museum of Art, Norfolk, Virginia
Gift of Walter P. Chrysler Jr.
(formerly in the collection of Alfonso Ossorio)

10. **Untitled**
1951
Ink on Japanese paper
17½ × 22 in. (44.5 × 55.9 cm)
Parrish Art Museum, Water Mill, New York
Gift of Edward F. Dragon in memory of Alfonso
Ossorio
(formerly in the collection of Alfonso Ossorio)

11. **Untitled**
1951
Screen print on paper (unique trial proof)
28¾ × 23 in. (73 × 58.4 cm)
Private collection

12. **Untitled**
1951
Screen print on Strathmore paper
29 × 23 in. (73.7 × 58.4 cm)
Private collection

13. **Untitled**
1951
Gouache, India ink, and graphite on paper
28½ × 21¼ in. (72.4 × 54 cm)
Private collection

14. **Untitled**
1951
Enamel, India ink, and graphite on paper
29 × 22 in. (73.7 × 55.9 cm)
Private collection

15A. **Untitled**
1951
Screen print on Strathmore paper
29 × 23 in. (73.7 × 58.4 cm)
Private collection

Jean Dubuffet, *Corps de dame (Body of a lady)*
(plate 44)

15B. **Untitled**
1951
Screen print on Strathmore paper
29 × 23 in. (73.7 × 58.4 cm)
Private collection

15C. **Untitled**
1951
Screen print on Strathmore paper
29 × 23 in. (73.7 × 58.4 cm)
Private collection

15D. **Untitled**
1951
Screen print on Strathmore paper
23 × 29 in. (58.4 × 73.7 cm)
Private collection

15E. **Untitled**
1951
Screen print on Strathmore paper
23 × 29 in. (58.4 × 73.7 cm)
Private collection

15F. **Untitled**
1951
Screen print on Strathmore paper
23 × 29 in. (58.4 × 73.7 cm)
Private collection

16. **Number 3, 1952**
1952
Enamel on canvas
55⅞ × 66⅛ in. (141.9 × 168 cm)
Glenstone
(formerly in the collection of Alfonso Ossorio)
(The Phillips Collection only)

17. **Number 7, 1952**
1952
Enamel and oil on canvas
53⅛ × 40 in. (134.9 × 101.6 cm)
The Metropolitan Museum of Art, New York
Purchase, Emilio Azcarraga Gift, in honor of William
S. Lieberman, 1987

18. **Untitled**
ca. 1952–56
Dripped ink on paper
28⅞ × 20⅞ in. (73.3 × 53 cm)
The Metropolitan Museum of Art, New York
Gift of Lee Krasner Pollock, 1982

Alfonso Ossorio
(American, born Philippines, 1916–1990)

19. **Perpetual Sacrifice**
1949
Ink, wax, and watercolor on board
40 × 30 in. (101.6 × 76.2 cm)
National Gallery of Art, Washington, D.C.
Gift of Paul and Hannah Tillich

20. **The Child Returns**
1950
Wax, watercolor, and ink on torn Tiffany & Co.
stationery
8⅜ × 12⅜ in. (21.3 × 31.4 cm)
Courtesy Michael Rosenfeld Gallery LLC, New York

21. **First Suckling (Sleeping Mother and Child)**
1950
Watercolor, gouache, ink, and wax on shaped paper
mounted to canvas
22 × 30 in. (55.9 × 76.2 cm)
Courtesy Michael Rosenfeld Gallery LLC, New York

22. **Five Brothers**
1950
Watercolor, ink, and wax on illustration board
18⅜ × 30¼ in.
The Phillips Collection, Washington, D.C.

23. **Tattooed Couple**
1950
Watercolor, ink, and gouache on paper
20¾ × 25½ in. (52.7 x 64.8 cm)
Collection of Michael Rosenfeld and halley k
harrisburg

24. **Head of Christ**
1950
Ink and watercolor on torn paper
30 × 22 in. (76.2 × 55.9 cm)
Ossorio Foundation, Southampton, New York

25. **The Helpful Angels**
1950
Watercolor, ink, wax, and graphite on torn paper
22½ × 30½ in. (57.2 × 77.5 cm)
Courtesy Michael Rosenfeld Gallery LLC, New York

26. **Holy Mother (Mother Church No. 2)**
1950
Ink, wax, and watercolor on paper
30½ × 22½ in. (77.5 × 57.2 cm)
Courtesy Michael Rosenfeld Gallery LLC, New York

27. **Untitled**
1950
Wax, watercolor, ink, and oil crayon with interior
cutouts on paper
22 × 30 in. (55.9 × 76.2 cm)
Ossorio Foundation, Southampton, New York

28. **Untitled**
1950
Watercolor, ink, and wax on torn Tiffany & Co.
stationery
9 × 11¼ in. (22.9 × 28.6 cm)
Courtesy Michael Rosenfeld Gallery LLC, New York

29. **Maimed Mother and Child**
1950
Watercolor, ink, wax, and graphite on torn paper
21 × 30 in. (53.3 × 76.2 cm)
Collection of Henry H. and Carol Brown Goldberg

30. **Couple and Progeny**
1951
Ink, wax, watercolor, and cut paper mounted on
black paper
30 × 22 in. (76.2 × 55.9 cm)
Parrish Art Museum, Water Mill, New York
Gift of Edward F. Dragon

31. **Family with Blue Children**
1951
Wax, gouache, ink, and watercolor on paper
30 × 22 in. (76.2 × 55.9 cm)
Collection of Louis and Sally Vanasse

32. **Crucifix: Seek & Ye Shall Find**
1951
Oil and enamel on shaped canvas
38 × 51 × 2 in. (96.5 × 129.5 × 5.1 cm)
Courtesy Michael Rosenfeld Gallery LLC, New York

33. **Advent**
1951
Oil and enamel on canvas
33 × 22 in. (83.8 × 55.9 cm)
Ossorio Foundation, Southampton, New York

34. **Full Mother**
1951
Oil and enamel on canvas
51 × 38 in. (129.5 × 96.5 cm)
Courtesy Michael Rosenfeld Gallery LLC, New York

35. **Martyrs and Spectators**
1951
Oil and enamel on canvas
45½ × 35 in. (114.8 × 88.9 cm)
Courtesy Michael Rosenfeld Gallery LLC, New York

36. Mother and Child
1951
Oil and enamel on canvas
45¾ × 28¾ in. (116.2 × 73 cm)
The Phillips Collection, Washington, D.C.
The Dreier Fund for Acquisitions, 2008

37. Red Family
1951
Oil and enamel on canvas
77 × 59 in. (195.6 × 149.9 cm)
Dallas Museum of Art
General Acquisitions Fund and Theodore and Iva
Hochstim Fund

38. Head
1951
Oil and enamel on canvas
32 × 24 in. (81.3 × 53.3 cm)
Ossorio Foundation, Southampton, New York

39. Untitled
1951
Oil and sand on Masonite
30 × 27 in. (76.2 × 68.6 cm)
Ossorio Foundation, Southampton, New York

40. Reforming Figure
1952
Ink, wax, and watercolor on paper
60 × 38 in. (152.4 × 96.5 cm)
The Phillips Collection, Washington, D.C.
Gift of the Ossorio Foundation, 2008

Jean Dubuffet

(French, 1901–1985)

**41. Terracotta la grosse bouche
(Big-mouth terra-cotta)**
1946
Oil, plaster, sand, pebbles, coal, and mirrored glass
on canvas
39⅜ × 31⅞ in. (100 × 81 cm)
National Gallery of Art, Washington, D.C.
The Stephen Hahn Family Collection
(formerly in the collection of Alfonso Ossorio)

42. Les Habitants de l'oasis (Oasis dwellers)
1948
Ink on paper
14¾ × 21¼ in. (36.5 × 54 cm)
Collection of Louis and Sally Vanasse, Amherst,
Massachusetts
(formerly in the collection of Alfonso Ossorio)

**43. Paysage avec promeneur saluant le public
(Landscape with walker greeting the public)**
1949
Oil on canvas
35 × 45¾ in. (88.9 × 116.1 cm)
Collection of Arne and Milly Glimcher
(Parrish Art Museum only)

44. Corps de dame (Body of a lady)
1950
Ink on paper
10½ × 8¼ in. (26.7 × 21 cm)
Collection of Arne and Milly Glimcher
(Parrish Art Museum only)

**45. Corps de dame — Château d'Etoupe
(Body of a lady — Castle of oakum)**
1950
Oil on canvas
45¾ × 35⅜ in. (116.2 × 89.2 cm)
Allen Memorial Art Museum, Oberlin College,
Oberlin, Ohio
Gift of Joseph and Enid Bissett
(The Phillips Collection only)

**46. Corps de dame jaspé
(Marbleized body of a lady)**
1950
Oil and sand on canvas
39¾ × 29 in. (101 × 73.7 cm)
National Gallery of Art, Washington, D.C.
The Stephen Hahn Family Collection
(formerly in the collection of Alfonso Ossorio)

47. L'Homme au nez menu (Man with small nose)
1950
Oil on board
31⅞ × 25⅝ in. (81 × 65.1 cm)
Courtesy Acquavella Modern Art, New York

**48. Concretions terreuses au soleil ardent
(Earthly concretions with hot sun)**
1951
Oil on board
28¾ × 42⅞ in. (73 × 109 cm)
Courtesy Acquavella Modern Art. New York

49. La Maison abandonée (The abandoned house)
1952
Oil on board
31⅞ × 36¼ in. (81 × 92.1 cm)
Courtesy Acquavella Modern Art, New York

**50. Paysage métapsychique
(Metapsychical landscape)**
1952
Oil on canvas
51⅛ × 63¾ in. (121.9 × 161.8 cm)
Des Moines Art Center
Gift of Melva Bucksbaum in honor of the Des
Moines Art Center's 50th anniversary

**51. Paysage au chien mort
(Landscape with dead dog)**
1952
India ink on paper
19⅝ × 25¾ in. (49.8 × 65.4 cm)
Collection of Arne and Milly Glimcher
(Parrish Art Museum only)

52. Paysage au chien (Landscape with dog)
1955
Oil on canvas
28¾ × 36¼ in. (73 × 92 cm)
Courtesy Acquavella Modern Art, New York

**53. Confiture matière lumière (Texturologie LIII)
(Preserves of light and matter [Texturology LIII])**
1958
Oil on canvas
38⅛ × 51¼ in. (96.8 × 130.2 cm)
National Gallery of Art, Washington, D.C.
The Stephen Hahn Family Collection